PRESTON

SINGLETARY

By Melissa G. Post, with essays by Steven Clay Brown and Walter C. Porter

PRESTON

echoes, fire, and shadows

SINGLETARY

Museum of Glass, Tacoma ~ University of Washington Press, Seattle and London

A special edition of *Preston Singletary: Echoes, Fire, and Shadows* is also available. It is limited to 200 and 20 artist's proofs. Each slipcased, numbered book is signed by Preston Singletary and is accompanied by *Killer Whale*, 2008, a 12x12-inch three color silk-screen print made for this edition from a stencil hand-cut by the artist. For more information or to purchase please call the museum bookstore at (253) 284-3009 or email store@museumofglass.org

© 2009 by the Museum of Glass and University of Washington Press

"Preston Singletary's Journey with the Raven" © 2009 by Steven Clay Brown

"A Spokesman for Culture" © 2009 by Walter C. Porter

Preston Singletary: Echoes, Fire, and Shadows DVD © 2009 by the Museum of Glass

Frontispiece: Photo by Russell Johnson and Jeff Curtis, courtesy of the artist

Design by Michelle Dunn Marsh
Editorial review by Laura Iwasaki

Printed in Singapore by CS Graphics

Library of Congress Cataloging-in-Publication Data

Post, Melissa G.
Preston Singletary : echoes, fire, and shadows / Melissa G. Post.— 1st ed.
 p. cm.
Issued in connection with the exhibition.
Includes bibliographical references.
ISBN 978-0-295-98918-1 (hardcover : alk. paper)
1. Singletary, Preston, 1963– —Themes, motives—Exhibitions. 2. Indian artists—United States—Exhibitions. I. Museum of Glass II. Title.NK5198.S46A4 2009
748.092—dc22 2008053860

Published by
Museum of Glass
1801 Dock Street
Tacoma, WA 98402-3217
www.museumofglass.org

In association with
University of Washington Press
P.O. Box 50096
Seattle, WA 98145-5096
www.washington.edu/uwpress

CONTENTS

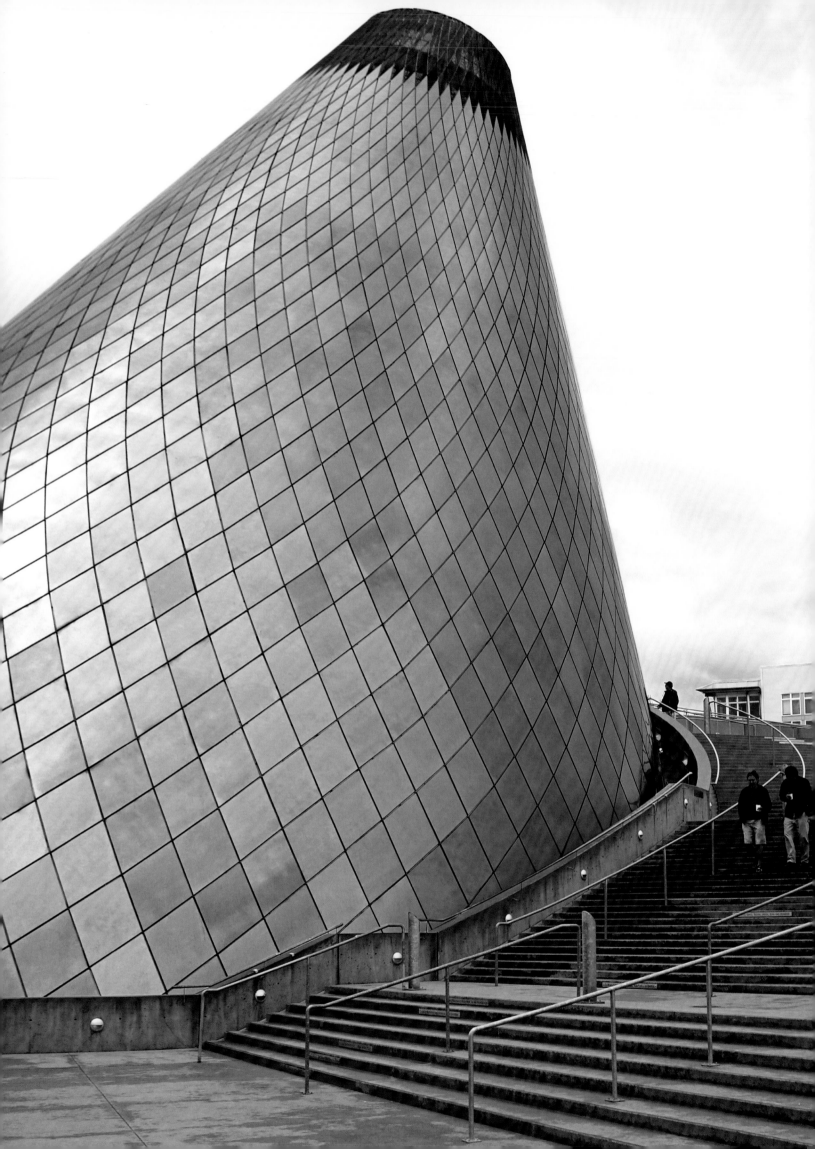

FOREWORD

Timothy Close

Director/CEO
Museum of Glass

The Museum of Glass is proud to present the exhibition *Preston Singletary: Echoes, Fire, and Shadows* and this accompanying catalog. Singletary's exquisite and distinctive works echo and honor the rich symbolism of the artistic traditions of Northwest Native cultures. The objects themselves cast shadows that invoke the mysteries and prophecies of Tlingit legend, myth, and spirituality.

As an artist, Singletary celebrates his Tlingit heritage through musical performances and the visual arts. Through his personal journey, Singletary pays homage to and explores this heritage by referencing the iconography of his ancestors in his work. Sculpting glass into the shapes of important Tlingit ceremonial objects such as masks, hats, rattles, and lidded boxes, he infuses them with symbolic narratives telling stories of creation, transcendence, and harmony. Equally important to Singletary, and as apparent in his work, is honoring the traditions of another group of people. Singletary grew up in Seattle, where he was enfolded in the close-knit community of glassblowers who defined the Northwest Studio Glass movement. He was schooled in the traditions of European glass, studying the aesthetics and techniques of glassmakers from Italy to Sweden, sharing in the rich, creative culture of contemporary artists. His work is a beautiful blend of both worlds.

This exhibition is more than a mid-career survey. It is an exploration of the melding of cultures, traditions, techniques, and imagination that defines Preston Singletary's vision and voice and illuminates the deeper realms of human spirituality.

The exhibition, the catalog, and the accompanying video documentary reflect the integration of yet another distinctive culture—the museum professionals and scholars whose dedication and effort give this project the depth it deserves as well as the generous donors who support this important work.

On behalf of the entire Museum staff and Board of Trustees, I offer heartfelt thanks to Preston Singletary and his family, who lent work (including some vital early pieces) from their own collections. I also thank Leonard and Norma Klorfine and their Foundation for generously supporting the Museum of Glass in the commission of Preston Singletary's *Clan House*, the monumental cast-glass house posts and screen, which serves as the signature work of the exhibition and a cornerstone of the Museum's Permanent Collection.

There are many individuals who deserve recognition for their dedication, effort, and contributions to this catalog. Essays from artist, author, and scholar Steven Clay Brown and noted Tlingit storyteller Walter C. Porter add wisdom and cultural perspective to this study of Singletary's work. Museum of Glass curator Melissa G. Post developed the exhibition, conducting original research and offering a comprehensive overview of the artist's evolution. And the University of Washington Press worked closely with the Museum to produce this compelling publication.

The Museum's entire curatorial team has earned accolades as well: Susan Warner, director of public programs; Rebecca Engelhardt, registrar; Liz Cepanec, Visiting Artist Program manager; Bill Bitter, exhibition designer; and Ginger Bellerud, curatorial assistant.

Preston Singletary is an established, highly respected artist, renowned for his inventiveness and technical prowess with glass as well his breathtaking homage to Tlingit tradition. The Museum of Glass is dedicated to glass—and to the artists who have chosen to work in this medium. It seems inevitable that these icons of Northwest culture would fuse. I think that you will enjoy and treasure *Preston Singletary: Echoes, Fire, and Shadows*.

Once in a great while, projects such as *Preston Singletary: Echoes, Fire, and Shadows* present themselves. On every level, the experience has proved enlightening and gratifying, ultimately surpassing all expectations.

We appreciate the generosity and support of the Leonard and Norma Klorfine Foundation, The Windgate Charitable Foundation, JoAnn McGrath, *The Seattle Times*, and *City Arts* Magazine and Encore Arts Programs.

Working with Preston has been a joy. From the outset, he consistently demonstrated his steadfast commitment to this project, including the exhibition, publication, and creation of an entirely new body of work. He facilitated innumerable aspects of the exhibition large and small, from identifying potential supporters to suggesting prospective lenders, all the while working on his most significant commission to date, the monumental *Clan House*. Throughout the process, Preston remained patient and willing to answer "just one more question" or to "tell that story one more time," while maintaining his composure and sense of humor.

ACKNOWLEDGMENTS

Melissa G. Post

Curator

Museum of Glass

We ackowledge the commitment of numerous artists, gallerists, and collectors. Preston's team has persevered, relatively unfazed (despite the numerous disruptions, in the studio and in the Hot Shop). We are grateful to Sweetwater Nannauck for facilitating research and to the artists who assisted Preston in completing the ambitious series of new works that are debuting at this exhibition. In particular we acknowledge Ray Ahlgren, president of Fireart Glass, Inc., who pioneered the painstaking techniques for casting the monumental *Clan House* posts. We would like to extend our profound gratitude to Leonard and Norma Klorfine for supporting this commission.

Recognizing the magnitude of this exhibition and publication, the following devoted gallery professionals took the time to comb through their archives. Grace Meils, associate director of Traver Gallery (Seattle), spearheaded this initiative, working with Ben Rosenblatt, gallery manager. Gary Wyatt, director, Spirit Wrestler Gallery (Vancouver, British Columbia); Mary Childs, co-director, Holsten Galleries (Stockbridge, Massachusetts); Douglas Heller, director, Heller Gallery (New York); Denise Phetteplace, director, Blue Rain Gallery (Santa Fe, New Mexico); Cecily Quintana, director, Quintana Galleries (Portland, Oregon); and Dena Rigby, director, Dena Rigby Fine Arts (Seattle), proved invaluable in forging the all-important links to potential lenders.

We are particularly grateful for the generosity and support of Preston Singletary and his family, Rachel Singletary Kopel, Theresa Sherman, and Jamie Sherman, for lending several very rare, early works. We appreciate the generosity and willingness of several institutions, such as the Corning Museum of Glass (Corning, New York) and the M.J. Murdock Charitable Trust (Vancouver, Washington) as well as numerous individuals nationwide who agreed to part with some of their favorite works for three years, including Tony Abeyta, Kim and Tony Allard, Alan and Lorraine Bressler, Cathy and Michael Casteel, Luino and Margaret Dell'Osso, Jr., Paul S. Fishman and family, Raven and Robert Fox, Larry Gabriel, James Geier, Clarissa Hudson, Clay Johanson, Scott Karlin, Alison and Dante Marioni, Ann M. Morrison and Steve J. Pitchersky, Lucy and Herb Pruzan, John and Beverly Young, and Dr. Edward Zbella. Dick Boak of C. F. Martin & Co. (The Martin Guitar Company) enthusiastically secured a customized Martin guitar, which debuts at the Museum of Glass.

Several artistic individuals enriched the publication and inevitably the exhibition, providing powerful insight into their relationships with Preston and perspective regarding his artistic evolution. For taking the time to provide this thoughtful commentary, I would like to thank Marcus Amerman, Dante Marioni, Benjamin Moore, Ed Archie NoiseCat, David Svenson, and William Traver.

We are indebted to photographers Russell Johnson, Jeff Curtis, and Philip Newton. Russell continues to amaze us with his exceptional photography of Preston's work. Philip provided dramatic black-and-white images, beautifully documenting one of Preston's 2008 Museum of Glass Visiting Artist Residencies.

In June 2008, Todd Pottinger, audiovisual producer, and I had the pleasure of traveling to Juneau, Alaska, to immerse ourselves in Celebration 2008 and the Northwest Coast Artists' Gathering. There, Todd filmed twelve hours a day or as long as the light shone on Juneau. His thought-provoking questions and detailed transcripts served as an invaluable resource and the foundation for yet another extraordinary documentary. Filming at Celebration 2008 was facilitated by a host of people. We are thankful to Clarissa Hudson, co-organizer of the Northwest Coast Artists' Gathering, for her warmth, candor, and creativity. Our gratitude goes to the staff at the Alaska State Museum, in particular Eugene Coffin and Kai Augustine, for keeping the museum open late for our interviews in Juneau. *Gunalchéesh* to the Tlingit, Haida, and Tsimshian Nations for welcoming us to Celebration 2008.

We are thrilled to be partnering once again with the University of Washington Press. Based on Susan Warner's stellar management of Museum projects, Jacqueline Ettinger, acquisitions editor, and John Stevenson, production manager, have enthusiastically supported *Preston Singletary: Echoes, Fire, and Shadows* from its inception. We are grateful to Yarrow Vaara and Linda Belarde of the Sealaska Heritage Institute for providing us with Tlingit translations. Michelle Dunn Marsh was enlisted for her superb design sensibilities, resulting in an exquisite, resonant publication as well as a deluxe collectors' edition. Essayists Walter Porter and Steven Clay Brown provide rich insight into Preston's oeuvre and its cultural significance.

Every member of the Museum staff plays an important role in the mounting of each exhibition, from facilities management to visitor services, from the docents to the board of trustees. The commitment begins with the director/CEO and extends to the staff. I thank my colleagues, who cultivate this dynamic environment known as the Museum of Glass: Tim Close, for his vision of making this a museum of the twenty-first century and spearheading ambitious projects such as this one; deep gratitude goes to Susan Warner, director of public programs, for her willingness to manage this publication with grace and finesse—she has established the gold standard, not only for Museum of Glass publications but also for educational and outreach programs. Her efforts to design dynamic educational programs are fortified by the work of the education team, including Ryan Branchini and Elisabeth Emerson.

My special thanks go to Ginger Bellerud, curatorial assistant, who, during a crucial period, rose to all of the challenges set before her, diligently and tenaciously tracking down works in collaboration with a succession of galleries and greatly contributing to the development of this publication. I appreciate the efforts of Rebecca Engelhardt, registrar, for her willingness to work under extremely tight deadlines and oversee the packing, crating, shipping, and insuring of each work in the exhibition; William Bitter, exhibitions designer, for conceiving how best to install *Clan House* and designing a compelling exhibition in collaboration with Preston; Liz Cepanec, Visiting Artist Program manager, for making the Visiting Artists Program world-class; the Hot Shop team of Ben Cobb, Alex Stisser, Gabe Feenan, Sarah Gilbert, and Conor McClellan for welcoming the visiting artists with open arms; Rosanne Nichols, Karen Gose Clemens, and Katy Evans, for forging ahead and garnering impressive support for the exhibition; and Julie Pisto, Susan Newsom, and Maria Kadile Konop, for designing and generating a superlative marketing campaign.

Finally, I would like to extend my heartfelt thanks to my parents, Connie and George A. Post, Jr., Althea, family, and friends, for their enduring support and empowering inspiration.

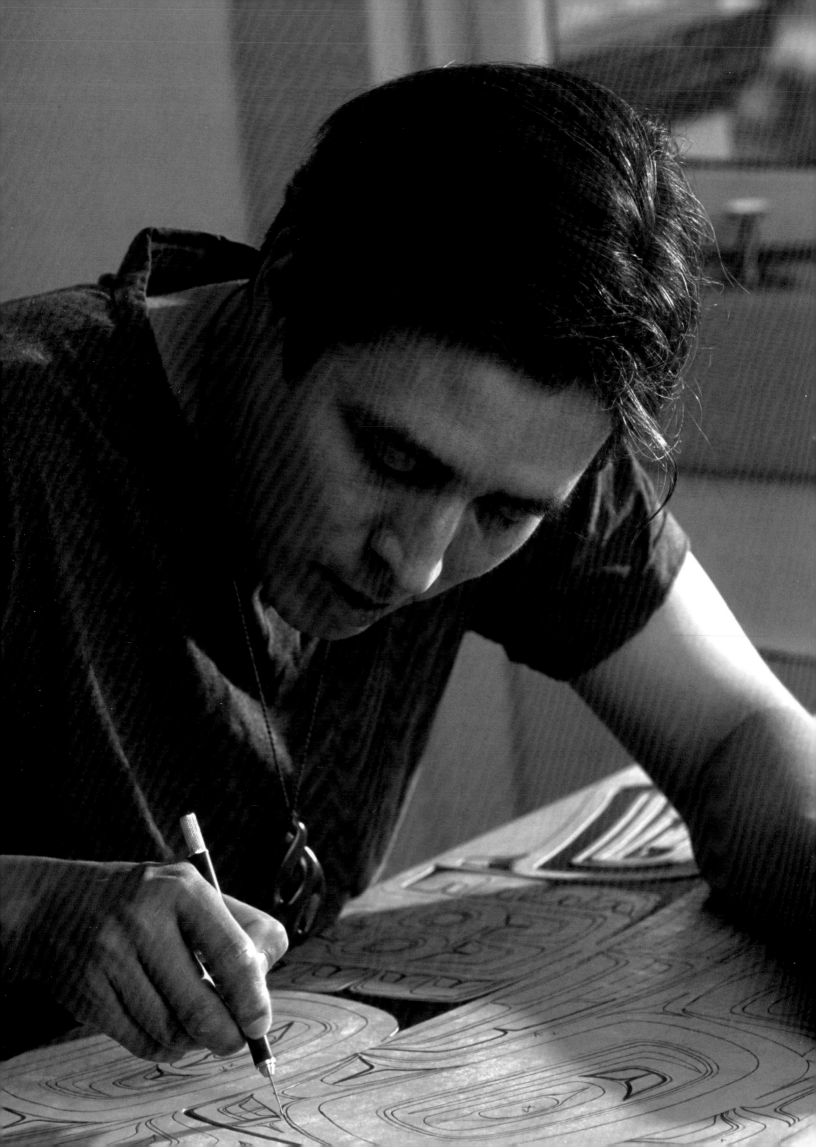

What I'm trying to do in my own way is represent my culture. It's sort of a reclamation process of taking charge of what it is that our people do and declaring who we are—contemporary people as opposed to an anthropological study. It's asserting my own style . . . my own vision to work in the way that I feel is comfortable.

—Preston Singletary

PRESTON SINGLETARY: NAVIGATING CULTURE AND GLASS

Melissa G. Post

Curator

Museum of Glass

Preston Singletary represents the new generation of Studio Glass artists, strongly rooted in his culture yet eagerly assimilating contemporary influences. For twenty-two years, he has pursued, in earnest, the art of glass, creating a distinctive body of work that honors the traditions of his Tlingit forebears, the techniques of European glass masters, and the aesthetics of contemporary art. To do so, he has embraced cross-cultural collaborations and commissions, discovering further ways of enriching his artistic expression.

His maternal grandparents were Tlingit, a Native American group in southeastern Alaska. Tlingit people traditionally used organic materials including wood, cedar bark, and spruce root in the creation of utilitarian and symbolic objects such as totem poles, baskets, and rain hats. Singletary uses glass to capture the essence of Tlingit forms, designs, and narratives, infusing this contemporary sculptural medium with new meaning.[1]

Singletary's journey as an artist and an individual has been perpetuated by successive encounters with influential people, interspersed with periods of deep introspection and cultural inquiry. In the process, he has been both a humble recipient of knowledge and a powerful disseminator of it. This essay, composed in conjunction with his mid-career survey *Preston Singletary: Echoes, Fire, and Shadows,* illuminates Singletary's artistic evolution and his vibrant contributions to the Studio Glass movement and the Tlingit culture.

Early Years: 1963–1974

Preston Lawrence Singletary was born in San Francisco, California in 1963 and moved with his parents to the Wallingford neighborhood of Seattle several weeks later. Among the gifts that Singletary's parents passed down to him were a love for art and music, a profound respect for the natural world, and the confidence to achieve his dreams. His mother, Jean, created bead and fiber art and conducted macramé workshops. His father, Preston, a talented illustrator, enjoyed poetry, painting, soapstone carving, and fly-fishing. Together, Singletary's parents often sang and played blues in their home, inspired by the soulful strains of Lead Belly (Huddie William Ledbetter, 1888–1949). At age eleven, Singletary began playing the piano, subsequently learning guitar and bass. He formed a band three years later, the first of

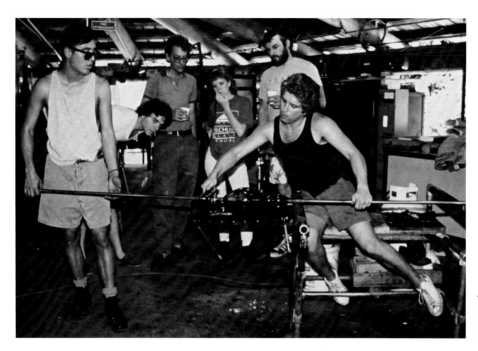

fig. 1 Preston Singletary (left) and Dante Marioni (right) with pipe at Pilchuck Glass School, about 1986.

many collaborations that would shape his life. Throughout this early period, Singletary was raised with stories about his Tlingit heritage from his great-grandmother, Susie Johnson Bartlett.[2] Growing up in this household infused with music, art, and culture proved profoundly inspiring to this man and his work.

Glass: 1977–1988

At age fifteen, Singletary met Dante Marioni, son of pioneering Studio Glass artist Paul Marioni. Their friendship had a lasting influence on Singletary's life, and they remain close friends to this day.

It was Marioni who introduced Singletary to the glass world and the original Glass Eye Studio, widely known for its decorative glass, in Seattle's famed Pike Place Market (fig. 1). As their friendship evolved, so too did Singletary's interest and involvement with the glass community. In 1982, following four years of study at Lincoln High School, he became a night watchman at the Glass Eye Studio. His responsibilities included cleaning the studio and filling the furnaces with raw glass. This overnight shift provided Singletary the means to pursue his music. It was, perhaps, during those hours that the hum of the furnace penetrated his psyche. Just three months after starting the job, he moved to the day shift, taking on the greater responsibilities of mixing chemicals and welding. Several months later, he was invited to blow glass.

From 1982 to 1984, Singletary learned and developed the fundamental skills necessary to blow glass, creating popular paperweights and ornaments that incorporated ash from the 1980 eruption of Mount Saint Helens. It was at the Glass Eye Studio that Singletary met Italian maestro Lino Tagliapietra. Tagliapietra's 1983 workshop forever altered the way Singletary perceived and approached glass. Rather than pursuing an academic art education, Singletary opted to train with the finest Studio Glass artists, enriching his understanding of the world through self-study, travel, and teaching. Through these formative experiences and with consid-

erable encouragement from his colleagues, Singletary developed his glassblowing proficiency.

In 1984, two encounters proved pivotal in shaping Singletary's artistic evolution. He enrolled in his first glass class at Pilchuck Glass School, where he met Sonja Blomdahl. Working with Blomdahl, Singletary learned the art of *incalmo*, a demanding technique in which two molten glass bubbles of precisely the same diameter are conjoined and then shaped into a vessel. Evidence of Singletary's work with Blomdahl would resurface nearly a decade later in *The Genies* series.

At Pilchuck, Singletary also met sculptor and self-trained Studio Glass artist Anthony (Tony) Jojola, a member of the Isleta Pueblo Indian group in New Mexico.[3] Jojola was a particularly influential figure for Singletary, encouraging him to research his family background and make pieces that related to his cultural heritage. This was the genesis of Singletary's investigations into his Tlingit tradition and his relationship with the Native American community and Pilchuck Glass School.

Prompted by these mentors and fellow artists, Singletary embarked upon a period of intensive self-study, which continues to this day. Curious by nature, he allowed his evolving awareness of Jungian dream analysis, Surrealism, and Primitivism to shape his studies. He found Primitivism and the spare modern forms it spawned particularly fascinating and began incorporating them into his design work. An extension of these interests manifests later, specifically in his amulets, defined by their biomorphic forms.

Singletary's subsequent studies at Pilchuck introduced him to other leading figures in the contemporary glass world. For a fifteen-year period (1984–99), he trained with Italian maestros Checco Ongaro, Pino Signoretto, and Lino Tagliapietra and emerging American glass masters Dan Dailey, Benjamin Moore, and Richard Royal.[4] These collective experiences furnished Singletary with vast artistic and technical knowledge, a foundation upon which he eventually established his distinctive style. Throughout this period, Singletary forged numerous lasting friendships. Ultimately, Pilchuck—both the place and the people—would transform him.

Following two years of production work at the Glass Eye Studio, Singletary joined Moore's team and worked in varying capacities between 1985 and 1999. Moore, like Dale Chihuly, had trained as a glass artist and designer at the Rhode Island School of Design (RISD) and had also received a Fulbright Fellowship to work in Venice. He imparted his interest in Venetian glass to those he mentored.[5] In Moore's Seattle studio, Singletary and Marioni trained with Moore, Royal, and Tagliapietra, developing and refining their Venetian glassblowing techniques.[6]

Moore's team worked on large-scale architectural and design projects. Singletary recalled, "After I landed the job with Benjamin Moore, the whole world just opened up. There I was, exposed to various artists and sensibilities." Moore recounted that, "Within a very short period of time, I came to realize [Singletary] had wonderful hands. [He was] multi-talented."[7] Singletary learned how to control the material with precision and finesse, gradually developing his own artistic voice and cultivating the seeds of his personal artistic ethos.

Throughout this period of artistic development, Singletary straddled two worlds—contemporary design and Tlingit iconography—producing several distinctive bodies of work. While the contemporary series reflects his European training and his

emergent design sensibility, his work with Tlingit designs represents his own cultural inquiry. The *Scribble Vases* (1985–90) (p. 48, cat. 1) comprise voluptuous vessels executed in transparent gem tones and embellished with fine black trails. Reminiscent of the Chinese-inspired vases of Italian glass designer Carlo Scarpa (1906–1978) and the drip paintings of Jackson Pollock (1912–1956), these works embody Singletary's nascent interests in classicism and Expressionism.[8] A few years later, he would reference these influences in his *Prestonuzzi* series (p. 52, cat. 4).

1989: A Pivotal Year

In the interim, Singletary experienced the first of two defining moments that would forever alter his aesthetic course. In the summer of 1989, he found himself again at Pilchuck Glass School. During this time, he was endeavoring to transfer Tlingit patterns directly from books onto glass. Singletary learned that his moiety (one of two basic complementary tribal subdivisions) is Eagle and his family house group is Kaagwaantaan. His clan's symbols are the killer whale, brown bear, eagle, and wolf. In essence, his group owns these symbols and the rights to create and display them "to illustrate where they come from."[9]

At Pilchuck, Singletary also met wood and neon artist David Svenson. Svenson's own portfolio was brimming with Tlingit designs. He had lived in Alaska for ten years, learned the carving tradition, and was adopted into a Tlingit family. Following extended conversations, Svenson introduced Singletary to Northwest Coast woodcarving and culture.

Hearing about Svenson's life in Alaska and seeing his photographs, including an image of Chief Klart-Reech's House (also known as the Whale House) at Klukwan, fueled Singletary's desire for cultural immersion (fig. 2). The interior of the Whale House, with its elaborate rainwall screen mounted between two immense house posts and clan treasures arranged in a potlatch presentation, would prove influential in his subsequent work, such as *Housefront Screen* (pp. 74–75, cat. 20).

Svenson, like Jojola, encouraged Singletary to continue his investigations, developing his work based on Tlingit designs. That year, Singletary decided to devote himself to "developing the process of integrating Northwest Coast designs in glass."[10] The process was neither straightforward nor immediate. It unfolded organically over the ensuing decade.

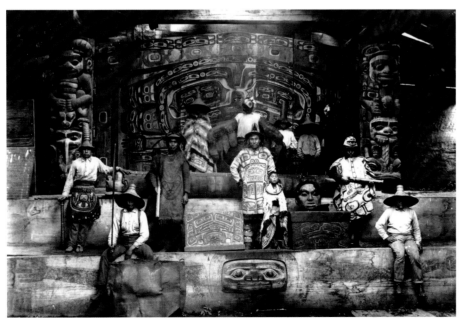

fig. 2 Interior of Chief Klart-Reech's House, Klukwan, Alaska, 1895. Eleven men and youths on a platform in the Whale House, with two bent-wood boxes, woodworm dish, rainwall screen, and house posts of "Raven" and "The Girl and the Woodworm" in the background. Alaska State Library, Winter & Pond Photograph Collection, P87-0010.

Subsequently, Singletary embarked upon a period of intensive research of Tlingit iconography as well as various forms of technical execution. His interest in the distinctive ovoid and U- and L-shaped patterns known as formline led to more formal studies. From these studies, Singletary would expand upon the notion of Native Alaskan art, creating in glass the objects that are revered in the Tlingit culture.

Singletary's endeavors to create "a hallmark of traditional Northwest Coast art" resulted in his first signature form, a Tlingit crest hat. In 1989, he presented *Wolf Hat* to his Aunt Theresa Sherman (p. 50–51, cat. 2).[11] Traditional Tlingit crest hats are emblematic of an individual's tribal status. They were woven from spruce roots and then painted with the anthropomorphic designs unique to that individual's clan. Singletary created his oversized, monochromatic glass hat using a technique called "sandcarving." The form was blown, masked with tape, and, finally, sandblasted. The taped areas remained raised and transparent; the sandblasted areas recessed and translucent. What began as a singular silhouette of a wolf, one of Singletary's own clan crests, evolved into a series of bears, frogs, and killer whales, each one more elaborate than the previous. Over time, Singletary's Tlingit-inspired designs became distributive or wholly abstract, as seen in *Shadow Catcher* (p. 76, cat. 21).

1990s: Influences and Design

At Singletary's first exhibition of Tlingit work in 1991, his Aunt Theresa's constructive criticism would forever alter his work and its visual impact. "Honey," she whispered, "you're missing the boat! Now go over and aim that spotlight directly over that hat." He did and the room full of spectators released an audible "ahhhhh." Inverting the form and bathing it in light produced dramatic shadows, animating the glass and enriching the iconography and the viewer's experience. Singletary had transformed this otherwise symbolic and decorative headpiece into a visually arresting entity. This form would become iconic within his work.

From 1991 to 1996, Singletary experimented with new techniques, creating the *Prestonuzzi* series, inspired by American artists Dante Marioni and Richard Marquis and Italian Napoleone Martinuzzi (1892–1977), a designer for Venini. In these pieces, Singletary combines Martinuzzi's monochromatic Art Deco forms, Marioni's vivid color and stylized auricular handles, and Marquis's unique method of titling his work.[12] Masterfully rendered, these works illustrate Singletary's budding design sensibility, a progression that would be amplified in his subsequent series, *The Genies* (1995–97) (p. 53, cat. 6).

As Singletary became more proficient as a glassblower, new opportunities presented themselves. In 1993, one decade after their first meeting, Singletary and Marioni accompanied Tagliapietra to Europe, assisting with a series of workshops and demonstrations at Sweden's Kosta Boda glassworks as well at the Iittala and Nuutajärvi glass factories in Finland.

In Sweden, Singletary met a young designer, Åsa Sandlund, who worked at Åfors, a division of Kosta Boda. Singletary returned to Sweden in December 1993 to serve as a gaffer for graduate students at the prestigious Konstfack University College of Arts, Crafts, and Design and the University of Helsinki in Finland. While there, he assisted Sandlund in creating sandblasted glass plates for her thesis exhibition,

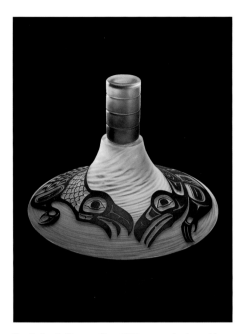

fig. 3 *Eagle/Raven Hat*, 1998, commissioned by Shee Atika

and she, in turn, introduced him to modern Scandinavian design and the design process itself. Singletary considers this his first artistic collaboration, the stimulus behind his long-standing interest in modern design. The two fell in love, returned to the United States, and married in 1995. He continued working at Moore's studio; she began a marketing career at Nordstrom, Inc. Singletary has three children: Sienna, Orlo, and Lydia.

Following his travels, Singletary initiated a new series, *The Genies,* in which he merged cross-cultural influences to exert a definitive style. While the restrained forms recall the works of modern Swedish ceramist Stig Lindberg (1916–1982), the bold Italian technique of *incalmo* and effortless color sensibilities reflect his training with Blomdahl and Marioni. These tabletop trios illustrate an artist clearly in command of a formal vocabulary, reveling in form, surface, and the nuances of overlay. With *The Genies*, Singletary presented a distinctly modern impression.

The very attributes that defined his eclectic, European-inspired vessel series, however, posed inherent challenges to the artist. He experienced the difficulty of carving out a niche—a personal artistic identity—making vessel forms. Alternating between European- and Tlingit-inspired designs for several years, Singletary found himself at a crossroads once again. He was simultaneously looking toward his wife and her family, admiring their sense of community and culture, while seeking a more personal expression of himself. The desire to discover his own voice prevailed. It provoked him to pursue sculpture and broaden his line of aesthetic inquiry. Singletary reaffirmed his commitment to developing his own style—rooted in Tlingit heritage.

1998: Transition to Tlingit Iconography

In 1998, Singletary began a period of independent study in Northwest Coast art with Steven Clay Brown, associate curator at the Seattle Art Museum, and Marvin Oliver, associate professor of American Indian Studies at the University of Washington. Between 1999 and 2006, these studies were augmented by hands-on design workshops with wood-carvers Gregg Blomberg, Brown, and Duane Pasco, among others. Applying these newly learned designs to simplified glass shapes, Singletary transformed cylinders, rondels, and conical forms into a distinctive series of totems, crest hats, and bowls with decorative motifs. In his early works, such as *Wasco* (p. 59, cat. 10) and *Whaler's Hat* (p. 77, cat. 24), he faithfully reproduced traditional designs. As his understanding of this formal visual language and its cultural meaning developed, he began improvising and creating his own vocabulary.

Singletary's later efforts in working with Tlingit designs materialized into a series of monochromatic elliptical forms. These were translated into grease dishes sandblasted with formline designs and *battuto*-carved (Italian for "beaten") canoes (pp. 62–63, cat. 12). In both, he presented subtle variations, alternating form and surface, transparency and translucency. These implicitly functional dishes served as the springboard to his aesthetic acculturation.

Gradually, Singletary's work evolved into decorative and sculptural forms, ranging from the secular to the sacred. The amulet became a recurrent motif throughout his oeuvre, exhibiting increasingly elegant proportions and complexity. In working with glass, Singletary bridges sacred tradition and contemporary innovation, expanding and enriching them both.

Commissions

Singletary entered a particularly prolific period from 1998 to 2004, gaining recognition and garnering significant commissions from individuals and institutions. In each of these projects, he embraced the opportunity to demonstrate his ability to meet challenges and expand his aesthetic horizons.

In 1998, the board members of Shee Atiká, a Native corporation, commissioned Singletary to make *Eagle/Raven Hat* (fig. 3).[13] According to Singletary:

> The Eagle and Raven represent the two moieties of the tribe; members belong to one or the other. Tribal law specifies that a member must marry over to the opposite side. This symbolizes balance within the tribe, but also functions to keep the bloodlines pure while forging alliances with other clans.

For Singletary, being commissioned by his tribe was a distinctive honor. It presented the unique opportunity to depict Eagle and Raven together as an affirmation of inclusiveness in contemporary Tlingit society.[14] Subsequently, he received several significant institutional commissions.

From May 22 to November 30, 2003, the Seattle Art Museum (SAM) presented *Preston Singletary: Threshold.* Coinciding with the Glass Art Society's 33rd Annual Conference, this special exhibition presented thirteen of Singletary's works, including blown and sandblasted hats, screens, vessels, and totem forms. These pieces engaged "the dramatic elements of fire, gravity, light, and transparency in new ways and [created] a provocative counterpoint to the long-established Northwest Native carving traditions that are well represented in SAM's permanent collection."[15] This exhibition honored the recent gift of John Hauberg's collection of Pacific Northwest Coast art and Singletary's newest commission.[16]

Seizing this "once in a lifetime opportunity," Singletary rendered in glass a monumental house screen ornamented with his family crest symbol, the Killer Whale or Kéet Shagóon (fig. 4). Historically, these carved and painted plank screens delineated the chief's quarters within the longhouse, providing him with privacy in the communal living space and serving as a "portal through which he could make a dramatic entrance when entertaining guests." Singletary viewed this exhibition as

fig. 4 *Killer Whale (Kéet Shagóon)*, 2003, commissioned by the Seattle Art Museum (2003.12)

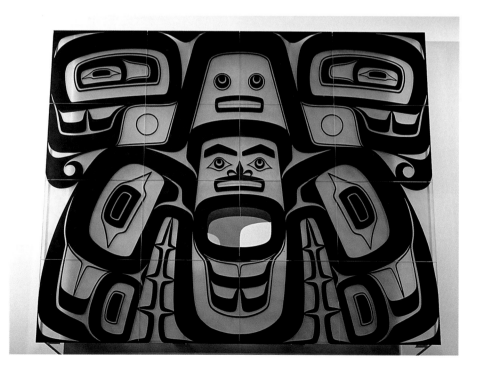

a metaphorical threshold. As he explained, "the medium of glass can be a threshold to the future for the cultural growth of Native people." He refers to his contemporary interpretation of an older screen as "modern heritage art."[17]

Also in 2003, Singletary was awarded the 18th Annual Rakow Commission from the Corning Museum of Glass, which "encourages artists working in glass to venture into new areas that they might otherwise be unable to explore because of financial limitations."[18] For this commission, Singletary created *Never Twice the Same (Tlingit Storage Box)*, which was unveiled during the 42nd Annual Seminar on Glass, October 16–18, 2003 (pp. 78–79, cat. 23).

Beyond its formal reinterpretation of the traditional cedar box, *Never Twice the Same* represented a significant departure for Singletary, moving away from representation and toward abstraction. This storage box was also his first attempt to create work on a distinctly larger scale. He recalled, "This was the first large cast box that I had fabricated. I wanted to illustrate that [this abstract] design system could be utilized to fill the entire space, as is most of the work in Northwest Coast style." This work preceded Singletary's larger *Bentwood Boxes* (pp. 90–91, cat. 29), which emulate the grandeur of the polychromatic painted cedar storage chests.

In 2003, Singletary was contacted by Emil Her Many Horses, curator of the National Museum of the American Indian, Smithsonian Institution. The museum was interested in permanently framing a new exhibition space, titled *Our Universes*, designed to tell the creation stories of various Native peoples. Singletary proposed the idea of Raven, and the museum commissioned him to create one. Singletary designed a three-foot-long bust of Raven in profile, dominated by the bird's impressive beak. For assistance in making this large-scale work, Singletary approached Richard Royal. Together, they pioneered new ways of fabricating, installing, and illuminating work using fiber optics.[19] *Raven Steals the Sun* was presented at the opening of the National Museum of the American Indian on September 21, 2004 (fig. 5). Singletary has reinterpreted this impressively scaled, wall-mounted Raven for *Echoes, Fire, and Shadows* (p. 126–127, cat. 50).

That year, Singletary was also commissioned to create a window for the St. Oakerhater Chapel of St. Paul's Cathedral in Oklahoma City (fig. 6). Rising from the ashes in the wake of the 1995 Oklahoma City bombing, the chapel commemorated the $7.5 million restoration of the cathedral and honored David Pendleton Oakerhater, the first American Indian in the Church's Calendar of Saints.[20] For this commission, the church's dean, George Back, decided that the artwork "should embody the spirit of primitive man." Acknowledging this concept, Singletary created a glass rondel, reminiscent of a war drum, and ornamented it with the Oakerhater glyph design, which was the priest's signature.[21]

Collaborations

Singletary's career has been punctuated by a series of encounters, which have fueled his artistic progression and fostered his distinctive voice. For him, "collaborations provide insight to the artistic process . . . I see [them] as a way to learn about Indian culture while sharing my knowledge of glass with others."[22] Cross-cultural in nature, these collaborations have catapulted Singletary into the limelight of the art world.

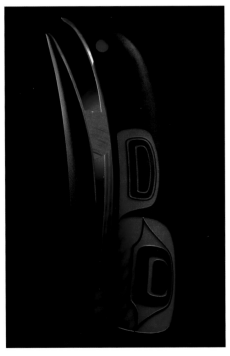

fig. 5 *Raven Steals the Sun*, 2003, commissioned by the National Museum of the American Indian, Smithsonian Institution (26/3273)

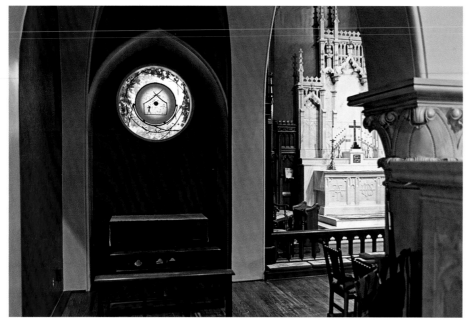

fig. 6 St. Paul's Cathedral, St. Oakerhater Chapel window, 2004

fig. 7 Preston Singletary with artist Joe David, 2000

In 1998, Singletary was introduced to noted sculptor, jeweler, and graphic artist Ed Archie NoiseCat (Shuswap/Stlitlimx), and from this meeting the two artists determined they wanted to collaborate. Together, they conceived and fabricated a two-piece bronze hinged mold, which they used to create a series of three-dimensional, traditional mask forms in glass. Alternating designs and color palettes, each achieved a range of effects reflecting his own unique cultural style, as illustrated in *Frog Mask* (p. 60, cat. 9) and *Frog Woman Mask* (p. 61, cat. 11). NoiseCat recalled that it was a true collaboration in that they used their talents in concert in order to create a new art form. Singletary continues to employ that mold in the creation of his masks.

In 2000, Singletary joined master carver Joe David (Nuu-Chah-Nulth or Nootka), then an artist in residence at Pilchuck Glass School, assisting him with a variety of unconventional projects (fig. 7). During the process of constructing a sweat lodge and participating in several sweats, Singletary experienced an epiphany, spiritually and artistically:

> He became my mentor, adopted me, and shared his name with me, Kaka Win-Chealth, which means Transforming Killer Whale. In Northwest Coast culture, one of the greatest honors that you can receive is a name. It denotes growth and change within your life. Joe impressed upon me that once you become a keeper of cultural knowledge it becomes a responsibility. . . . Joe helped me understand the designs on a deeper level. He encouraged me to design with fluidity and originality and helped me develop a spiritual connection in a Native context, which I feel informs my work.

Singletary emerged from this collaboration with a sense of purpose and a clear direction. From this point on, he created increasingly cohesive bodies of work that honored Tlingit tradition and infused it with new vitality.

Since 2000, Singletary has continued to evolve artistically, creating progressively ambitious work. To achieve his sculptural aspirations, he engaged the talents of figurative glass sculptor Ross Richmond in 2001.[23] Incorporating Richmond's diminutive figures into Singletary's larger-than-life-size rattles, they composed intimate portraits of beings, both animal and human. Singletary's aesthetic unfolded in

rattle forms and his signature sculptural works, such as *Raven Steals the Sun* (p. 69, cat. 17).[24]

Although his designs appear to be classically Tlingit, Singletary maintains they are not crest art. Instead, he says they explore the connections and transference of knowledge between spirits—shaman and animal: "When I'm reducing form and trying to use it as a canvas for creating a new shape, I look at crest symbols that belong to individuals or families, as well as shamanic art, because it is a little less defined as to the kinds of crest animals that you see."

Singletary continues to pursue Raven as a motif. Regarded as a trickster possessing transformative powers, Raven holds an esteemed place in Tlingit culture. In the traditional Tlingit creation story, Raven undergoes a series of transformations, bringing the sun, moon, and stars to earth and its inhabitants. Raven has become an integral aspect of Singletary's aesthetic, appearing in forms ranging from bowls with decorative motifs, to *Transference* rattles (p. 73, cat. 22; pp. 82–83, cat. 27). Singletary credits Richmond with expanding his sculptural vocabulary and helping him to develop this increasingly complex work.

In 2001, Singletary had yet another life-changing experience. Pilchuck was undergoing significant changes and celebrating its thirtieth anniversary. To honor its founders Dale Chihuly, Anne Gould Hauberg and John Hauberg, and to commemorate their contributions, the school planned to erect a monumental totem pole, originally conceived in 1994 by David Svenson. Singletary helped design and drive to fruition this twenty-foot carved cedar masterpiece ornamented with symbolic glass elements. Many of the aesthetic details of the pole reflect John Hauberg's contributions to the Native community.[25] The project was team-based, commanding the commitment of numerous individuals who converged on the campus that summer to erect the totem pole (figs. 8–10).[26]

For Singletary, the *Founders' Totem Pole* represented a highlight of his collaborations and commissions to that point. He considers co-teaching with David Svenson "an immeasurable experience" and the project itself a "rite of passage. . . . It was like the ancestors were smiling on me for being a part of the major project." In it, tradition and change manifest in the fusion of materials, the intersection of cultures, and the creation of a new community.

figs. 8–10 left to right: Community procession with *Founders' Totem Pole*, 2001; *Founders' Totem Pole*, 2001; *Founders' Totem Pole*, 2001 (detail).

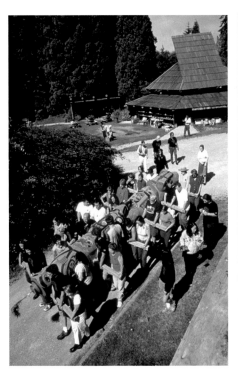 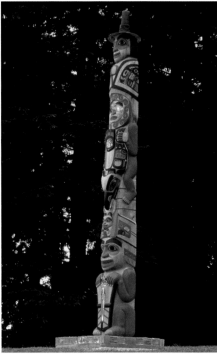 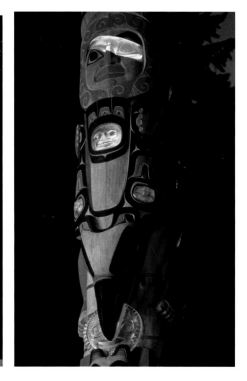

Yet another facet of Singletary's collaborative nature and commitment to the Native community is demonstrated in his efforts to perpetuate the culture through educational intersections. In 2006, Singletary co-taught with Native bead worker Marcus Amerman (Chocktaw) during ICONO-Glass, a lecture series and workshop at Pilchuck.[27] They combined "beading and European glassblowing . . . encouraging students to integrate influences from their own personal history and cultural heritage while sharpening their hot-glassworking and sandblasting skills."[28]

That same year, Singletary and award-winning Tlingit multimedia artist Clarissa Hudson organized the Northwest Coast Artists' Gathering, a dynamic biennial convening of Tlingit, Haida, and Tsimshian artists, in Juneau, Alaska.[29] Working with Amerman and Hudson, Singletary contributes to the perpetuation of the Tlingit culture and its rich artistic history while acting as an ambassador to Native and contemporary art communities.

Grateful for the opportunities bestowed upon him and cognizant of his responsibilities, Singletary continues to work with students and the Native community. Through teaching, he reaches out to new students, fostering their interest in the material as a mode of artistic expression. "I'm helping Native American artists working with glass to develop their own sensibility." His future aspirations are not only to continue to impart his knowledge to Native people but also to create a training ground where they will be able to learn about glass. He concludes, "The more we learn about what is possible, the more we internalize all of those things—influences and technologies—and come up with new forms. We're all evolving as a result of all of this."

Cross-cultural connections are at the core of Singletary's artistic collaborations. In 2005, in conjunction with noted Santa Clara Pueblo potter Tammy Garcia, Singletary translated traditional pottery forms into blown glass, sandcarving them with Garcia's designs. The resulting exhibition, *Visions in Glass,* was so successful that Singletary and Garcia teamed up again in 2008 for *Visions in Glass II.* Not only did Singletary garner the attention of the Native American art collecting community, but he also concluded that they "were successful in advocating glass as a new tradition" (see figs. 21–22 on pp. 43, 44).

In 2007, Singletary joined forces with Maori jade carver Lewis Tamihana Gardiner (see figs. 19–20 on pp. 40, 41). Intrigued by the archetypes and legends that link their Pacific cultures, the two artists aspired to explore their artistic similarities as well as their distinctive differences.[30] They agreed that every piece they created would reflect their imprints; the strength of the work would derive from its integrated designs. Characterized by their sleek forms and inherent color sensibilities, ranging from the subtle to the saturated, *Toki Amulet* (pp. 104–105, cat. 39) and *Devilfish Prow* (p. 107, cat. 36) are among the signature works that define this collaboration, which was collectively exhibited as *Fire & Water* at Spirit Wrestler Gallery in Vancouver, British Columbia. Reflecting on his numerous cross-cultural collaborations, Singletary concludes, "I have been inspired through connecting glass to my culture. Observations of Native culture and community have been extremely important to my development as an artist."[31]

Singletary's greatest artistic collaboration manifests in the depth of his studio team.[32] Following his mentors' examples, he actively cultivates the next generation of glass artists, employing a team of twenty. This team is integral to Singletary's success, providing him precious time to develop his distinctive style, while ensuring a methodical and exacting approach to his work.

This broader community of artists provides a healthy infusion of ideas and inspiration. Many of his collaborations have been sustained over long periods of time. He has been blowing glass for fifteen years with Robbie Miller and Paul Cunningham,

and working for nearly a decade with glassblowers Joe Benvenuto and Brian Pike as well as designer and coldworker Maurice Caldwell. For seven years, Greg Dietrich has been coldworking for Singletary, while Ross Richmond has been hot sculpting the menagerie of animals and humans that distinguish some of Singletary's most accomplished work. The enduring commitment of these artists to one another stands as a testament to their mutually rewarding experience.

Music and Musicians

While glassblowing has taken precedence in his life, Singletary has never forsaken his childhood dream of being a musician. An avid audiophile, he considers music a driving force in his life, and it continues to exert a profound influence on his work. Reading reviews, seeking obscure titles, listening, and collecting are among his interests. For him, the melding of sounds is as important as the lyrics. He derives as much artistic inspiration from pioneering musicians Jimi Hendrix and Miles Davis as from visual art equivalents. One of his most dynamic musical collaborations is Little Big Band (founded between 2003 and 2006).[33] Singletary plays bass in this "Native Funk" band that offers a fusion of traditional Native and pop lyrics, music, storytelling, and modern improvisation while showcasing the contemporary nature of Alaskan Native music.[34] Music would prove integral to Singletary's new direction in 2008.

New Directions

Since 2005, Singletary has continued to develop his own style, employing traditionally inspired iconography in his modern heritage art. He considers glass both a versatile medium and a vital art form. Glass intrigues him as much for its material and metaphorical properties of strength and fragility as for its intrinsic qualities of permanence and preciousness. While Singletary initially was inclined toward accurate reproductions of classic Tlingit designs, this studied approach eventually gave way to a more improvisational telling of his own stories. For him, glass offers endless opportunities to explore, expand, and "develop a style reflective of his culture."

From 2007 to 2009, Singletary has moved confidently in a new direction. Respecting the ideas of intellectual property associated with crest art, he has come to embrace abstraction within the style. While crest art continues to serve as his aesthetic touchstone, shamanic materials—such as amulets, masks, and rattles—figure more prominently in his work, alluding to his heightened spiritual awareness.

Among Singletary's most accomplished mask renderings to date are *Frog Medicine Frontlet* (pp. 84–85, cat. 25), *Raven Man* (p. 95, cat. 30) and *Chieftain's Daughter*, p. 96–97, cat. 34). In these works he introduces new materials, such as human hair, to create compelling portraits that expand his repertoire artistically and technically.

Form and ornament coalesce in the works created during Singletary's 2008 Visiting Artist Residency at the Museum of Glass. Here, he exploits the sculptural qualities of glass and its proclivity toward organic forms, employing it in the creation of his Modernist series. Methodically coating each blown glass piece with successive layers of powdered color, he creates an opaque black ground—an ideal canvas for

for his intricately sandcarved designs. With these newest forms, including *Breaching Killer Whale* (pp. 118–119, cat. 41), *Eagle/Raven* (p. 123, cat. 45), *Black Gold* (pp. 116–117, cat. 40), and *Woodworm Amulet* (p. 131, cat. 54), Singletary celebrates his cultural identity.

In a 1999 interview with *Native Peoples* magazine, Singletary spoke of his desire to create "larger pieces, three- to four-feet tall, resembling the Tlingit Totem poles found in Southeastern Alaska."[35] Three years later, at William Traver Gallery in Seattle, he created a contemporary clan house, showcasing glass objects arranged as a potlatch presentation, reminiscent of the Whale House at Klukwan, Alaska.[36] This dramatic and moving presentation would influence his later installations.[37]

Nearly one decade after he first envisioned it, Singletary exceeded his dream with the creation of *Clan House*. His most ambitious and significant work to date was unveiled at the Museum of Glass in conjunction with his mid-career retrospective exhibition, *Preston Singletary: Echoes, Fire, and Shadows*. Commissioned by the Museum of Glass through the generosity of Leonard and Norma Klorfine, *Clan House* is as impressive as it is imposing. This cast-glass triptych comprises a 7½- by 10-foot house screen displayed between two 7½-foot-high, 530-pound reinterpretations of the bas relief carved Tlingit interior longhouse posts (pp. 132–139, cat. 42). Together, Singletary and master casting technician Ray Ahlgren charted new territories in large-scale glass casting to create this monumental work.

For over two decades, Singletary has pursued progressively ambitious educational and experiential opportunities. His artistic success derives from his enduring curiosity, persistence, and willingness to take risks, effectively using a contemporary material to illuminate a traditional culture.[38] Sophisticated and spirited, his work reflects a synthesis of his experiences—exuding the inherent integrity of European craftsmanship and a profound reverence for his Tlingit heritage—executed with American ingenuity and flair.

Is he popularizing Tlingit art? Perhaps. Ultimately, Singletary is making the work accessible to broader audiences, expanding their appreciation and understanding of the aesthetic. "I always felt that I wished people could be attracted to it for reasons other than the ethnic aspect, but at the same time that's what gives it its power." Adapting forms and stylizing them—in material, scale, color, and ornament—Singletary creates decidedly postmodern expressions. Fusing traditional and contemporary designs exquisitely rendered in glass, he is contributing to the preservation and perpetuation of the Tlingit culture.

Singletary has left his indelible imprint on Tlingit tradition, modern art, and contemporary glass. In seeking his cultural connections, he has discovered his voice—artistically and spiritually. A cultural navigator, he is charting new waters, encouraging the Tlingit people to reexamine their traditions. In the process, he is redefining a unique and extraordinary artistic expression. With profound humility, Singletary says, "I don't think I'm there yet though, really. I'm still mastering the form, and you know, we're always learning on an ongoing basis." Like a shaman, Singletary mediates between two worlds, using new materials to communicate old stories, breathing new life into the Studio Glass movement and Tlingit art, and transforming our twenty-first century perceptions of them in the process.

NOTES

1 This essay is based on a series of interviews with Preston Singletary, conducted between April and September 2008.

 Southeastern Alaska is a territory that includes a vast archipelago and mainland, from its southernmost point in Ketchikan to its northernmost around Yakutat. As a matrilineal society, the Tlingit pass down their heritage through the mother.

2 Susie Johnson Bartlett gave Singletary a Tlingit name, Cochane, which translates literally as "Sound of the Rattling Chains." She passed away at age 102, when Singletary was 17 years old. Singletary's paternal grandparents and great-grandparents are of mixed European descent; his maternal great-grandparents, George and Susie Johnson Bartlett, were full-blooded Tlingit Indians. George was killed in a logging accident while their daughter Lillian was still a young child. Susie later remarried Dionesio Gubatayo. Together, the family moved to Seattle in 1919. When Lillian grew up, she, too, married a Filipino man, John Abada. Their daughter, Jean Abada, met and married Preston Singletary, giving birth to two children, Preston Lawrence (1963) (named after his Uncle Lawrence, Aunt Theresa's husband) and Rachel (1971).

3 Preston Singletary, "Indian-uity, Glass Symbols of Cultural Knowledge," *The Glass Art Society Journal* (2003): 42. Jojola began working with glass in 1974. Three years later, he founded the Taos Glass Arts and Education program with the technical and financial support of Dale Chihuly. Singletary noted that Jojola's initial glass explorations were "viewed with suspicion."

4 During this same period, Singletary worked as a gaffer, or assistant, to many of these same artists as well as Dale Chihuly, Fritz Dreisbach, Stanislav Libenský, Marvin Lipofsky, Timo Sarpaneva, and Ann Wåhlstrom.

5 As the educational coordinator and a faculty member at Pilchuck Glass School (1974–1987) and a designer at Venini (1978, 1979), Moore was also responsible for bringing Tagliapietra to the United States for his premiere visit in 1979.

6 Collaborating with Dante Marioni, Singletary produced a limited edition of forty whimsical, yet technically masterful *Alligator Goblets* (p. 55, cat. 8). Both Singletary and Marioni remain especially indebted to Tagliapietra.

7 In addition to the encouragement and inspiration he received from his mentors, Singletary was awarded several study grants and scholarships from organizations such as the Institute of Alaska Native Arts (1985), the Jon and Mary Shirley Foundation/Pratt Fine Arts Center (1996), and the Washington Mutual Foundation/Pilchuck Glass School (1995 and 1999). This support assisted him in continuing his artistic endeavors. In turn, he would go on to give back to the community, sharing his knowledge and skills by teaching at schools throughout the world.

8 In his first international exhibition, at the International Glass Trade Show in Japan, Singletary exhibited vibrant versions of these vases in red, yellow, and orange.

9 Craft in America, *A Journey to the Artists, Origins and Techniques of American Craft.* Video clip.

10 Preston Singletary, "From the Fire Pit of the Canoe People," *Fusing Traditions: Transformations in Glass by Native American Artists,* ed. Carolyn Kastner, 18.

11 Eventually, Sherman gave the hat to her son, Jamie. During this period, Singletary also gifted a *Sun Mask Vase* to his sister, Rachel (p. 54, cat. 7). These two works remain in his family.

12 Lino Tagliapietra combined Marquis's surname with that of Carlo Scarpa to create the title of the series, *Marquiscarpa*. In this case, Singletary formed the title *Prestonuzzi* by merging his name and that of Napoleone Martinuzzi.

13 In 1971, President Richard M. Nixon signed into law the Alaska Native Claims Settlement Act (ANCSA): "a settlement of all aboriginal claims within the state of Alaska between Alaska Natives and the federal government." The government awarded monetary compensation, forming twelve Alaska Native regional corporations and 200 local village corporations to manage the indigenous land. As a registered member of the Tlingit tribe, Singletary became a shareholder in the tribal corporation known as Shee Atiká. For detailed information about ANSCA, see http://www.ancsa.net/law/ancsa.

14 The following year, the United Way commissioned Singletary to create the *Leadership Giving Panels*, a donor recognition wall (1999). Drawing upon his early design experience, Singletary sandwiched the commemorative panel of names between two panels of glass ornamented with Native designs. This simple yet ingenious design provided flexibility and portability, allowing the organization to create new donor panels with relative ease and to display them in spaces of its choosing.

15 *Preston Singletary: Threshold*, Past Exhibitions, Seattle Art Museum. http://www.seattleartmuseum.org/exhibit/exhibitDetail.asp?WHEN=&eventID=3462.

16 Ibid.

17 The Northwest Native American Collection, Seattle Art Museum. http://www.seattleartmuseum.org/pressRoom/PDF/NW%20Native%20Collection.pdf.

18 Tina Oldknow, "Notes," *New Glass Review* 25 (2004): 77.

19 Singletary described two physically demanding and unsuccessful attempts at wielding thirty pounds of glass using the traditional approach—making two long cuts on a giant bubble and then pulling out and sculpting the glass. He and Royal decided to try an alternative method. Sculpting a large closed bubble into the general form of the raven and subsequently sandblasting away the jawline, they succeeded on their first attempt.

20 According to church officials, Oakerhater was "a valiant, lithe Cheyenne warrior in his youth, a prisoner of war in his 30s . . . a victim of westward expansion and a lonely deacon of the Episcopal Church from 1881–1931."Owanah Anderson, "Rebuilding with New Tradition: New Oklahoma City Chapel Named after First Native American Saint," *Episcopal Life*, April 1, 2004. http://www.episcopalchurch.org/26769_38042_ENG_HTM.htm

21 Of particular note is the red smudge, which appeared when Singletary marvered the bubble for the prototype. Convinced that everything happens for a reason, the church determined the smudge was symbolic of the sun.

22 Singletary, "From the Fire Pit," 19.

23 A graduate of the Cleveland Institute of Art, Richmond trained with glass sculptor William Morris.

24 Singletary also created only two versions of *Yéik*. Feared and revered for its ability to thrive on land and in the water, this spirit, in the form of the Land Otter, is believed to posses supernatural powers, bridging two worlds.

25 John H. Hauberg was born in 1916 in Rock Island, Illinois. His father, John Henry Hauberg, was an attorney, businessman, and noted local historian. His mother, Susanne Denkmann, was the daughter of lumber giant F. C. A. Denkmann, an early partner of Frederick Weyerhaeuser. Singletary recalls that Hauberg "repatriated a dagger to a family in Angoon [Alaska], was adopted by that family and given a Tlingit name. [He] donated his Northwest Coast Native art collection to the Seattle Art Museum and the land where Pilchuck was situated to the school. As he was an heir to Weyerhaeuser [the internationally renowned lumber and paper products corporation], a cedar monument seemed appropriate." http://www.lib.washington.edu/speciaLcoll/findaids/docs/papersrecords/HaubergJohn2850_7.xml.

26 The following artists were involved in the creation of the *Founders' Totem Pole*: the carvers at Alaskan Indian Arts in Haines; John Hagen, Greg Horner, Wayne Price, Preston Singletary, David Svenson, and Clifford Thomas, with the assistance of Steven Clay Brown, Irma Brown, Joe David, Bill Lynch, Marvin Oliver, and the "Wood and Glass Totem Pole" class at Pilchuck Glass School (Singletary and Svenson conducted a class of ten students—six of whom were Native Americans—to cast the glass elements); the Pilchuck community, including emerging and established artists, administration, and board; and an array of natives and elders.

27 Recalling this collaboration, Singletary explained, "I wanted to tap into someone who thought a little more conceptually so I could develop that side." He continued: "I had admired Marcus's work and our many conversations made me want to collaborate with him through teaching. He has a very open and 'pop' sensibility. His contemporary beadwork has a conceptual side. He works with many different materials. So I decided he would make a good teaching partner."

28 *Native Peoples* (July/August 2006): 28.

29 In 2008, the Northwest Coast Artists' Gathering was held at the Old Armory in Juneau, Alaska, June 3–4, 2008. The mission of the Northwest Coast Artists' Gathering is to "bring together artists and facilitators who work in the indigenous Northwest Coast style of art: to foster dialog; to develop connections; to explore new materials and techniques; to inspire new work; and to create a community that is inclusive and thoughtful, and that honors tradition while moving into the 21st Century." http://www.artstream.net/gathering/08GatheringIndex.htm.

30 For example, he observed that "whereas the Maori allowed for room in their designs, the Tlingit tendency was to fill every space."

31 Singletary, "Indian-uity," 42.

32 Singletary's team comprises Maurice Caldwell (from 1998, studio work); Joe Benvenuto (from 1999, blowing and grinding, etc.); Robbie Miller (fifteen years, blowing and collaborating musically); Paul Cunningham (fifteen years, blowing); Brian Pike (ten years, blowing); Ross Richmond (seven years, blowing); Greg Dietrich (seven years, coldworking); Michael Fox (six years, blowing); Nadège Desegenétez (six years, blowing); Becca Chernow (six years, blowing and studio work); Sean O'Neil (four years, blowing); Greg Owen (four years, blowing); Tony Bianco (four years, blowing); Geoff Lee (four years, blowing); Terry Rau (four years, studio work and sandblasting); Sean Albert (two years, blowing); Eric Woll (two years, blowing); Jason Christian (two years, blowing); April Surgent (two years, studio work); and Britt Shanta (one year, taping and sandblasting).

33 In 2002, a videographer approached Singletary regarding a potential collaboration. He wanted Singletary to collaborate musically with noted jazz musician Wayne Horvitz, to create soundtrack material for the Seattle Art Museum exhibition *Preston Singletary: Threshold*. They engaged noted Tlingit performing artist Gene Tagaban to contribute spoken word and Grammy Award–winning vocalist Star Nayea, among others. From this initial collaboration, Singletary formed Little Big Band.

34 More recently, Singletary's love of music corresponded directly to his work. In 2008, he was commissioned by C. F. Martin & Co. (The Martin Guitar Company) to create a guitar design (p. 110, cat. 51).

35 Ben Winton, "Creating: Preston Singletary—Native and European Tradition Meet in Preston Singletary's Tlingit Glass Designs," *Native Peoples* 12, no. 3 (Spring 1999): 48.

36 The exhibition also included sacred objects such as a large screen, paddle, copper, bentwood box, dish, dance staff, soul catcher, warrior mask, and two video masks. *Clan House* was flanked by cedar steps and thrust against a dramatic hand-painted mural. Several of the pieces from this exhibition are included in *Preston Singletary: Echoes, Fire, and Shadows*.

37 Singletary further developed this theme at Heller Gallery (2001) and the Seattle Art Museum (2003).

38 "Historically," Singletary says, "Natives have always adapted new materials, new ways of working and new tools, helping the culture develop and grow." Rather than rely on dwindling natural resources, Singletary seizes the opportunity for the culture as a whole to evolve. Embracing this material shift will ensure the culture not only survives but also flourishes in the changing world.

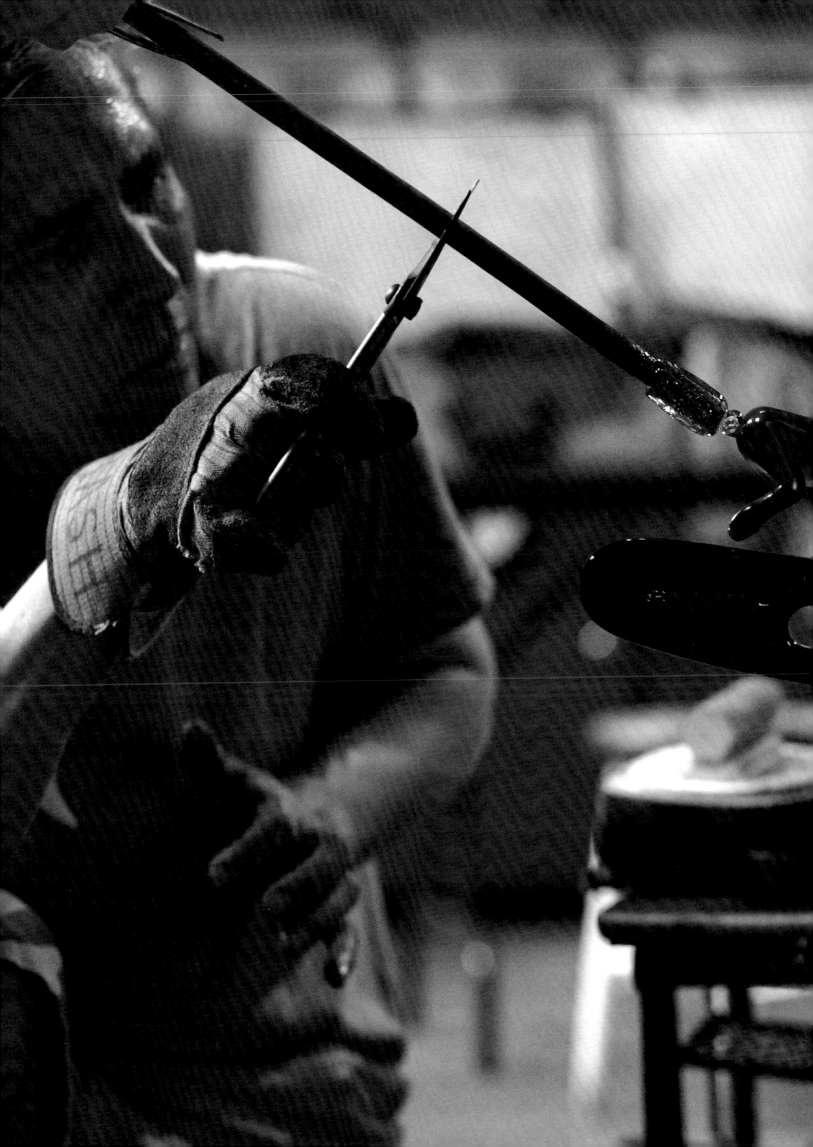

In Northwest Coast mythology, Raven is the embodiment of creative power—known for bringing light into the world, sending rain to the landscape, and performing many other essential and creative deeds. Raven is also known as a trickster, willing to use his cunning and wisdom in working his creative magic. When Preston Singletary decided to take up Northwest Coast art as a new expression within his already established glass works, he also made the choice to journey with this creative spirit and energy, and to see its world from within. Singletary did not grow up within Tlingit culture and has instead employed the art form in conjunction with his glass works as a kind of window or lens through which he can see and experience a part of that world in a hands-on manner. As his skill and expertise with the art form has grown,

PRESTON SINGLETARY'S JOURNEY WITH THE RAVEN

Steven Clay Brown

just as his skill and experience with the processes of working glass have continued to expand, it appears that his window into Raven's world has opened up wider and wider, its lens becoming sharper and clearer. The results of his deepening look into this art style are manifest in his work. As he has become more deeply immersed in that world, getting closer to its source piece by piece, his work has become an integral part of the tradition, feeding back into its origins.

Northwest Coast art has many levels, and one can descend to these levels as one becomes more familiar with its guiding principles, reaching ever deeper toward its heart and soul, its creative essence. At its center core, Raven himself guards the gates, and only those who eventually master its essence can pass within. Along the way, Raven is also the guide, but people can see its secrets only to the extent that their eyes have been opened. Singletary's journey with the Raven has become extensive, and his knowledge of Raven's world, as manifest in the Northwest Coast art style, has also expanded. He has learned to adapt a new set of tools, materials, and techniques that are completely foreign to this tradition, and he does it in such a way that the results appear to be very much a part of the original whole. It is one thing to use the tools and techniques employed by woodcarvers of the past, making new examples of masks, rattles, and amulets that reflect this tradition, although that's an accomplishment in itself. It's quite another to create very similar results with entirely different materials, different processes, and different tools altogether. Singletary's knowledge from his study and practice of the art form is well matched by the level of his craft, the fluidity of his techniques in glass.

The gift that is this tradition was laid down in its basic form and codified by the founding artists of ancient generations, and some individuals within each new generation of artists/practitioners have added something to the cauldron from which they drew, expanding the tradition in some new way in terms of color use, form, proportions, or applications. This has been going on for centuries, and the art form as we know it today is the successful blending of many of those contributions. At some point, Singletary began adding new things to the cauldron, seasoning the stew of the tradition with his own personal taste and style. The most obvious of these additions are new applications—glass has been a new venue in which to sow the seeds of this

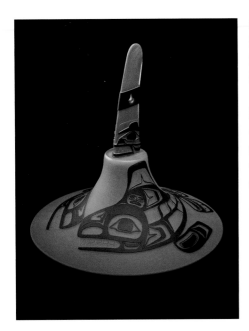

fig. 11 *Killer Whale Crest Hat*, 2000

art form—and Singletary has truly led the way in this field. He is the work's creator—blowing, coloring, molding, forming, annealing, designing, and sandcarving the glass, from start to finish. His hands-on, total involvement with each artwork distinguishes him in this field and illustrates the very high level of his craft.

Not only has he been incredibly prolific; he has also exhibited constant growth in his accomplishments. Even in the series of multiples he has done over time one can see changes, evolution, increased understanding and facility, with not only the tools of the glass trade but also the tools of the Northwest Coast art tradition—the formlines and their junctures, their connections, their ability to flow and harmonize with sculptural forms. Formlines are the essence of a Northwest Coast image. The painted or carved lines of swelling and diminishing thickness form a net or web of positive design elements, which are pierced by the relief-carved or cut-through negative areas within a given design representation. The concept of formlines has been the foundation of this art form for millennia and has been adapted in myriad new ways over the last two centuries, yet it still retains the energy and vitality that have made Northwest Coast art the passion of generations of artists.

At the time Singletary began his work in the Northwest Coast art style, he was already a highly skilled and inventive glassworker. He had previously worked in European styles, as can be seen elsewhere in this volume, and was greatly influenced by the work of the Swedish glass company Kosta Boda, with which he had an ongoing relationship. Singletary's work in those styles was clean and refined and was gaining recognition. His Tlingit heritage at that time was in the background, and it would not move into the foreground until the right catalysts appeared.

Through his association with Pilchuck Glass School, Singletary came into contact with glass and neon worker Dave Svenson, who had been raised in an artistic family in Haines, Alaska. Svenson worked for many years with the Tlingit and other carvers of Alaska Indian Arts, a Haines institution since the 1950s, and had become very skilled in the sculptural and two-dimensional arts of the region. Svenson's example and encouragement prompted Singletary to experiment with a move in that direction, to begin his journey with Raven. By all indications, the journey got off to a good start, and he has never slowed down to look back.

Some of the first traditional Northwest Coast forms that caught his eye were in the gracefully swelling lines of a woven spruce-root hat, broad at the base and tapering upward in a concave curve like the bell of a trumpet or other brass instrument. The most elaborate woven hats bore painted Northwest Coast formline images of crest emblem creatures, constructed of interlaced design forms that displayed beautifully on the regal-looking headgear. These made the perfect study, both in their refined form, which Singletary would coax the glass into representing, and in their elegant decorations. Without the benefit of Raven's vision, though, the two-dimensional design aspect can form a barrier that is not easily penetrated. Singletary's journey into the Northwest Coast art style began with the approach many initiates take: learning to understand the art by reproducing traditional designs of the past. This he did with great finesse, applying them to new forms and creating objects that had never existed before.

Assisted in this new sight by Bill Holm's book *Northwest Coast Indian Art: An Analysis of Form*, Singletary quickly came to fathom the basics of the art style.

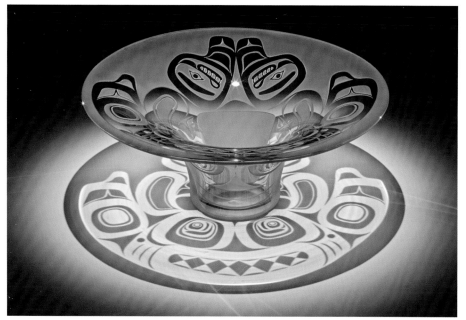

fig. 12 *Shark Hat*, 2007

Here the broad head of the shark can be seen at the center forward in the shadow design, with the body and pectoral fins on either side. The tail of the fish can be seen at the top rear of the hat itself, each half of it with a profile masklike face in the ovoid shape. The bold, rounded forms of this original Singletary design lend a playful character to the graceful way the design wraps around the hat.

Experiencing Holm's book can be like seeing through the eyes of Raven, which enables one to delve more deeply into this new universe of two- and three-dimensional design. Soon Singletary had absorbed enough to successfully modify traditional designs and adapt them to the new versions of old forms that he was creating in glass. Almost right away, the magic that he sensed would be there began to happen: The sandcarved design areas in the glass stopped the light, and the clear areas let it through, resulting in remarkable shadow plays that extended the art outside the object itself and into the exhibition environment.

Singletary then swiftly moved to another level—a more experimental stage. He began taking his first steps into original design, no longer leaning on examples from the tradition's past. He began to see with Raven's eyes. Singletary began to perceive and internalize the core concepts of the art form and to be conscious of the ways in which sculpture and two-dimensional design influence and interact to create great works of art. From then on, he has continued to broaden his experience and to draw ever more deeply from this infinite well of traditional art and knowledge.

When Singletary creates a Northwest Coast–style box in glass, complete with four sides of harmonious formline designs and a traditional-style lid, it perfectly reflects the painted boxes of the past and present. His design work encircles the box, quadrant by quadrant, with compositions that illustrate the deepest core principles of the art form—harmonization, tension and flow, movement, and consistency of scale. The relief carving, accomplished with sand under air pressure, also reflects the traditional form, but in a slightly deeper way that works appropriately with the material. Singletary understands his material well and applies design work that is of the optimum scale and depth. The result is bold and strong, like the design shapes he uses. He has drawn his inspiration from the older Northwest Coast tradition, the style of the eighteenth- and early-nineteenth-century masters. In this approach, the design forms—ovoids and U-shapes—are bold and powerful, the design movements relatively simple and spare, but they contain a great deal of power and tension in the line work. His compositions are highly original, and yet they carry the essence and the flavor of the best of the old work. The old-timers, long gone, would be amazed to come back to this world and see what he is doing. They would marvel at their creations applied to a substance that many of them would never have seen in their

lifetimes, and yet it has been worked and decorated in a way that they would know well and easily recognize.

And a box is not all that they would recognize and admire. Among these old-timers would be bowl and ladle carvers, rattle makers, amulet engravers, hat weavers, and painters, and all would know and respect this work, this reflection of their world in such a remarkable and, to them, foreign medium. So what is it about this work that would be so familiar to them? The answer to that question could be spelled out in voluminous descriptions of formline conventions and how they were adapted to sculptural forms in the historical tradition. And there may be room for that here. But the basic answer is one of essence. Singletary's work captures the essence of Northwest Coast style and gives it new life in a new medium.

His *Soul Catcher* series is an example of his ability to recharge the traditional approach to an object. The bone amulets known as soul catchers come from the Tsimshian shamanic tradition. A shaman sought out the souls of his patients in the spirit world, where they had been taken by malevolent spirits or witches, and returned them to their rightful owners, thereby curing them of their disease. Soul catchers were usually carved from the femur of a bear and hollowed out to form a tube, with a length of seven to ten inches being a common size range. They were hung on a leather cord around the shaman's neck. The shape of the bone lent itself to the creation of a form that swelled slightly toward each end, and they were usually covered with two-dimensional formline designs representing the crest or spirit helpers of the shaman who owned them. The bilaterally symmetrical designs were made to fit the amulet's shape, usually with the heads of the creatures they depicted facing outward at each end. Often the mouths of the creatures were cut through as if slightly open. The cavity within the bone tube was originally fitted with stoppers of softened cedar bark, which were said to contain the recovered soul within.

Singletary took the idea of the soul catcher and blew it up to monumental proportions, something between two and three feet in length. He then had a good-size "canvas" on which to practice his skill in traditional design, creating new examples of this very old object type that conveyed their inherent sense of power and spirituality by means of this dramatic leap in scale.

fig. 13 *Soul Catcher*, 2001
(detail, pp. 70–71, cat. 18)

In this monumental rendering of what is traditionally a small bone amulet, Singletary has incorporated the traditional form of the objects with an original version of their typical formline embellishment. He has included the representation of abalone shell inlays, which are present in the most elaborate historical examples. The eyes, teeth, and nostril openings are accented by the simulated abalone inlays. A twisted cedar-bark suspension rope completes the image.

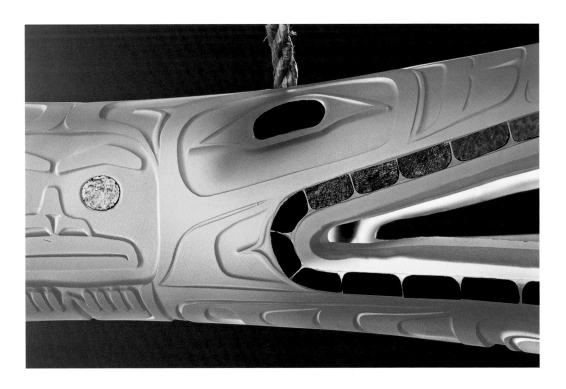

In the soul catcher illustrated on the preceding page, wolflike heads diverge from a central human face, with human hands visible just below the oval of the face. The relief "cuts," produced by sandcarving, precisely reflect those of the relief carving and engraving traditions that would have been employed in a historical soul catcher. Without the benefit of indicated dimensions, a viewer would be hard-pressed to know that this was not an actual-size soul catcher, less than eight inches across.

One of an exciting series of collaborative works Singletary has created with Lewis Tamihana Gardiner, a Maori artist from New Zealand, *Devilfish Prow* (2007), combines elements of Northwest Coast art with imagery from Maori culture. The prow is based on the sculpted elaborations that were attached to the bows of the *waka*, or war canoes, of the Maori. The head of the devilfish, or octopus, is at the bottom, upside down in this view. Its birdlike form is based on the mouth of an octopus, which resembles a bird's beak. Covered with raised black circles representing suckers, the tentacles of the octopus extend upward in this view, gently interweaving like leaves of kelp. Sandcarving has subtly raised the tentacles above the background. Also overlaid in black are elements of Maori style, which adapt well with the Northwest Coast devilfish. At the top of the prow is a symmetrical Maori image, carved in jade. The collaborative works produced by these two artists illustrate how well the two art traditions work in concert with each other. The best of their collaborations make the task appear easy, but the comfortable appearance of these juxtapositions belies the skill and artistry required to truly make such a blending successful.

Another of Singletary's hats, based on the forms of both a woven spruce-root and a carved wooden hat type, illustrates his mastery of design conventions. This hat exhibits much of the feel and visual power of the eighteenth-century Tlingit formline style. The overall form of the hat and the characteristics of the overlaid, sandcarved design reflect the essential appearance of early Tlingit headgear like this one, though the colors employed here are clearly new to the tradition. In it, we can see some characteristics of coastal art history. The earliest woven hats of the historical period were painted only in the upper, more smoothly woven section,

which ended just above the midway point from the top down. Tlingit wooden hats from that period followed the same convention, even though the texture of the material was not a concern as in the woven versions. (This is a strong indication that, in historical terms, the woven hats came first, and the wooden versions were a subsequent development.) Hat carvers of the eighteenth century therefore confined their painted and relief-carved designs to the upper crown of the hat. Later artists, in the early years of the nineteenth century, began to extend their painted designs over this conceptual border, and before long, paintings often covered the whole surface of the hat. Many of these artists incorporated this borderline into their compositions, acknowledging its existence while crossing over it, as can be seen in Singletary's hat design. On his hat, Singletary indicates this line at the top of the ovoid at the back and along the top edge of the featherlike forms along the sides.

On the Northwest coast, objects like hats, masks, rattles, amulets, bowls and containers, staffs, and sculptures were created with ceremonial and cultural purposes in mind. Among their reasons for being was crest emblem display, which strengthened the structure and status of the hereditary clans, recorded their histories in encapsulated forms, and identified the family origins of the objects' owners. They were functional objects whose uses were multilayered and inextricably interwoven with cultural history and expression. Contemporary objects, particularly those in a nontraditional medium like glass, are not inherently a part of that historical context. Many artists have produced contemporary objects for traditional use, but these are a minority among all the kinds of objects and sculptures being created today. Glass versions of traditional ceremonial objects cast themselves apart from traditional use, and yet, as an enduring symbol of their historical counterparts, they have a powerful presence. Somehow the unique qualities of the material itself, and the processes of intense heat and transformation that are required to work it, conspire to give us a sense of permanence amid fragility, of strength crossed with sensitivity, which is unlike anything else. Singletary has taken this remarkable substance along on his journey with the Raven, and what he has left behind is testament to his skill and artistry—and to the wonder and beauty of Raven's creations as well. The artist's journey is not over, and we look forward to the new works and the new expressions that this remarkable collaboration will produce in the future.

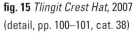

fig. 15 *Tlingit Crest Hat,* 2007
(detail, pp. 100–101, cat. 38)

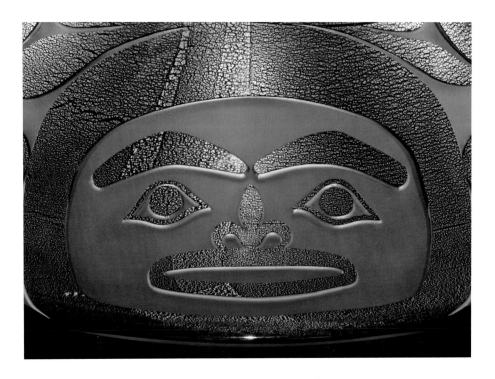

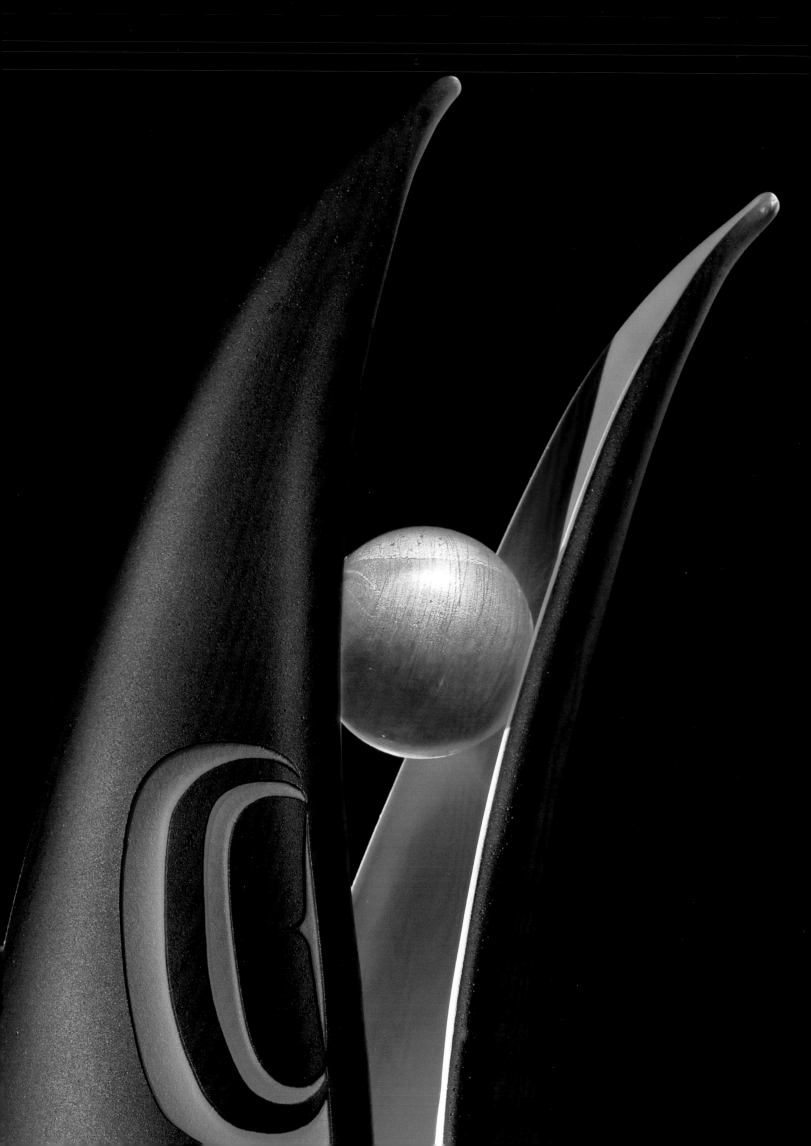

A Musician Trapped in a Glassblower's Body

In the old days things were made for a purpose, and there was a story
and maybe even a dance and a song that went along with it.

—Preston Singletary

A SPOKESMAN
FOR CULTURE

Walter C. Porter

I first met Preston Singletary in the summer of 2006 at the grand opening of the Smithsonian Institution's National Museum of the American Indian in Washington, D.C., where his distinctive Northwest Native designs in glass were on display. We met again at the "Sharing Our Knowledge" conference in Sitka, Alaska, where he gave me a book about his work and we established an ongoing dialogue.

After studying Singletary's art and reading what he'd written about each piece, I recognized that his work, much like my own, focuses on the history and lives of the Tlingit people. Although our people are pretty much Westernized in how we live today, Singletary and I have both seized the opportunity to bring traditional Tlingit culture to the forefront of what we are about in modern times.

In our dialogue following the Sitka conference, I found myself interpreting Singletary's work using Tlingit mythologies and Bible legends that I had been working with. One example is the Tlingit Lazy Boy/Strong Man story about meditation and becoming powerful on a spiritual path, which in many ways is the source of our creativity.

In the Lazy Boy/Strong Man story the lazy boy symbolizes a person meditating. Like a person meditating, he appears to be doing nothing, but by the end of the story he demonstrates that he has become spiritually powerful by taking a sea lion by the hind flippers and ripping it in half. In biblical scripture it says, "Be still and know that I am God," meaning that through meditation we begin to access the universe and all that it holds for us. When we examine Singletary's work, we see familiar things—glass, light and shadow, Tlingit art and design—but we see them all in a new way because of how they've been combined. This new way of seeing inspires stillness and wakes a part of us, bringing with it a new experience of power and expression that is both delightful and exciting.

Singletary mentions that he feels like "a musician trapped in the body of a glassblower." In the world of science they say that the physical world and the universe are made up of two things: sound and light. They also say that all matter in the universe is a form of vibration, including glass. From this perspective, a musician stuck in a glass artist's body can only be a magnificent thing, expressing both of our universe's basic components together.

Having said this, I think that Singletary's assessment of himself is very appropriate. Shaping hot glass and forming it into beautiful works of art can very easily be compared to creating and arranging music, which we see and hear from the same place in the inner mind.

Raven Steals the Light

Singletary's design selections are impressive, interesting, and very timely to this day and age. I use the word *timely* because there is a spiritual awareness coming to be in the world today. Native American ceremonies are being revived in the United States and Canada; young Native Americans are moving back to their villages in hopes of learning from their cultural roots. Many non-natives want to learn about the Sun Dance and sweat ceremonies, and other religions, like Buddhism, are making their way into American spiritual culture, not to mention the thousands and thousands of young people getting involved with conventional churches. With books like *A Course in Miracles*, by the Foundation for Inner Peace, people like Gerry Jampolski, Gary Renard, Marianne Williamson, and many others are emerging as influential spiritual teachers and writers. Last but not least, we hear from spiritual leaders and indigenous elders everywhere that male dominance of this world is declining and, through spiritual guidance, women are once again returning to leadership roles in all aspects of life.

Singletary's artwork featuring Raven with the stars, moon, and sun in his mouth punctuates the importance of rising spiritual awareness. The figures relate directly to the story "Raven Steals the Light," in which Raven releases the stars, the moon, and the sun into the sky. In Northwestern cultures like the Haida, Tlingit, Tsimshian, and others, Raven (Yéil) is our creator. Yéil is normally referred to as the trickster because of the many characters he plays in the stories told about him. It may be significant that Coyote, the trickster in stories from the southwestern United States, also releases the stars, the moon, and the sun into the sky.

In the book *The Black River People*, the late Robert Cleveland (Inupiaq Eskimo from Ambler, Alaska, just east of Kotzebue) tells the same story of Raven stealing the light and calls it "The Origin of Light." Variations in the story can be attributed to the vast differences between the tundra and ice of northern Alaska and the forested terrain of southeastern Alaska and coastal British Columbia, yet there is no question that Cleveland's tale is the same story. Raven is the main character, and he steals the light, releasing the stars, moon, and sun into the sky. The same thing happens over and over in traditional tales from different regions, from Coyote in the southwestern United States, to Maui, the trickster in the South Pacific, and so on. An Australian storyteller told me that in Aboriginal stories, a bird releases the stars, moon, and sun into the sky. My experience and information gathering tells me that these are all the same story in essence.

I derive great inspiration from comparing an older way
of thinking about culture to my current notion of society.

—Preston Singletary

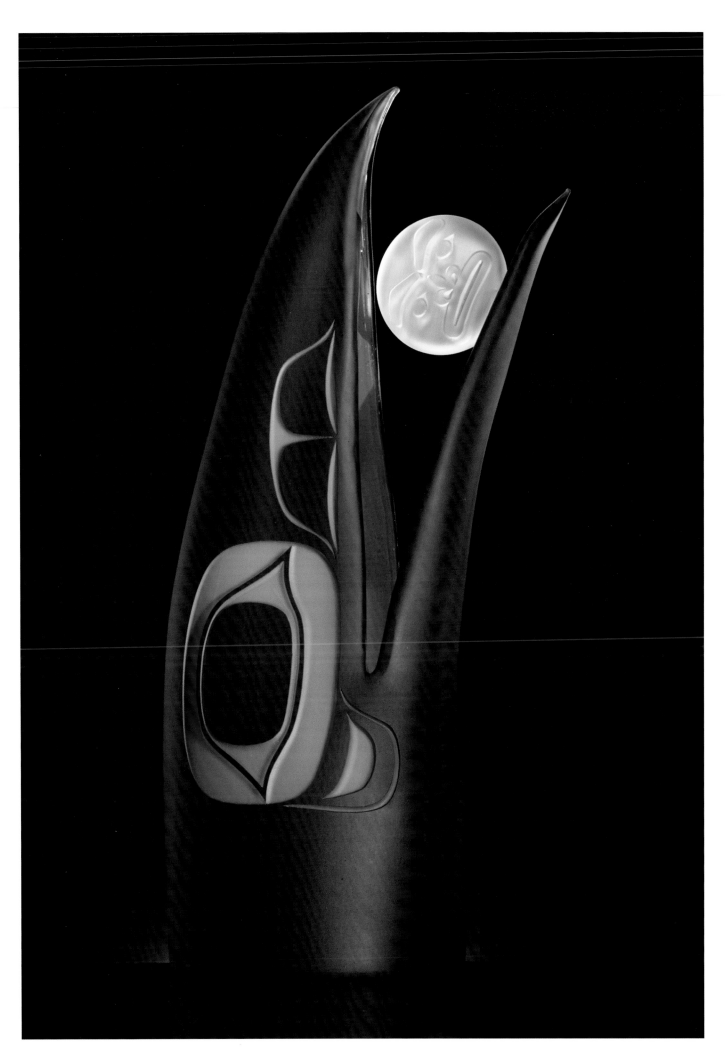

fig. 17 *Raven Steals the Moon,* 2006

fig. 18 Sketch of *Raven Steals the Stars*, 2008

As with all mythologies, the Raven story is symbolic and if read literally would not make sense. Traditionally, all Native artists and craftsmen explain their work and show how a story follows the design set forth. Singletary looks to culture in his creations and takes us into the Tlingit world of creativity, giving us the feeling that the elders of his past are calling to him. Examining how Raven steals the light will help us to understand the story Singletary tells through his designs and also give us a perspective from which to understand how his glassblowing talents have developed. In one of Singletary's books he refers to this story as "How Raven Brings Light to the World."

Before I start the story, it's important to mention that many anthropologists and mythologists have discovered similarities among stories and religions from all around the world. Singletary and I, after much discussion, discovered that we both have noticed the same universality. In some cases we can interpret stories using all factions of meaning from many religions when appropriate, but in this case, because biblical (New Testament) scripture is so similar to the "Raven Steals the Light" story, I will show parallels between the Bible story and the Raven story, then use them both to shed light on the unique nature of Singletary's creative gifts and expressiveness. It is these qualities that allow us to share in Singletary's learning of Tlingit culture and see how it has made him into a master craftsman.

In the beginning, Raven (our Creator) comes to the earth and finds the earth and its people in total darkness (living in ignorance and without spiritual leadership). He finds people on the Nass River fishing for eulachon and asks them where the light is. They tell him that Naas Shaak Aan K̲áawu has the light (stars, moon, sun) in three boxes in his community house. They tell Raven also that he has a young daughter who comes to the river each morning to drink from it. Raven, wanting to steal the light by releasing it into the sky, designs a plan to do so. First he changes himself into a speck of dirt and puts himself into the river so as to float right by where the young maiden drinks first thing in the morning. As he drifts by, she dips her ladle into the water and unknowingly picks up Raven (as the speck of dirt) with the water. Before she drinks the water, however, her father tells his servants to check the water for dirt and throw it out if they see any. They see the speck of dirt that is Raven, and so they throw the water out. This symbolizes the Native American sweat ceremony, in which people cleanse their minds through prayer.

Raven regroups and this time changes himself into a spruce or hemlock needle, floating down again, hoping that the maiden will pick him up in her ladle again, and she does. Because the needle is the same color as the ladle, the servants do not see him this time, and she drinks Raven down. She then becomes pregnant with Raven. In the old days, when Tlingit women gave birth, they would dig a hole in the earth to birth into and line it with garments; in this case they lined it with valuable and fancy furs. However, the baby would not be born, and they went to a medicine woman for help. When she looked over the situation, she saw the problem and told them to take out the furs and line the hole with moss. Then the baby was born. Because she is unmarried, the maiden daughter of Naas Shaak Aan K̲áawu is a virgin, which symbolizes that our new birth is a spiritual one. Putting the moss in the hole symbolizes a humble birth, much like Christ's birth in the manger.

When Raven is born as a human baby, he grows quickly and sees where the boxes are, knowing that they have the stars, moon, and sun in them. Before long he asks his grandfather, Naas Shaak Aan Káawu, and his mother if he can play with the boxes. It's important here to break down the meaning of the grandfather's name. "Aan Káawu" means the one above us or the Creator, and "Shaak" means the jewels and treasures of life, like healing, sharing, and love; "Naas" in this case is interpreted as "miracle."

They both say no to him playing with the boxes, and this asking and saying no goes on for some time, and then all of a sudden Raven blows up and starts crying and shouting that he wants to play with the boxes, and he won't stop. After some time his grandfather, who loves him, can't stand it anymore and tells his servants to let him play with the first box, with the stars in it, and they do. We see that asking and crying symbolize that it's important for us to be totally dependent on the one above us, and yes, we get what we want when we are persistent. Jesus says, "Come to me as a little child," meaning be totally dependent on him for everything, and we will get what we want. In this case Raven is asking for spiritual help, and when he asks, he receives.

After Raven Boy gets the box with the stars in it, he plays and plays with the box with the stars. One day he notices that no one is looking, and he opens up the box and out come the stars, up through the smoke hole in the community house, and up into the sky, and they've been there ever since. When we play, we play to be happy, and this is accomplished by forgiving. Play, play, forgive, forgive. Jesus says, "Forgive seven times and then seven times that amount," showing that forgiveness is a continuous practice every day of our lives. The literal use of stars in the night for guidance and direction is common all over the world. The stars in this story were in the box and are released; this shows us that guidance and direction are within us, waiting to be released. Noticing in the story that the stars come from within the box, we begin to see what Jesus means when he tells us that the Kingdom of Heaven is within.

Before the moon is released, Raven again plays and plays with the moon box, showing us that forgiveness (symbolized by playing) is an ongoing process. When Jesus was leaving the earth, he said, "I leave you now and I leave you the Holy Spirit. He will not guide you by his own intuition but by me." In the Raven story it's the same: The moon is a reflection of the sun's light, giving us the ability to see and understand what we see in darkness. In real life when the moon shines at night, we can see and understand what we're looking at, even though it's still dark outside. As we said before, the world began in a state of darkness (ignorance), and in this case the moon is symbolic of the Holy Spirit. At this stage of our development, we begin to see and understand the world the Holy Spirit provides for us at this stage in our spiritual journey.

I started working with Tlingit designs to find my own voice.

—Preston Singletary

Raven then plays and plays with the box before he releases the sun into the sky. When the sun shines, it shines on everything. There is even light in the shadows. Raven is showing us that in this stage of our development, we become like Jesus; our love for the world becomes pure and all-encompassing. Jesus sees only love and sees a reflection of himself in everyone. He doesn't see crime, he doesn't see suffering, and he doesn't see evil, because his thoughts are without blemish.

Notice here also that the stars, moon, and sun came from within the boxes. If we could look at all three of them in the sky together, we would see that we are looking at the whole universe. Having seen this, we now understand further that when Jesus says, "the Kingdom of Heaven is within," he means that everything there is to know about the Creator's spiritual kingdom is within us: all knowledge, all wisdom, and, to Singletary and other artists, all creativity.

After the light is released, Raven Boy turns back into Raven Spirit and returns to the Nass River, where it is still dark. From one side of the river he hollers to the other side, where the people are still fishing for eulachon, saying, "Give me fish and I will give you Light," and they get angry with him and say, "You are not the One with the Light, you are not the One with the Light." After he repeats himself to them several times and they keep up with their anger, he lifts his right wing, and the moon is there and shines out to them. When they see the moon shining, they say, "You are the One with the Light, you are the One with the Light!"

This part of the story is telling us that when truth comes to us, we (the angry eulachon fishermen in the story) are not always willing to believe in it, and many times we get angry because truth threatens the things that we treasure in life: our own ideas of what's good and bad, our own ideas about how to solve the world's problems, and our justifications for attacks and war. When Raven lifts his wing and shows the moon to the people and they say, "You are the One with the Light," they recognize that we have become a manifestation of the Holy Spirit and his voice speaks through our being one with him.

At this stage in our development we speak like Jesus and say things like "I and my father are one." We say that because it's true, and all of us will say that at some point in our journey back to the Light.

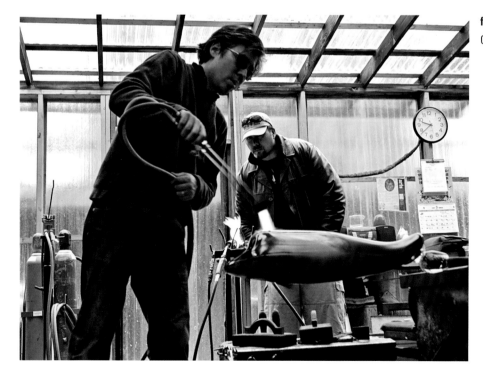

fig. 19 Singletary working with Lewis Tamihana Gardiner, Seattle, 2007

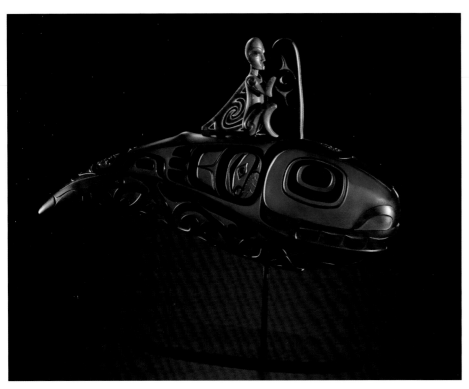

After the people recognize Raven for who he is, the people with the fur regalia go into the forest kingdom to live, the people with the feathered regalia go into the bird kingdom to live, and the ones who wear the fish regalia go into the ocean kingdom to live. We realize fully that we are all One Spirit.

I would like to emphasize how important it is that these unique and powerful designs of Raven stealing the light came to be through Preston Singletary. Through his choice of designs and writings to accompany his artwork, Singletary demonstrates the strength of Tlingit culture and shares with us his beliefs about how his people really were: They were people guided by their stories, they were organized, they were problem solvers. They were free of the runaway crime, social problems, and extreme dysfunctional behavior we experience today in many aspects of our lives.

In my research on the designs that come from the "Raven Steals the Light" story, I realized that our people knew that following the stories' examples will lead one on the right path. Seeking guidance through the stories brings answers; light is shed on whatever topic or area of insight we desire. Symbolically speaking, the stars give direction and guidance. The moon, because of its illuminating light in the darkness, brings understanding to any situation. The sun sheds light and clarity on all things.

In the beginning of this Raven story, Raven finds the world in darkness (ignorance) and sets out to find the light (wisdom and knowledge). When viewing Singletary's glasswork, we sense that he acknowledges the importance of light in how his work is viewed. At the same time that he is sculpting a work of art in glass, he is also sculpting how the light will fall through it and tells us that he's come to think of it as a sort of kinetic sculpture. Singletary's combination of glass and light brings Tlingit design and art to a higher level, capturing the enjoyment and delight of all who see it. At the same time, knowing that he intentionally created the design of the stars, moon, and sun in Raven's mouth to reflect a well-known Tlingit story increases the meaning and power of his work. We find ourselves mesmerized as we focus on this great piece of art, the hub in a whole wheel of connections.

I hope that my work can be viewed on other levels not associated
with ethnicity, while at the same time ethnicity is what gives it power.

—Preston Singletary

All through the story, Raven shows us what to do to release the light from the boxes that contain it. First Raven puts himself in water (cleansing); then he is born to a virgin mother (a spiritual beginning). He asks his Creator for all things (symbolized by a crying baby) and learns to be totally happy, which comes from the continuing practice of forgiving one another and the world. This is symbolized by Raven playing and playing with the boxes where the light is, or by us forgiving continuously each and every day, which leads to happiness. If I hurt your feelings by something I say or do to you, from that moment on, you will probably have an impression of ill will about me. When you get tired of carrying that impression around and decide to put it down, that's forgiveness—not so much forgiveness of me as forgiveness of your impression or perception of me.

When we learn this type of forgiving, we no longer see the world as something wrong; we stay focused on cleaning up our own minds, and the world takes on an image of beauty like it should. As we get better and better at this, we also find our voice (the Holy Spirit speaking through us) and share this knowledge with others. That's why this story and Singletary's designs of Raven with the stars, moon, and sun in his mouth are so important. There is only one thought that entertains unhappiness, and that's the unwillingness to forgive.

Singletary's own development parallels that of the Raven story. He speaks about an event that happened early on in his glassworking training, bringing about changes in his life and effecting positive results in his work. He met Joe David, Nuu-Chah-Nulth from the west coast of Vancouver Island, through the artist-in-residence program at Pilchuck Glass School. As the relationship continued, David, a Sun Dancer connected with the Lakota people, introduced Singletary to the sweat ceremony, in which individuals enter a small circular dwelling that seats a small group of people. The sweat lodge leader pours water over hot rocks as he teaches the participants how to pray for their own cleansing. The Christians refer to a similar act as baptism, in which an individual is taken to a lake or river, lowered backward into the water by the minister, and washed clean of his or her sins. Water as a cleansing element is the common link between the sweat lodge, baptism, and the Raven story.

Singletary refers to this experience as his "rites of passage ceremony," and he believes that it gives special meaning to the new life he created by venturing into glassblowing and finding his own ways of expressing creativity. He talks about the

importance of traditional Native songs that he learned in the sweat ceremony and the quiet and soothing effect they had on his mind, helping him to become more and more comfortable with the work he was doing. While working, while creating, the artist focuses totally on his art, losing consciousness of time. The mark of a master is that we as viewers are taken to the same place: totally focused on and aware of the work we see, feel, or hear, to the exclusion of time.

Jesus says, "Look at the Lily, it neither spins nor toils." Most of us are "worldaholics"; we chase after everything, and we can't get enough of what we think is out there. Our minds are spinning all the time, and because of that, our ability to be co-creators with our Creator eludes us. In his art we can see Singletary setting out on a spiritual quest through ceremony and self-discipline because of what his culture has to offer. We all benefit by the creativeness that, in his own words, chose him.

In the story "Raven Loses His Beak" there is a character similar to the Scriptures' Lucifer. In this story a fisherman claims that he is the best fisherman of all; Lucifer in the Scriptures claims all his talents and gifts are his own. He declares independence from his creator and says, "What do I need Him for?" Singletary, by contrast, demonstrates a humble approach to creativity. When asked if he sees his creativeness as similar to that of Salvador Dalí, who claimed that he was "the vehicle in which creativeness comes," Singletary is reticent about making that claim; instead he puts the focus on the fact that working with others on his projects is enjoyable and says that much of his creativeness comes to him in that kind of environment.

Art can only speak truth about the manner of its making, and so we see new dimensions and significance emerging from Singletary's art when it is created in collaboration with others (his work with Lewis Tamihana Gardiner and Tammy Garcia is a fine example) and viewed in relationship with its environment, especially in relationship with light. When the shadows created by his *Wolf Hat* (or clan hat) (pp. 50–51, cat. 2) creation were seen for the first time, they provoked a collective gasp of awe from those gathered. The fluidity and unity of Singletary's works in glass, the grace and completeness with which culture, symbols, and art are brought together, show us without words what it is to let the world go and remember who we are.

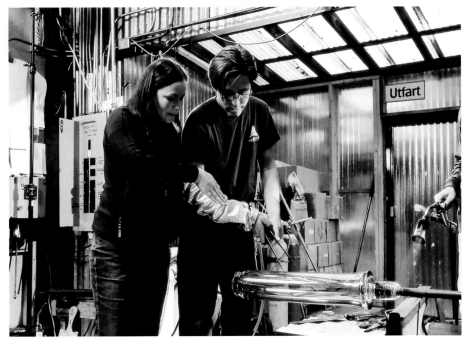

fig. 21 Singletary working with Tammy Garcia, Seattle, 2005

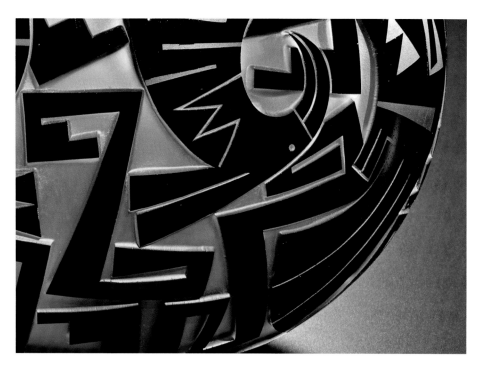

fig. 22 *Parrot Seed Jar*, 2005
(detail, p. 81, cat. 26)

More about Preston Singletary

Preston Singletary was born August 9, 1963, in San Francisco. He is Tlingit and Fili-
pino. His Tlingit clan is Kaagwaantaan, Eagle Moiety, Box House, from Sitka. Single-
tary's family includes both parents, a younger sister, his wife, Åsa, whom he met in
Sweden, and three children, Sienna, Orlo, and Lydia.

Except for a brief stint in Juneau and six months in Sweden, Singletary has lived
his entire live in Seattle but travels extensively. He credits living abroad, in part, for
expanding his perception of who he really is. While he had always felt like some-
thing other than a "typical American"—he's Alaska Native, he's Filipino—living in
Sweden helped him to realize just how American he really is. To him, it would be
quite an experience for all Americans to live outside the country for a time; maybe
they would begin to see things a little differently, too.

The study of Eastern religions and Japanese martial arts, aikido in particular,
has been another strong influence in Singletary's life and art. He notes that once he
began aikido training, he found himself moving differently in each moment, even (es-
pecially) when working at glassblowing. The concepts of harmony and unity that are
so central to Tlingit culture are present in Eastern religions and martial arts as well.
If we can see harmony and unity in Singletary's finished art, we know they were
present during its creation.

Connecting with the Power Within

Even though Singletary doesn't talk about a separate power that influences his creativeness, I get a sense that he is sensitive to a power of some kind "right next to him," as Don Juan says in Carlos Castaneda's books. From the moment I met Singletary, I felt comfortable in his presence, and I am sure that his team feels the same way about working with him. He tells me that working with glass is a team effort and that each role in the creation of a given project is just as important as the other. We can see that he takes the same care in crafting his designs: Each detail is just as important as the other, and every element matters. Every light, every shadow through the glass are vital to the expression he is crafting.

Here again we get the sense that Singletary swings back in time. There is no such word as *privacy* in the Tlingit language; we have always been a social people. We lived close together in groups and were always interacting with one another through storytelling, working, hunting, and continuous genealogy as a form of bonding rather than as a form of family history. If you look at the old nineteenth-century photographs of the villages we lived in, you'll see that the community houses were always together. We lived and created together. Singletary evokes the communal creative process in all of us, both through his choice of designs and by the teamwork used to create them.

Singletary attributes many qualities of his work to ancestral or genetic memory. We don't know what he says or asks for in the sweat ceremony, but we do know that whatever obstacles were once there have been removed through prayer and song, allowing him to peek into the vast reservoir of design and unchanging culture from his ancient ancestors. I, like many who see, welcome this gifted experience. Like our elders, I am grateful to be invited into Singletary's world, and when he says he has found his voice, we can, by looking at the wonderful things he is creating, hear him loud and clear.

fig. 23 *Wolf Hat*, 1989 (pp. 50–51, cat. 2)

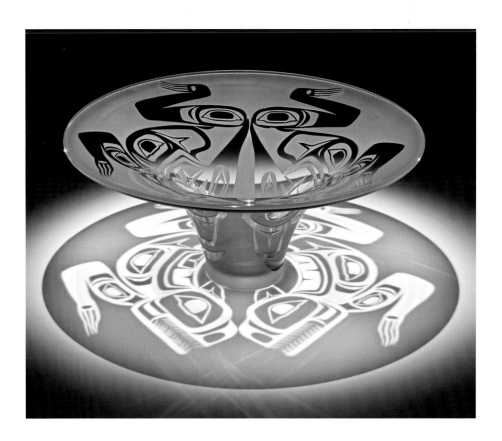

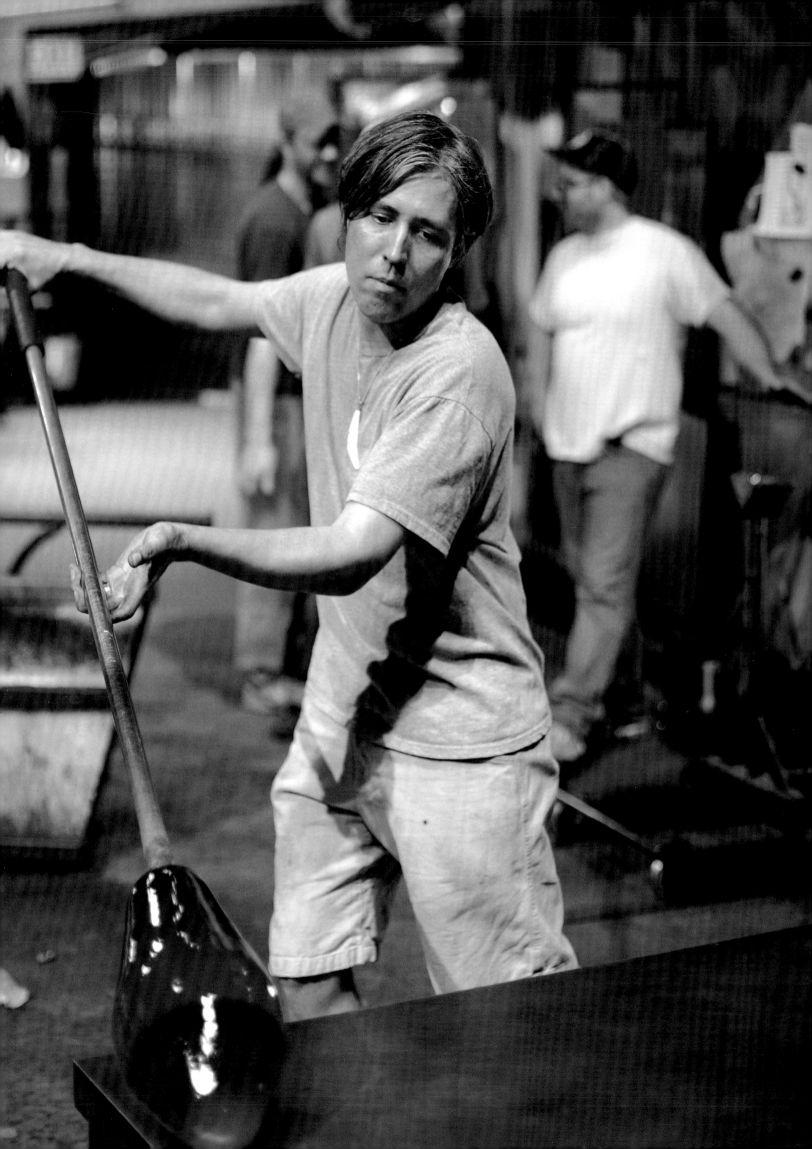

PRESTON

catalog of the exhibition

SINGLETARY

Titles listed in English and Tlingit as appropriate

Opposite: Preston Singletary, Visiting Artist residency, Museum of Glass Hot Shop, February 2008

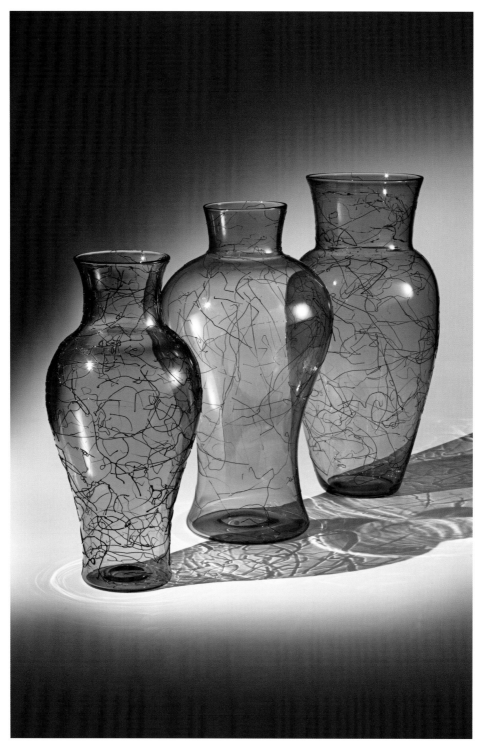

cat. 1 *Scribble Vases*, 1985

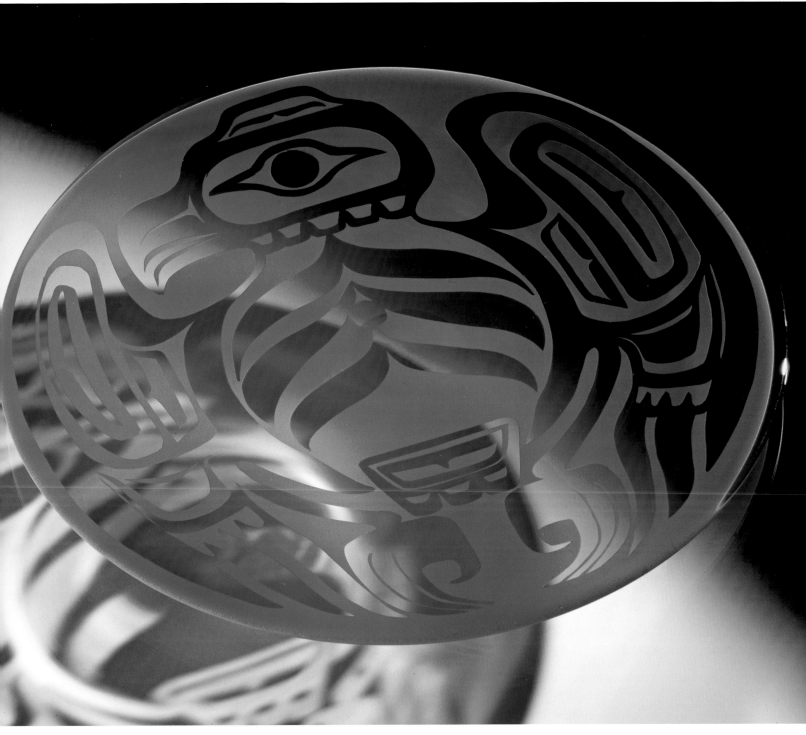

cat. 3 *Eagle Plate* (Ch'áak' Kélaa), 1994

Next spread:
cat. 2 *Wolf Hat* (G̲ooch S'aaxw), 1989

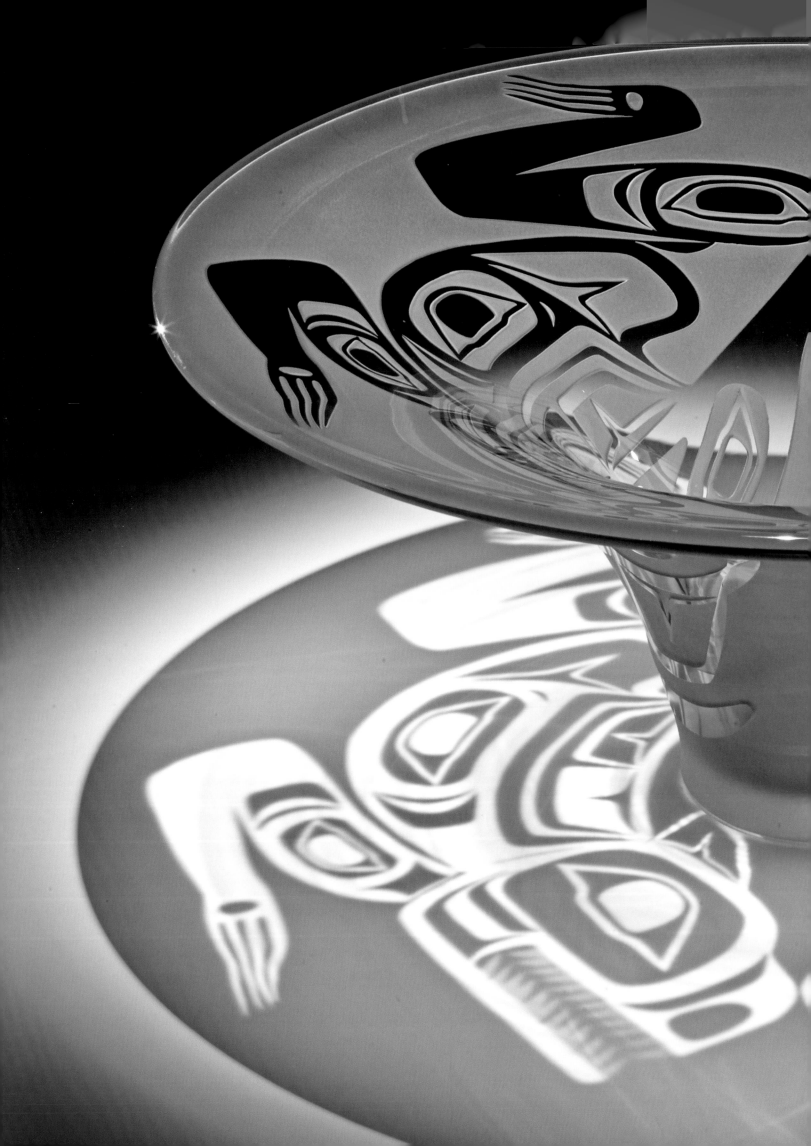

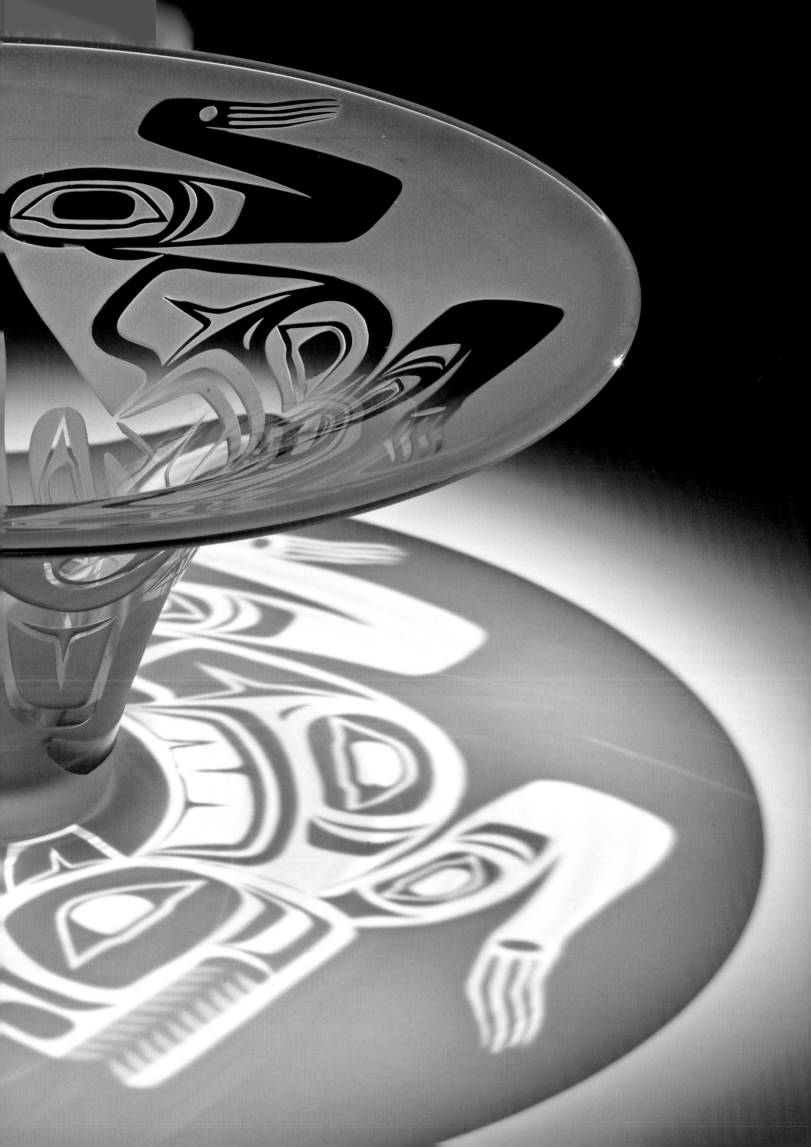

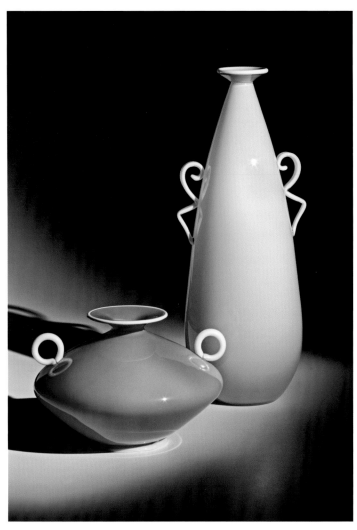

cat. 4 *Prestonuzzi Vases,* 1995

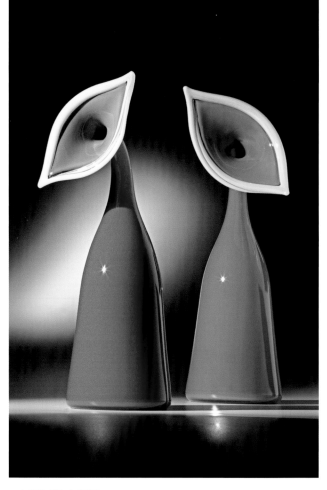

cat. 5 Untitled, 1996

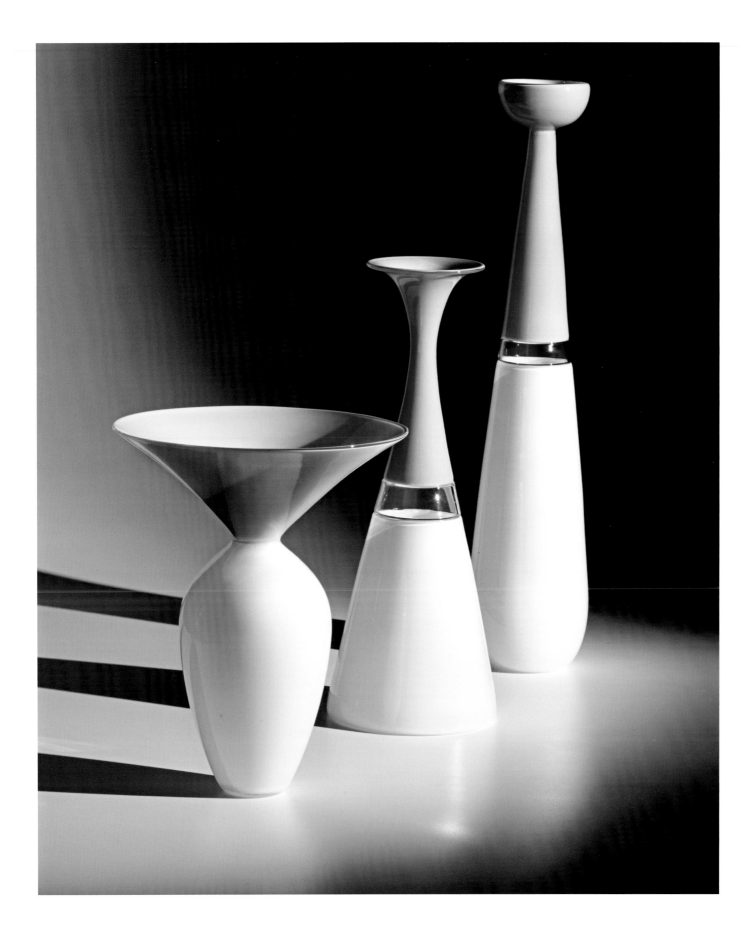

cat. 6 *The Genies,* 1996

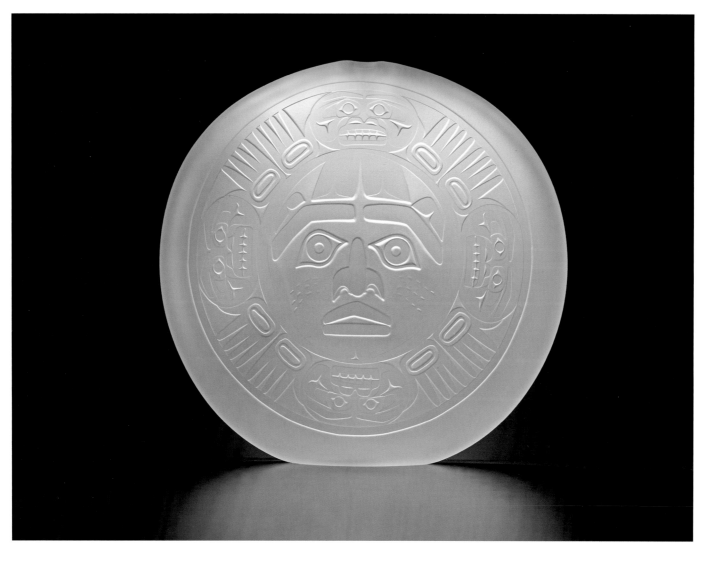

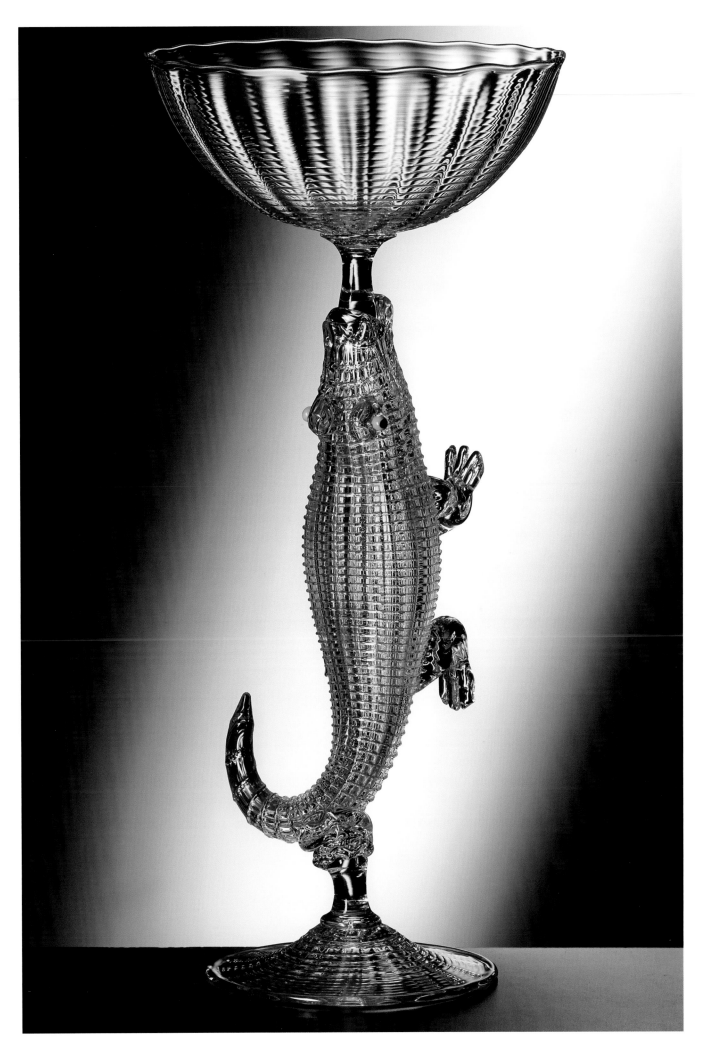

cat. 13 *Copper* (Tináa), 2001

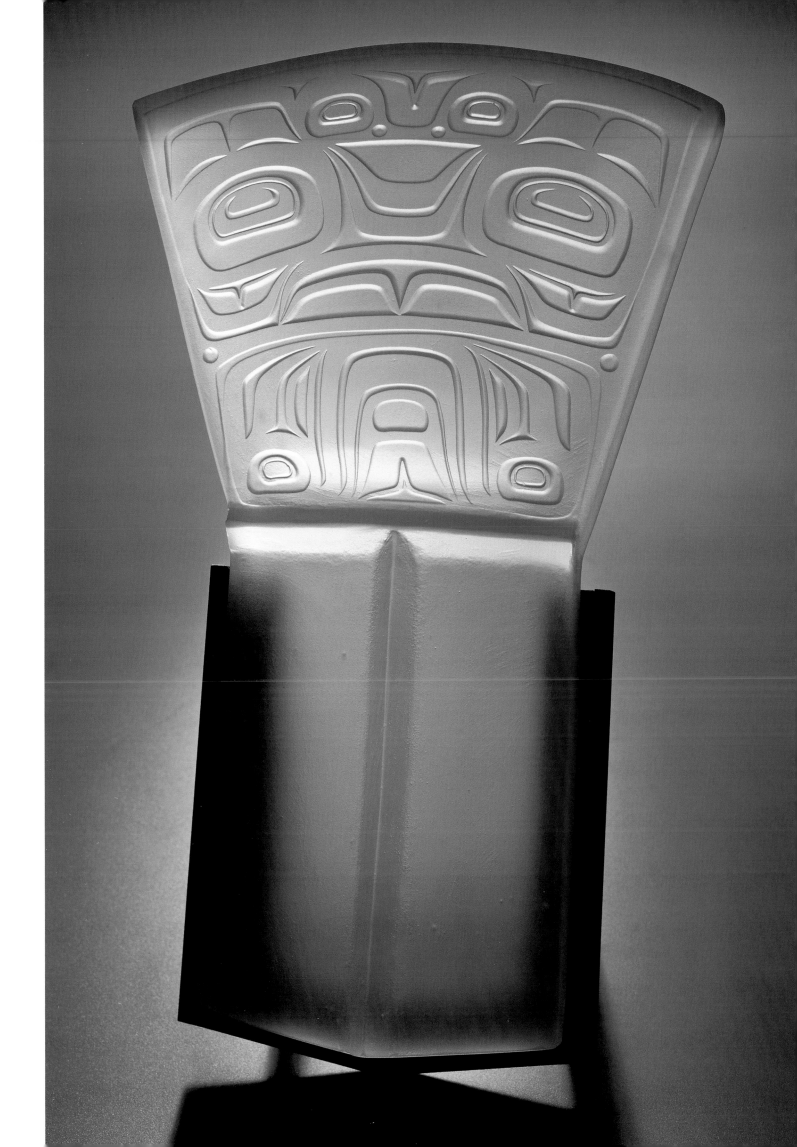

Opposite:
cat. 10 *Wasco* (Jinook Kwáan—Chinook people), 1999

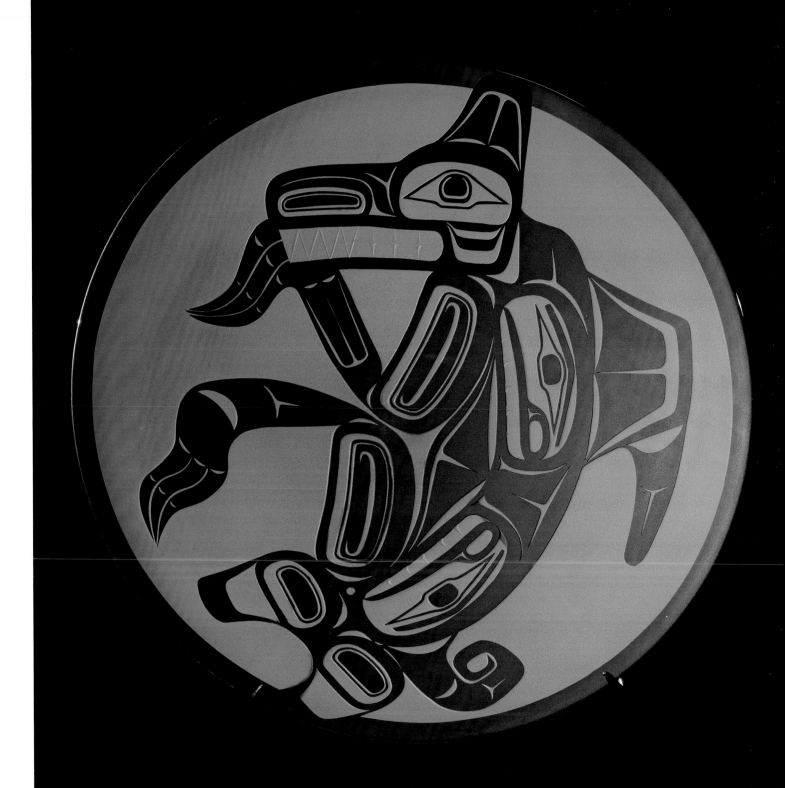

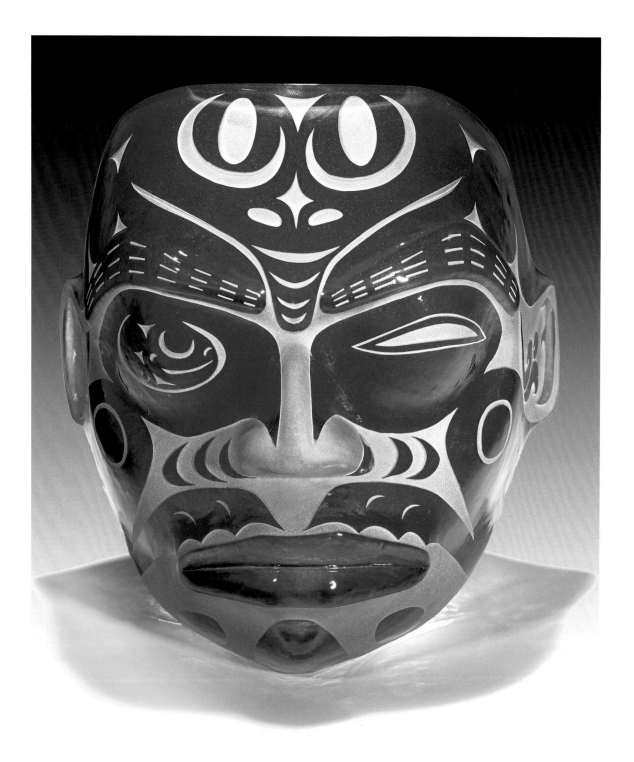

cat. 9 *Frog Mask* (Xíxch Yéigi L'axkeit), 1999

Opposite: **cat. 11** *Frog Woman Mask*
(X'ichí Shaawát L'axkeidí), 2000

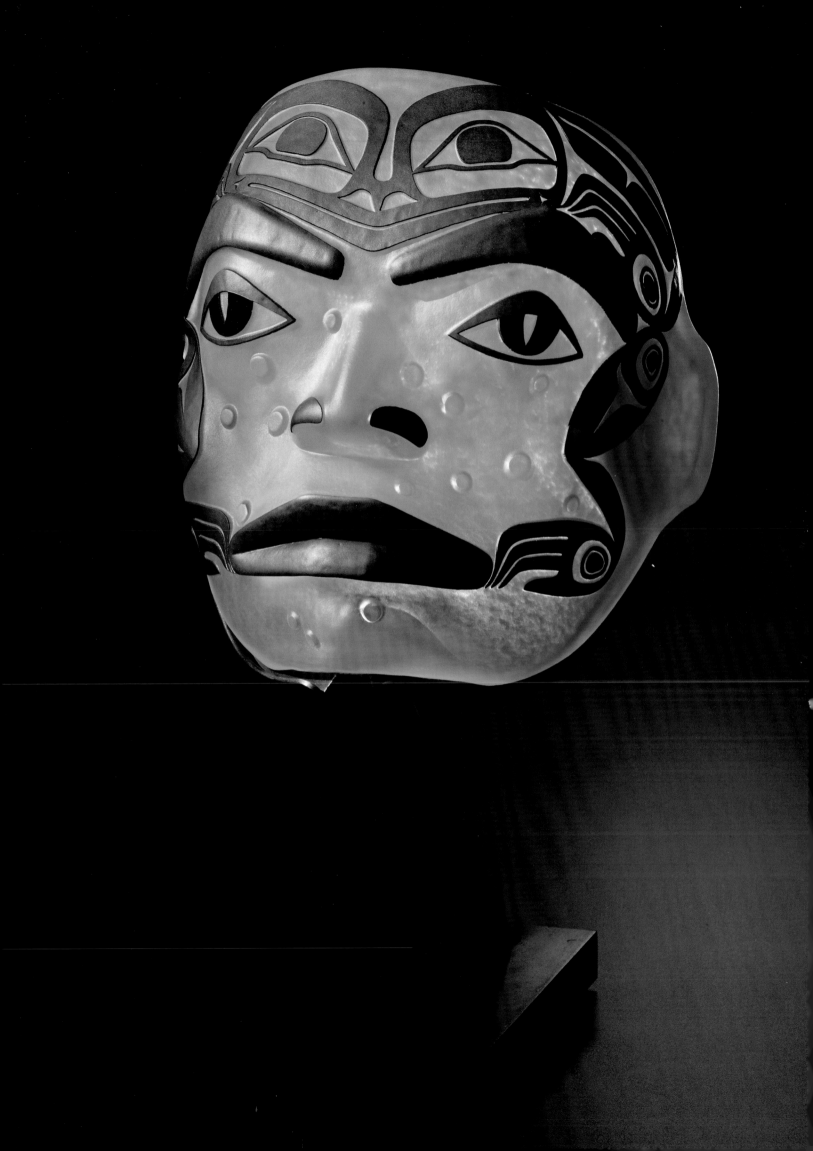

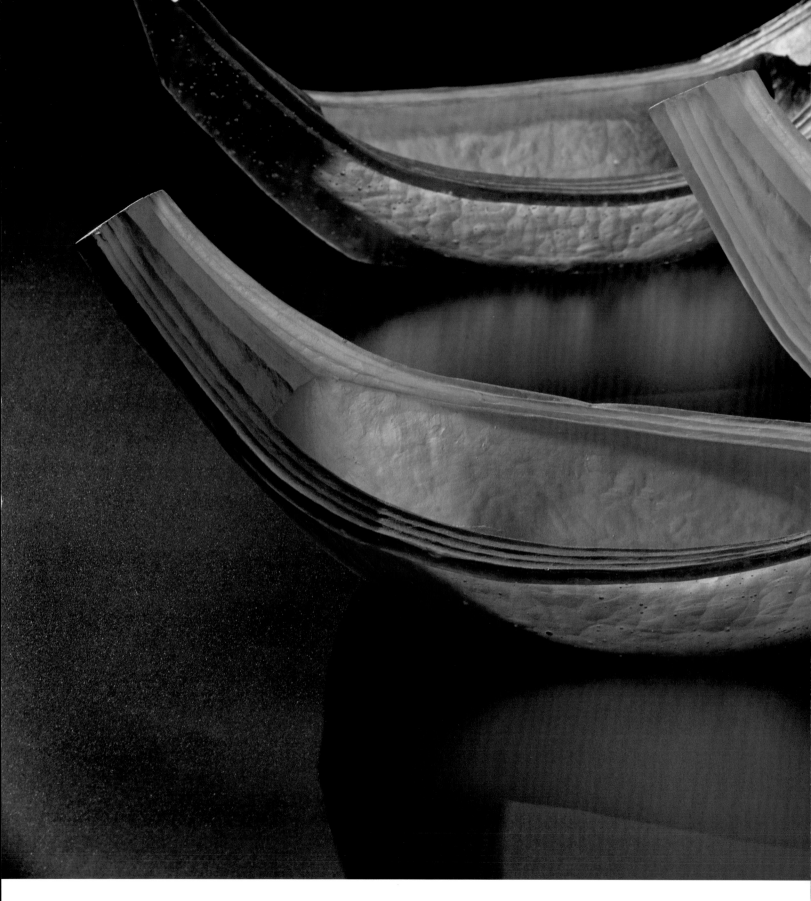

cat. 12 *Canoe Dishes* (Yáakw Sʼíxʼxʼ), 2001

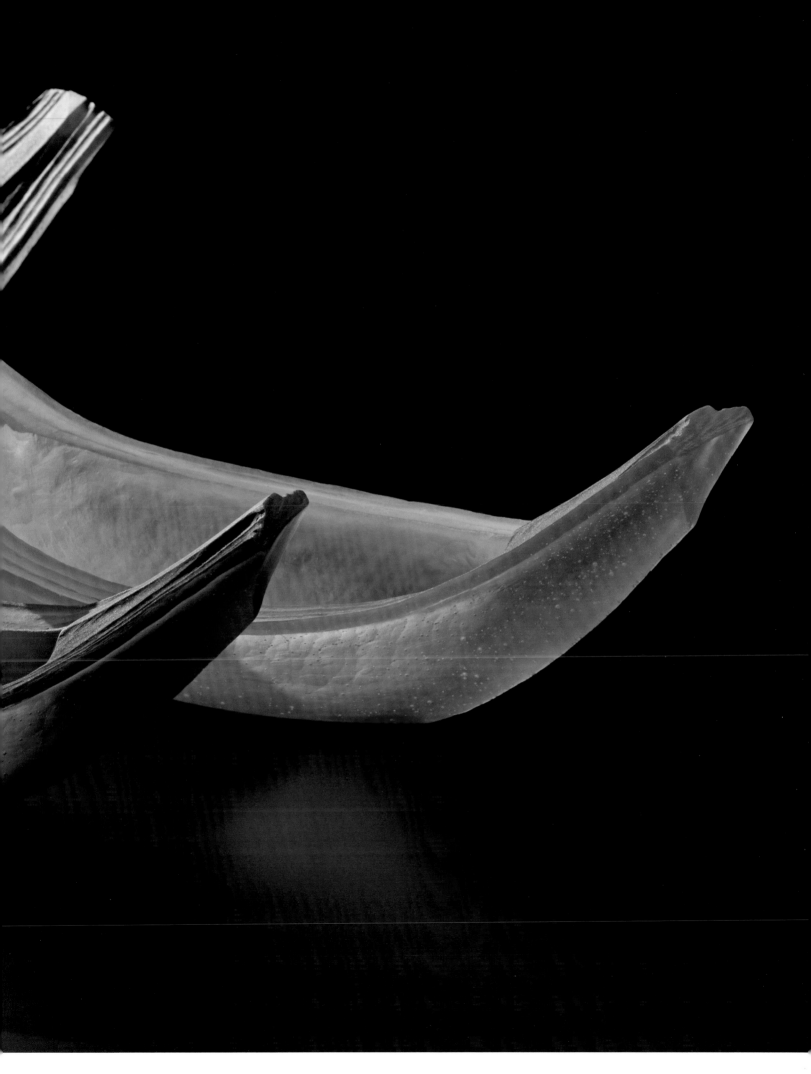

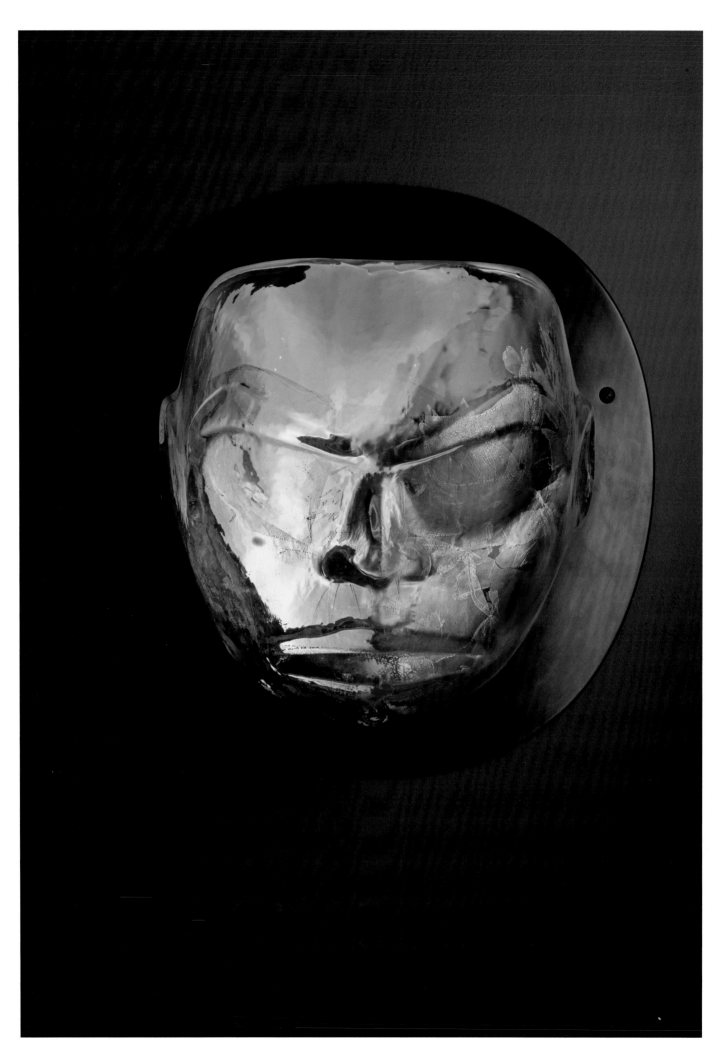

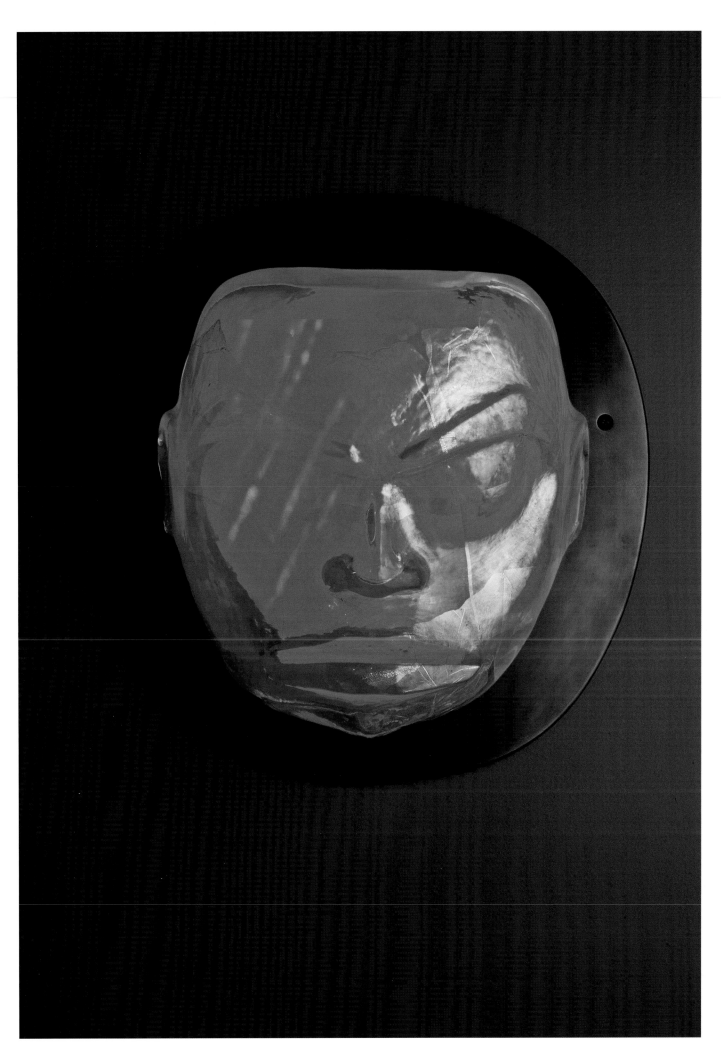

cat. 16 *Rain Mask* (Séew L'a<u>x</u>keit), 2001

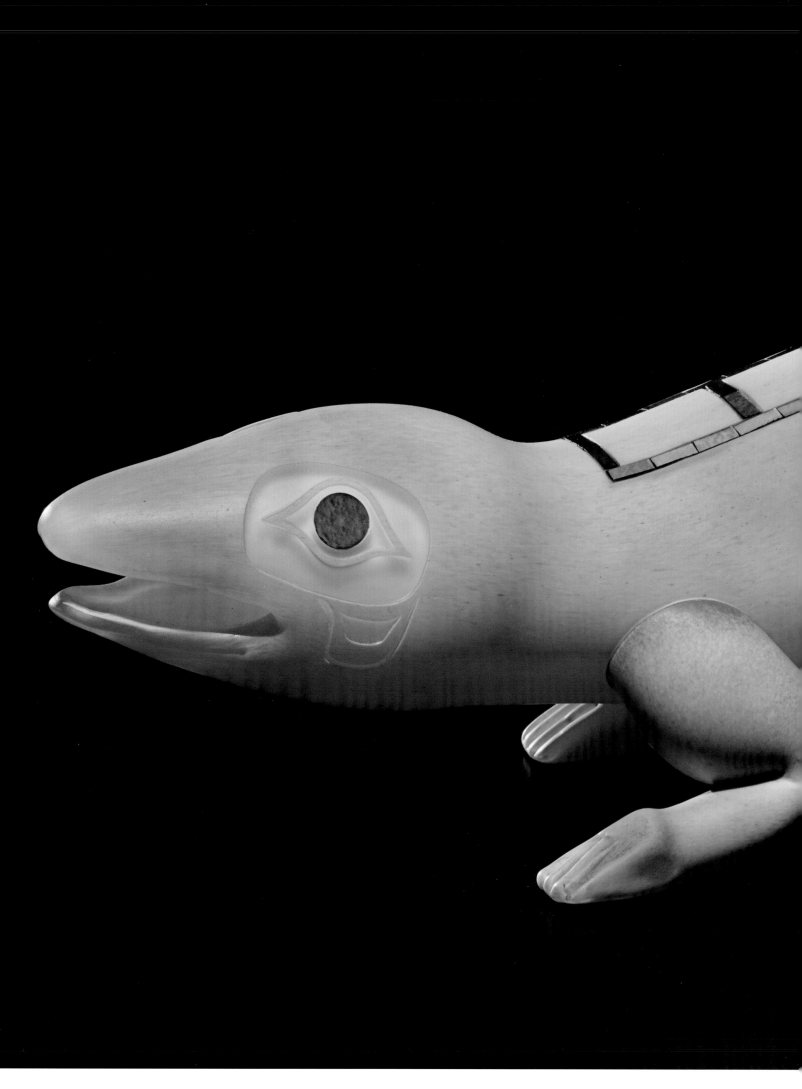

Opposite:
cat. 17 *Raven Steals the Sun* (G̲agaan Awutáawu Yéil), 2001

Next spread:
cat. 18 *Soul Catcher* (K̲áa Yahaayí Shatl'ék̲wx'u), 2001

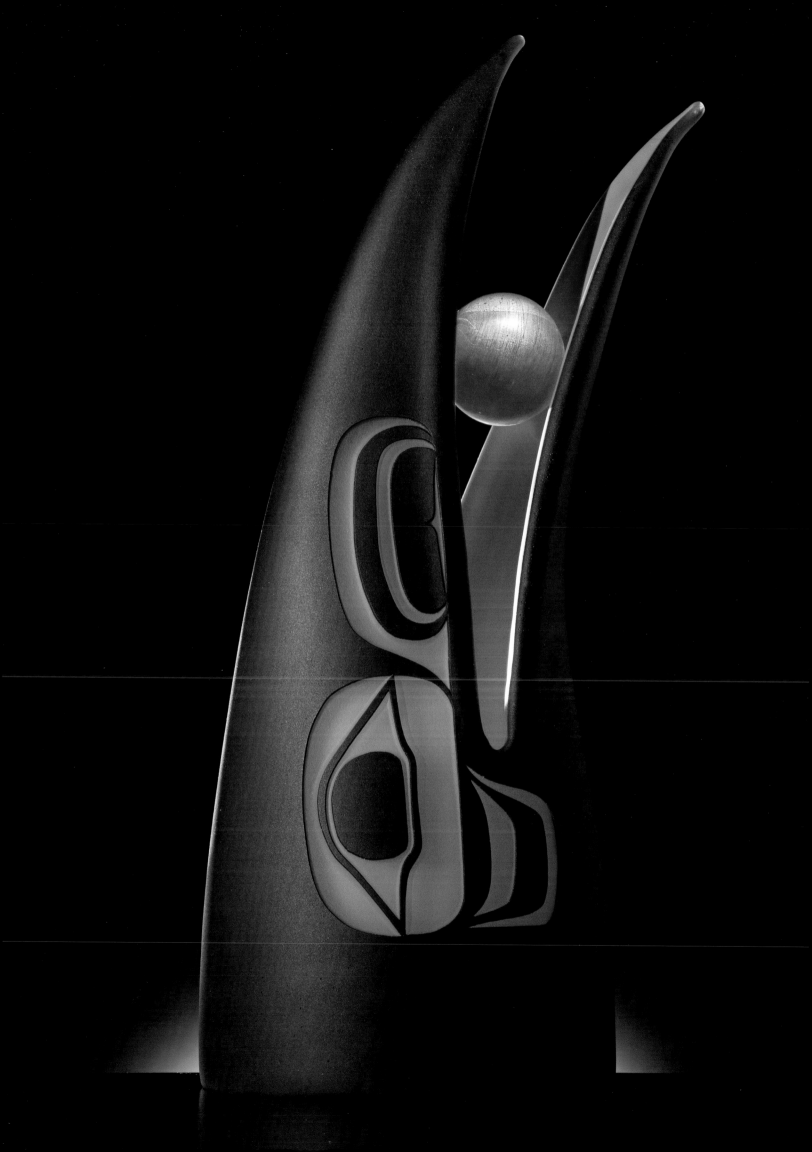

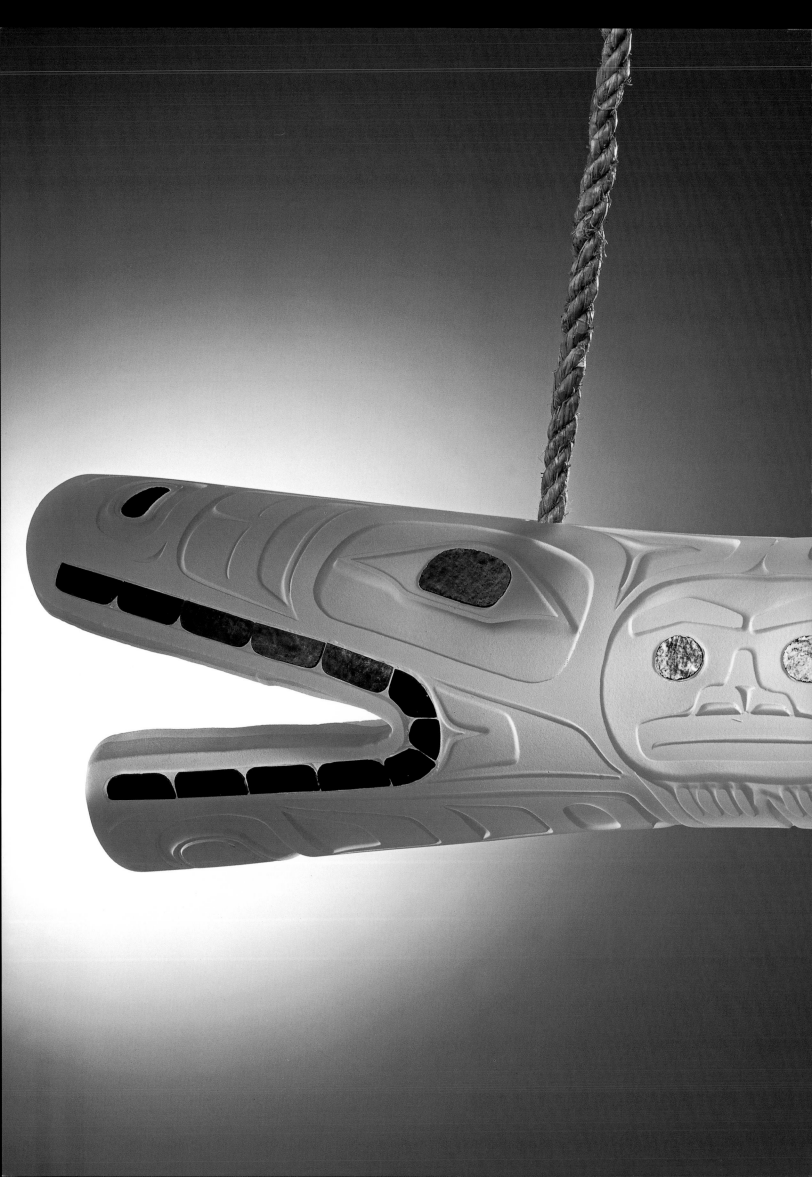

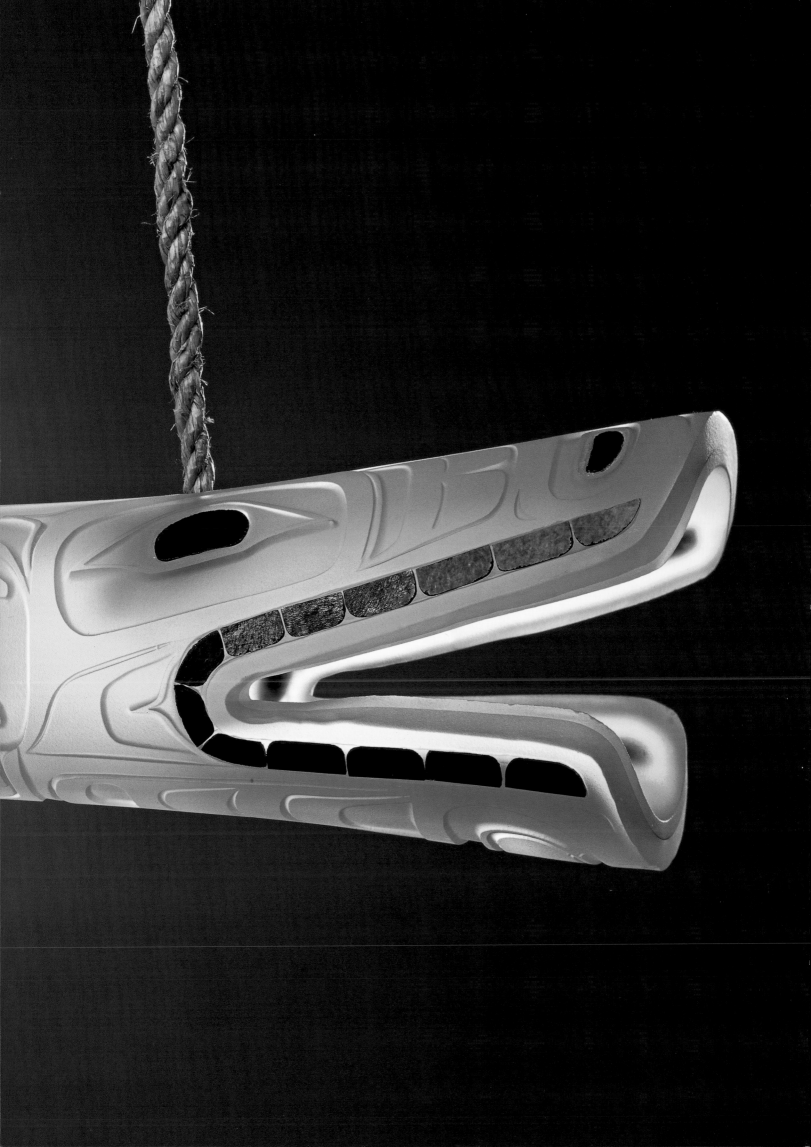

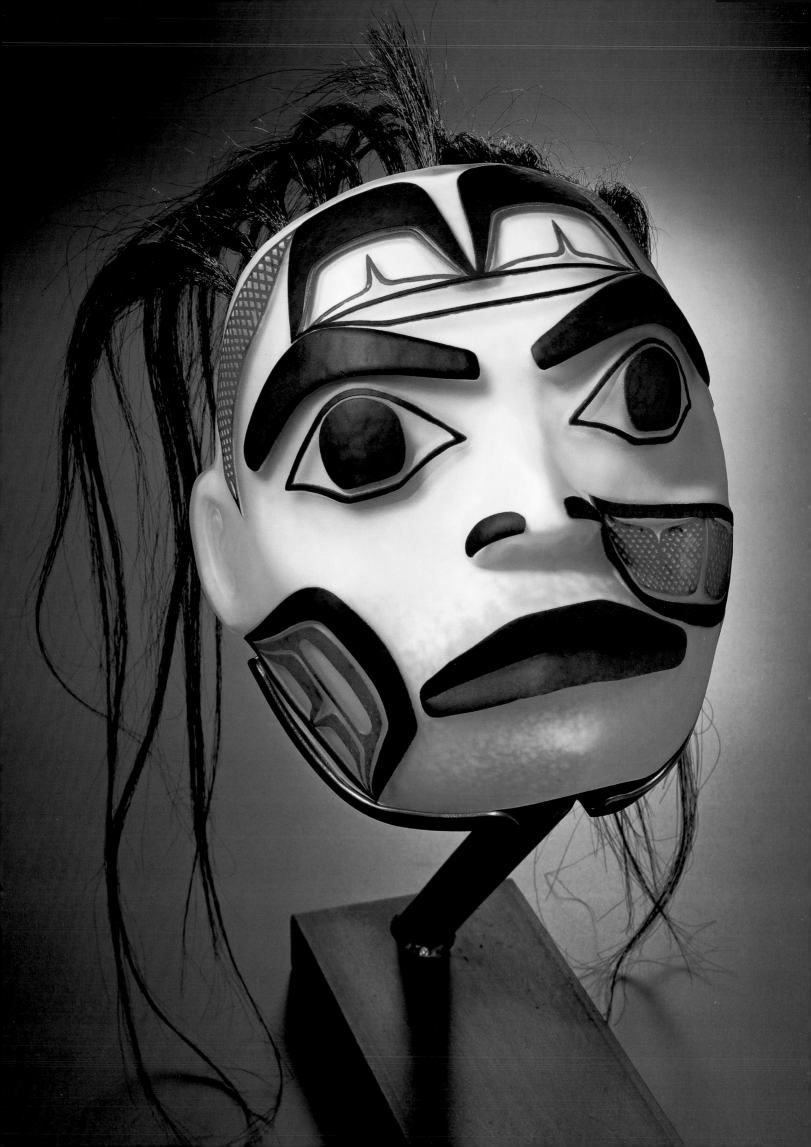

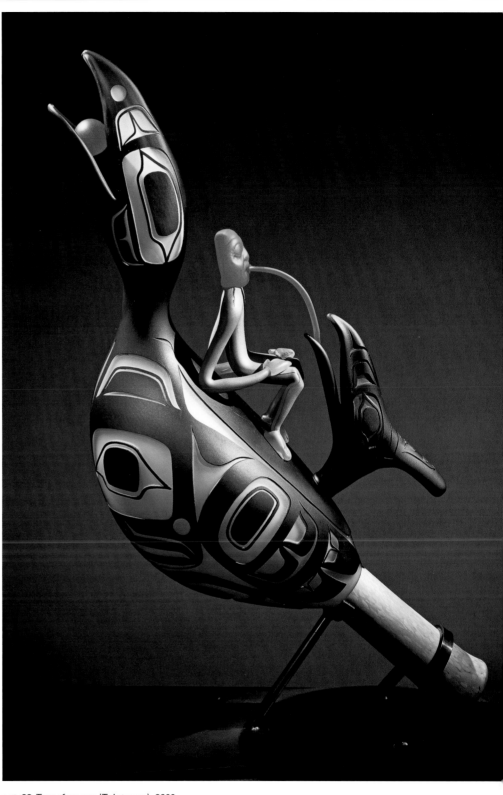

cat. **22** *Transference* (Tulatseen), 2002

Opposite: **cat. 19** *Warrior Mask* (X'igaa Káa L'axkeit), 2001

cat. 20 *Housefront Screen*
(Hít Ya X'éeni), 2002

cat. 21 *Shadow Catcher*
(At Yahaayí Shatl'ékwx'u), 2002

Opposite:
cat. 24 *Whaler's Hat*
(Yáay Kalaxachx'e S'aaxw), 2003

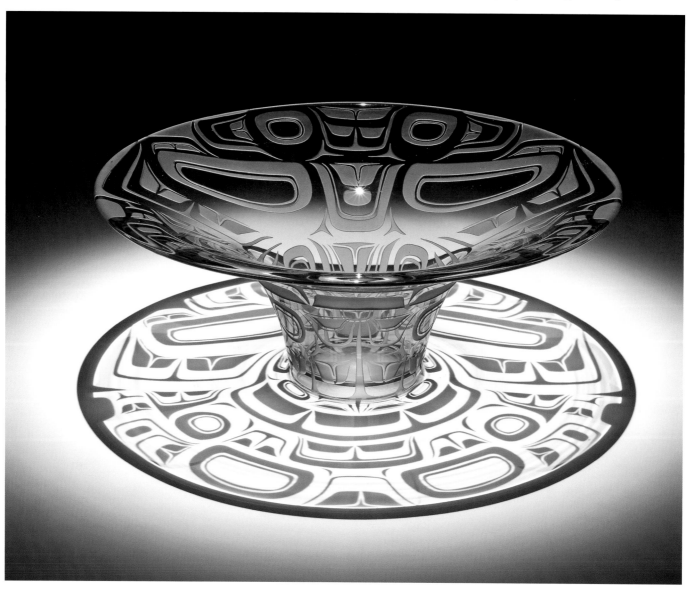

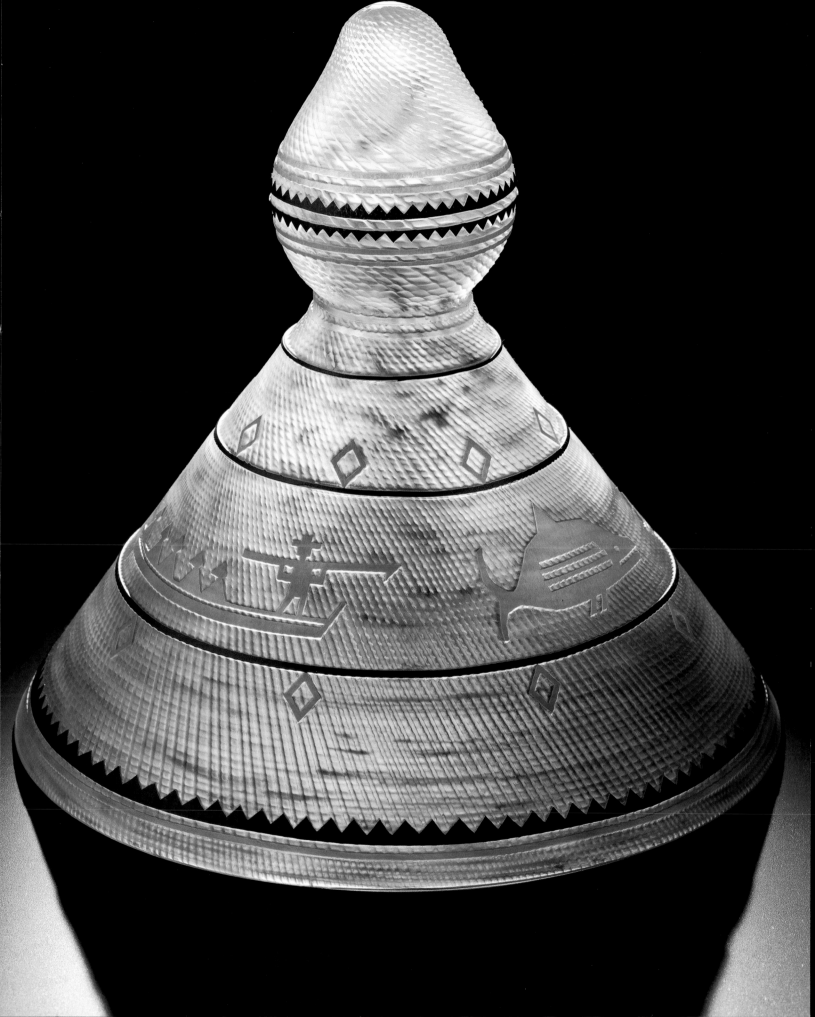

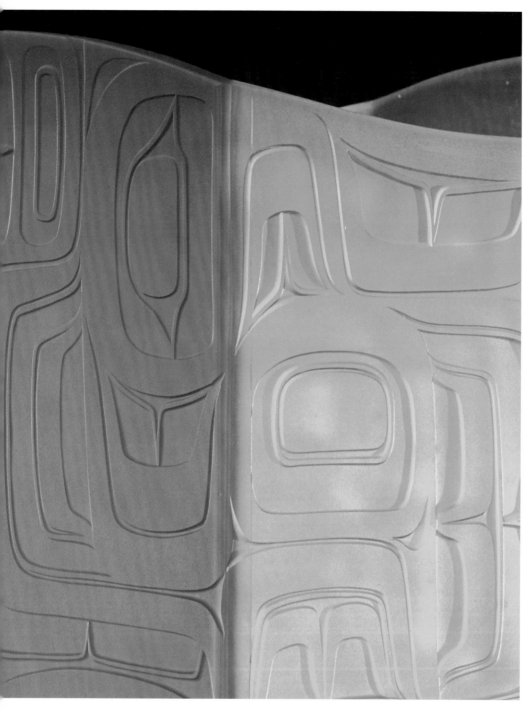

cat. 23 *Never Twice the Same (Tlingit Storage Box)*
[Tleil Tla<u>x</u> Wooch Yá<u>x</u> Udatí (Lá<u>k</u>t)], 2003

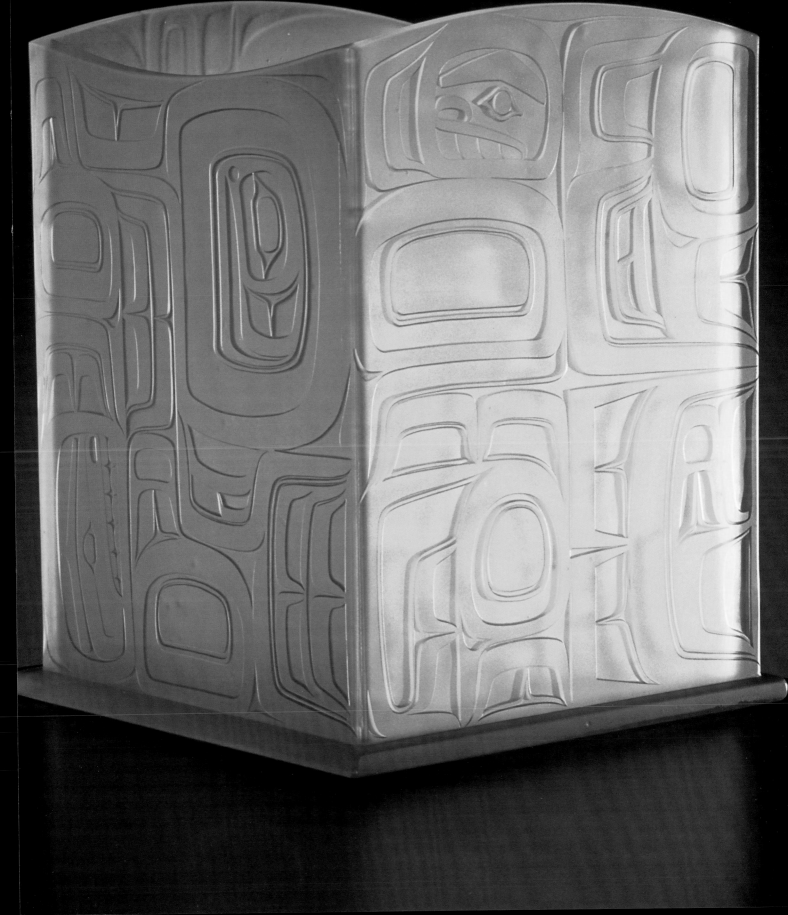

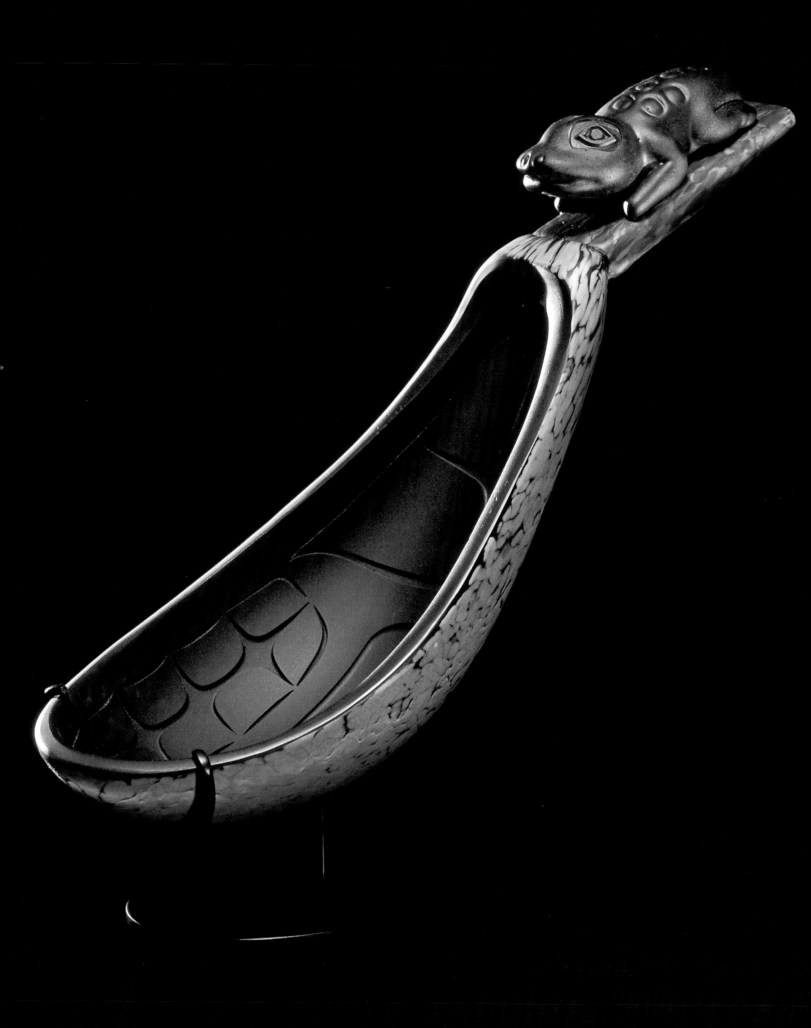

Opposite:
cat. 28 *Water's Edge* (Séew L'axkeit), 2005

cat. 26 *Parrot Seed Jar*
(Yoo X̱'ayatáni Tsítsk'w At X'aakeidí T'oochinéit), 2005

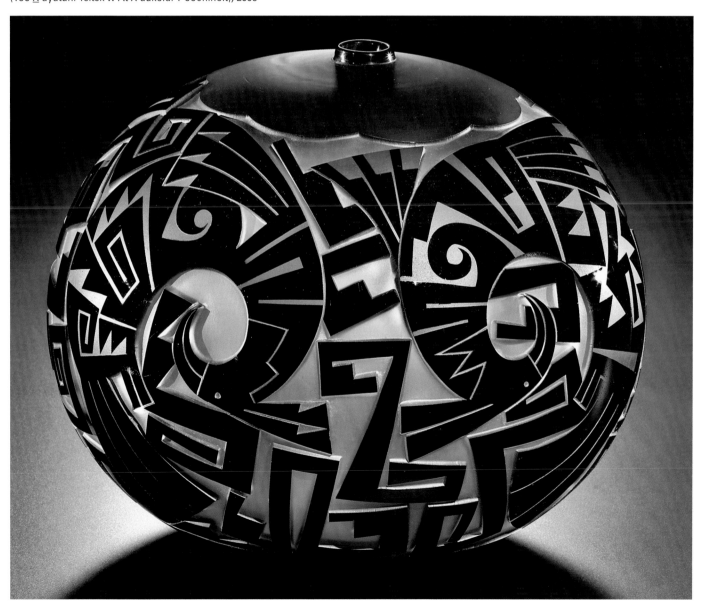

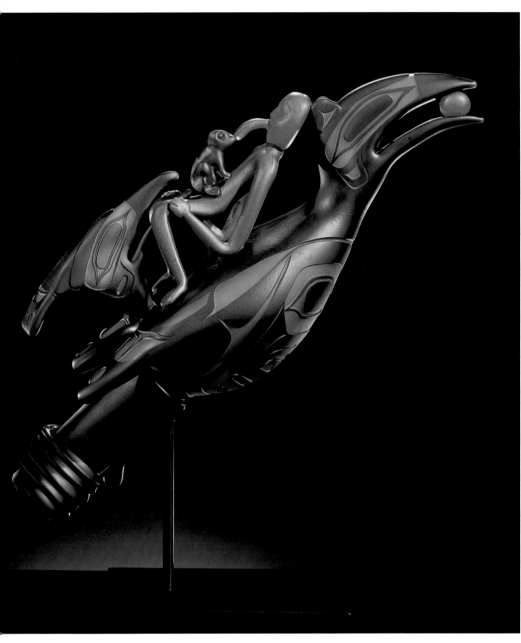

cat. 27 *Transference* (Tulatseen), 2005

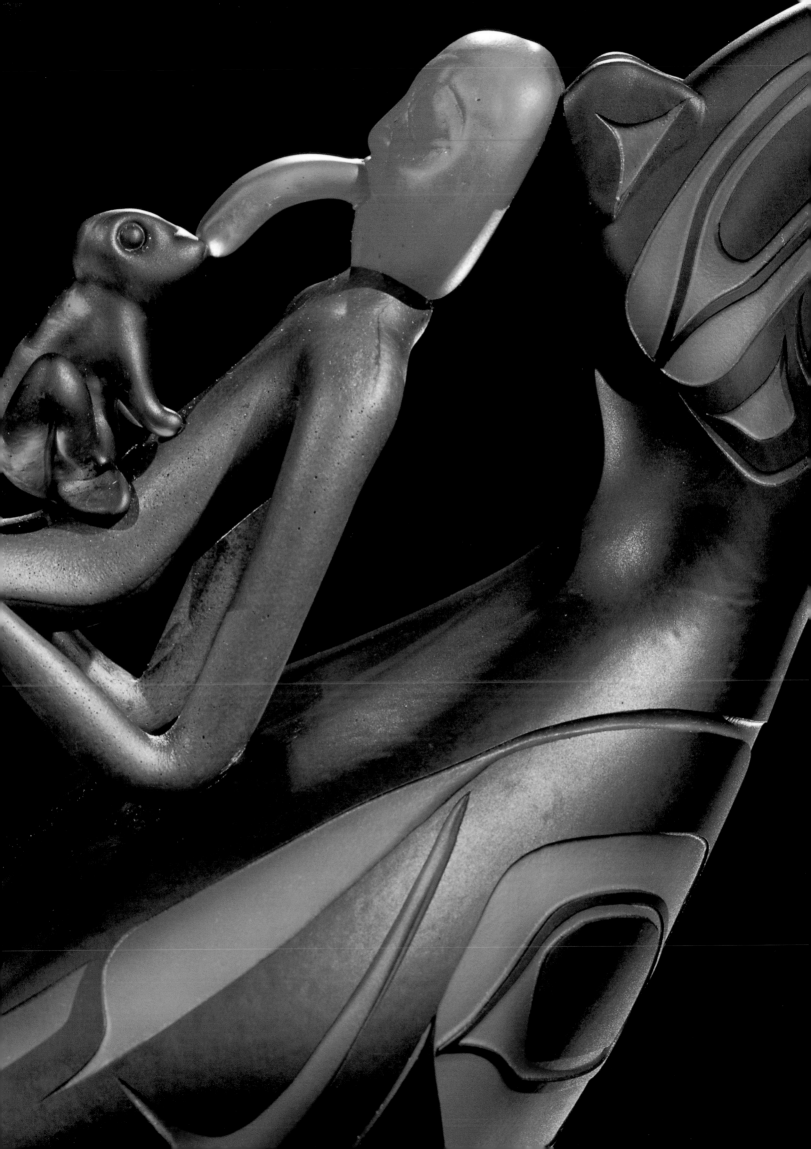

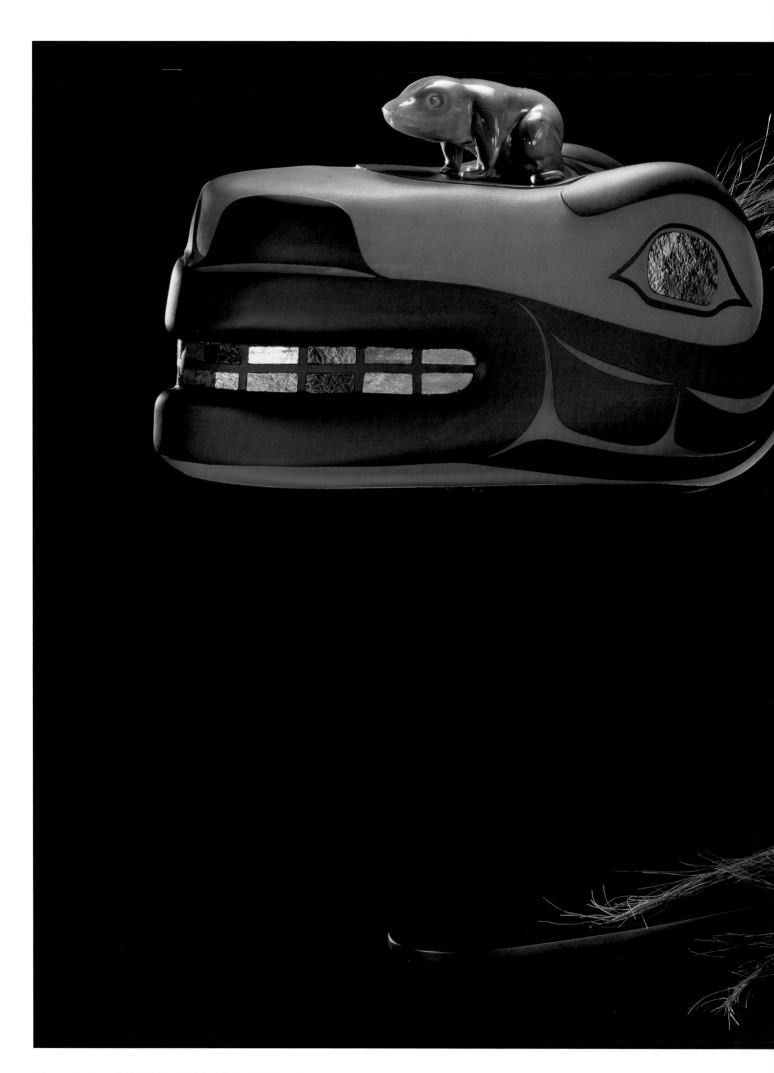

cat. 25 *Frog Medicine Frontlet* (Xíxchi Naagú Kaktu.át), 2005

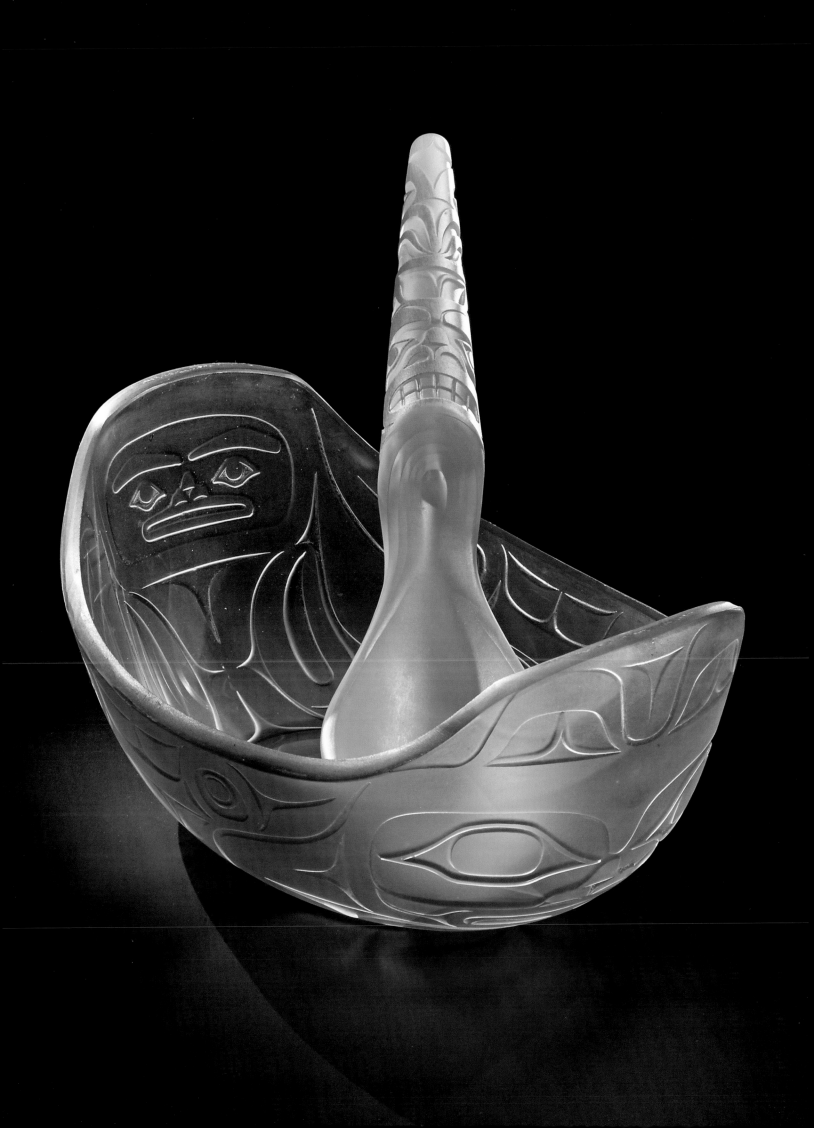

Opposite:
cat. 32 *Land Otter Man* (Kooshdaa Káa), 2006

Next spread:
cat. 29 *Bentwood Box* (Lákt), 2006

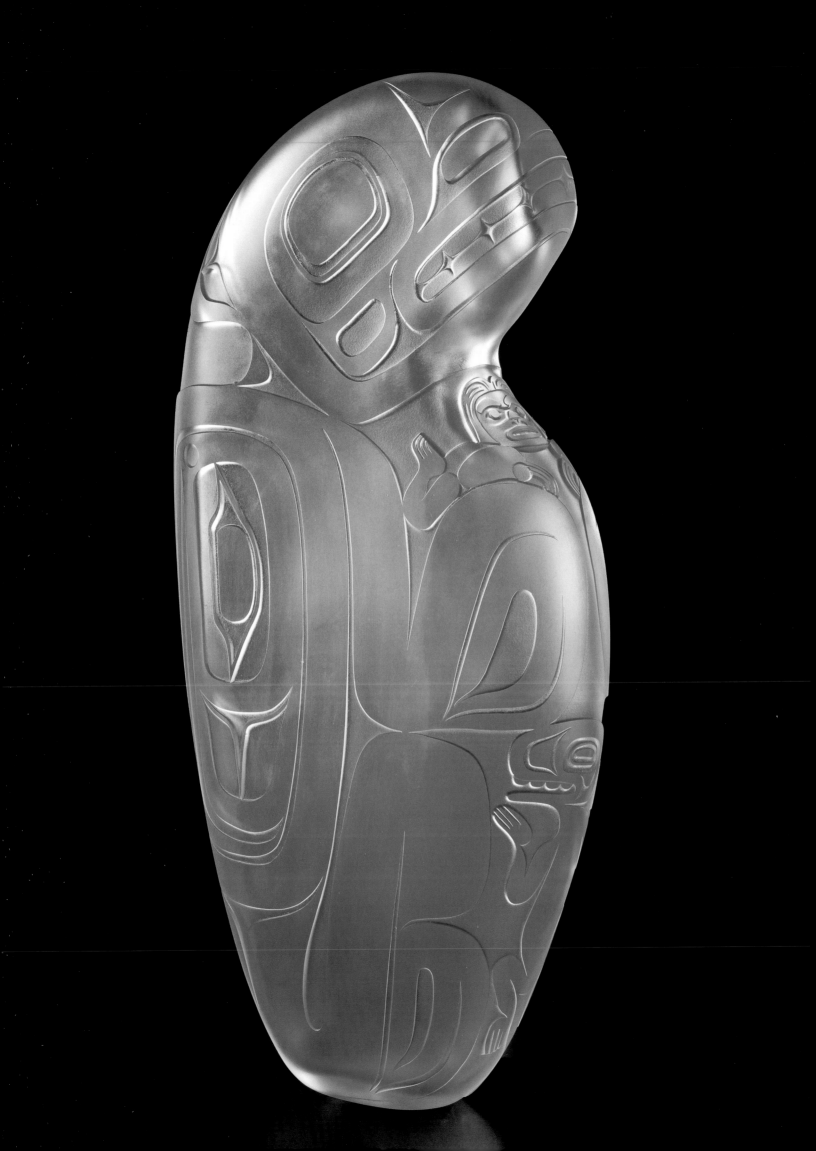

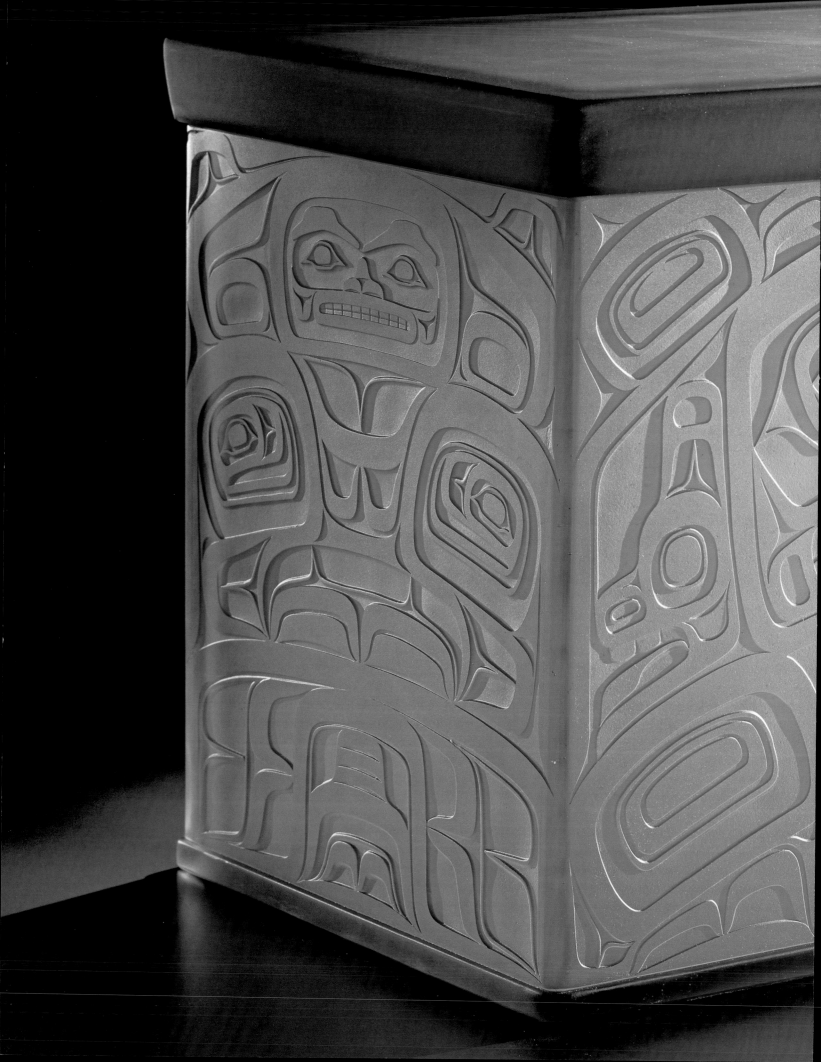

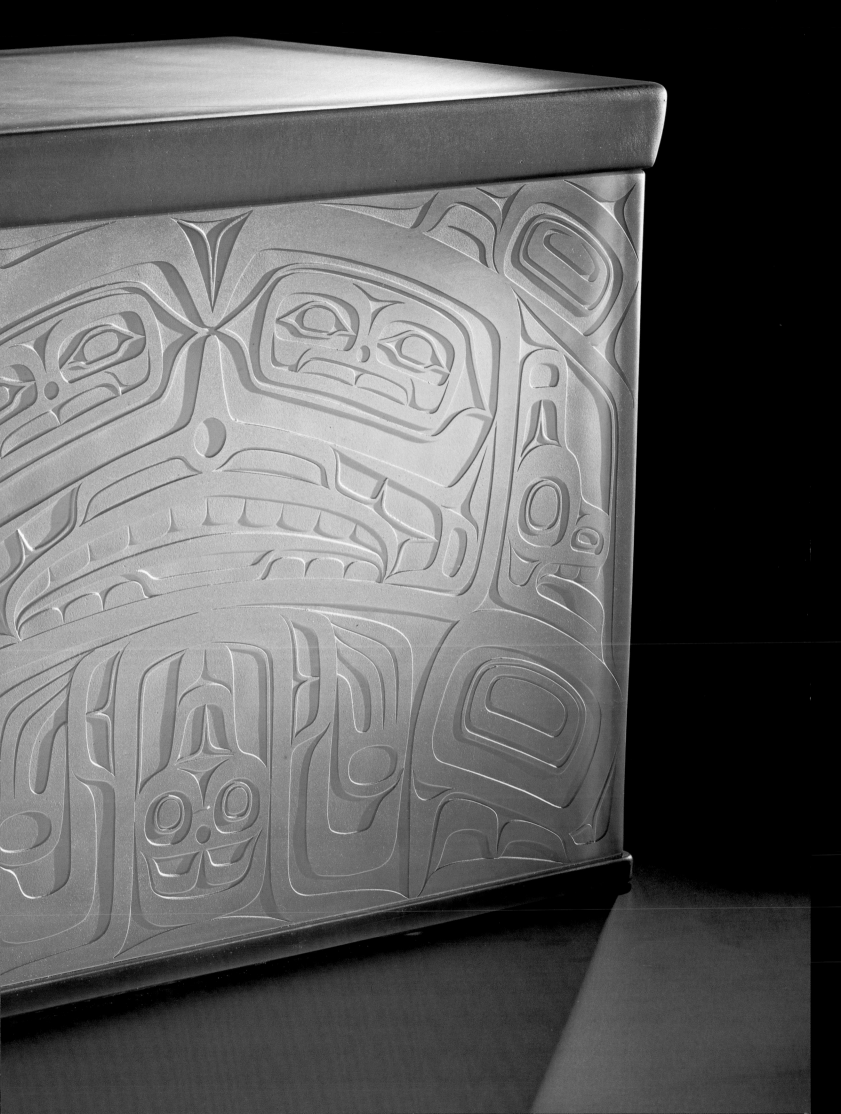

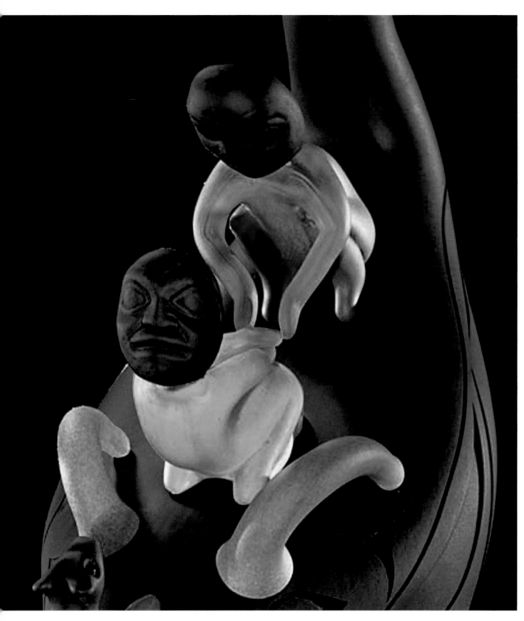

cat. 33 *Oystercatcher Rattle* (Lugán Sheishóo<u>x</u>), 2006

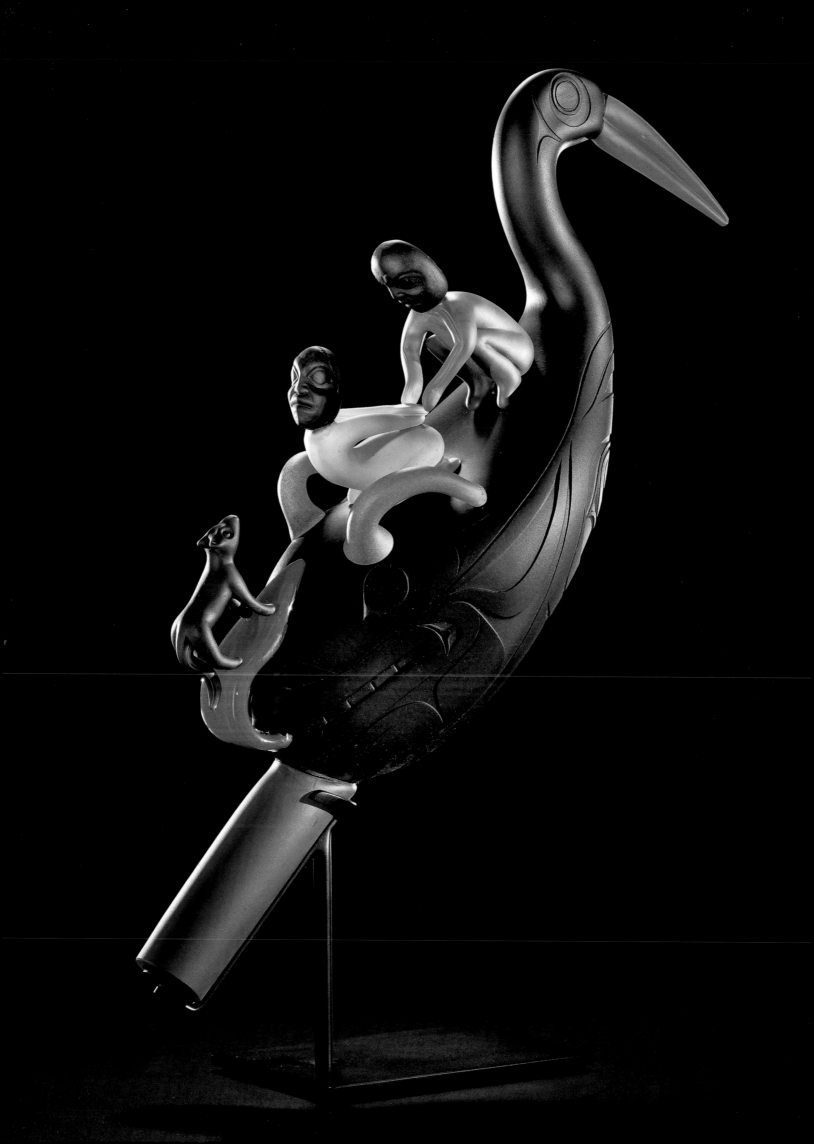

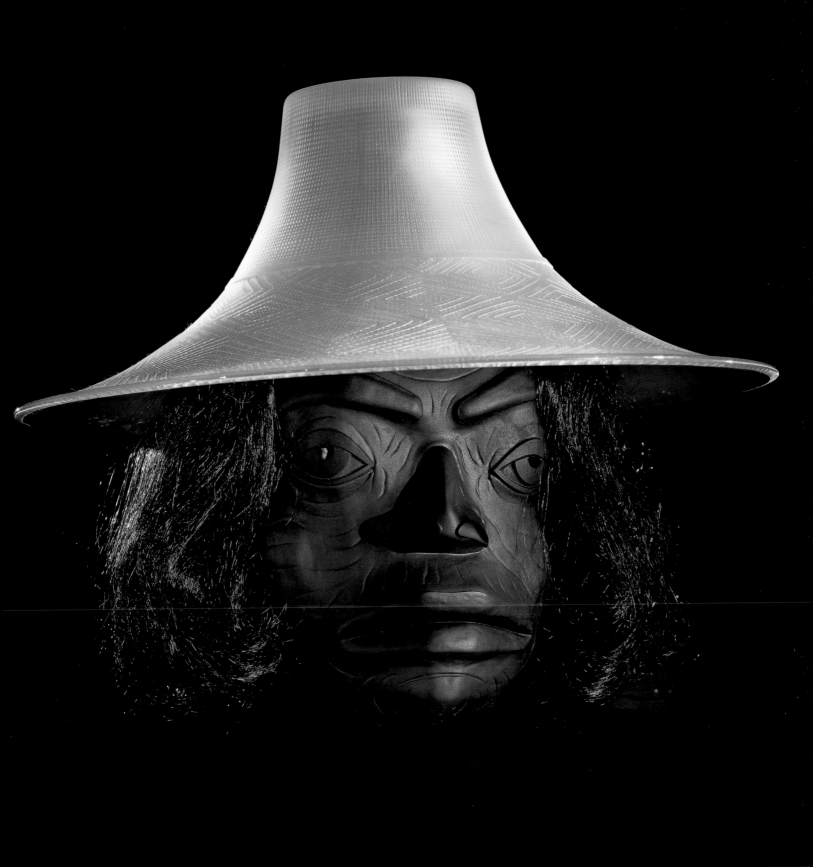

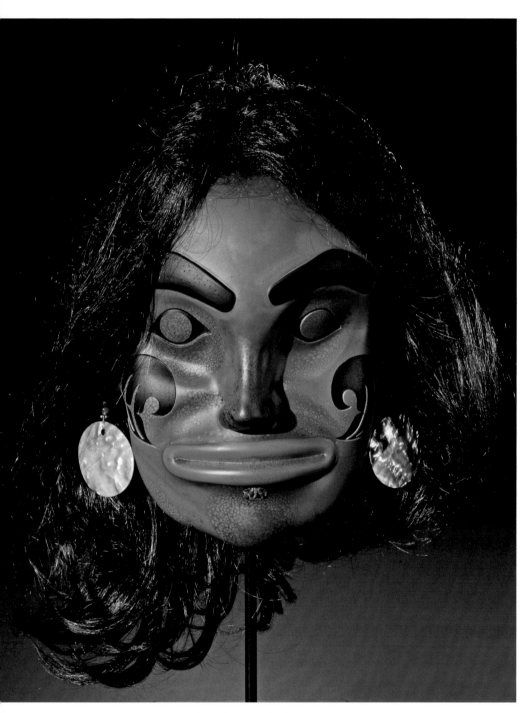

cat. 30 *Chieftain's Daughter* (Kéet Shagóon Sée), 2006

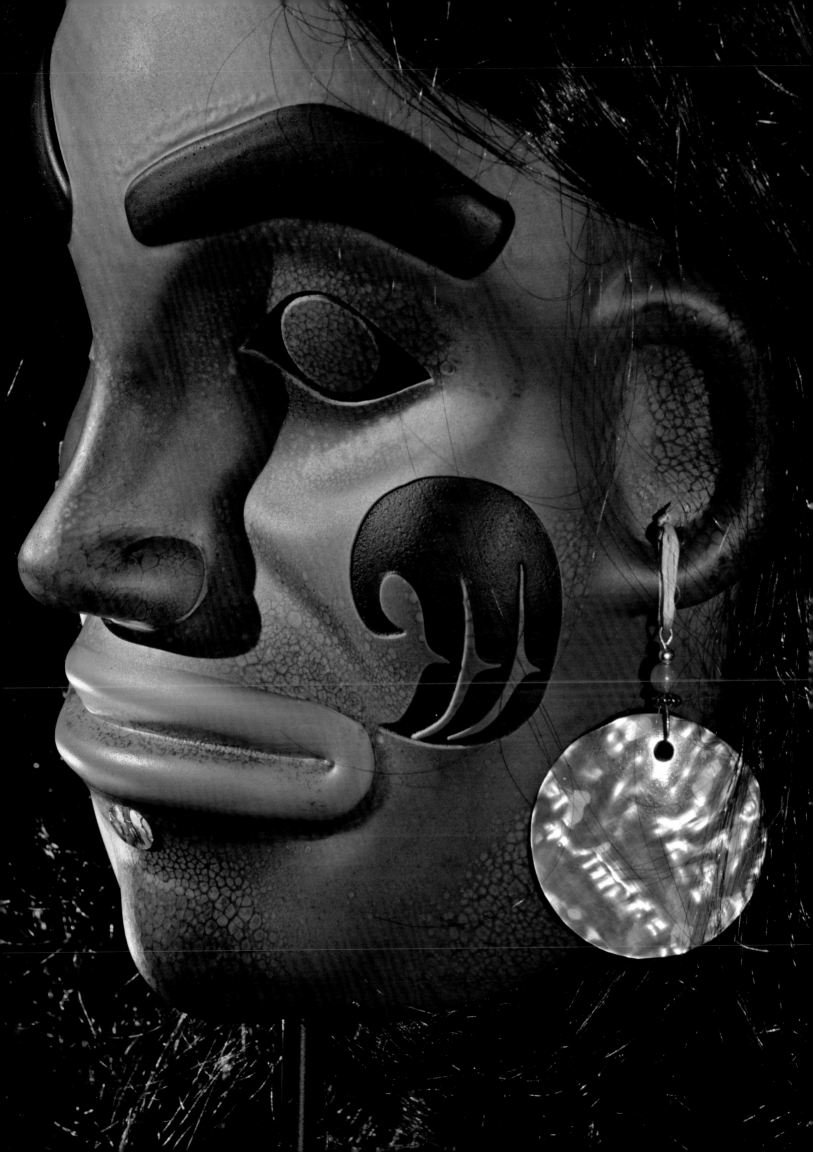

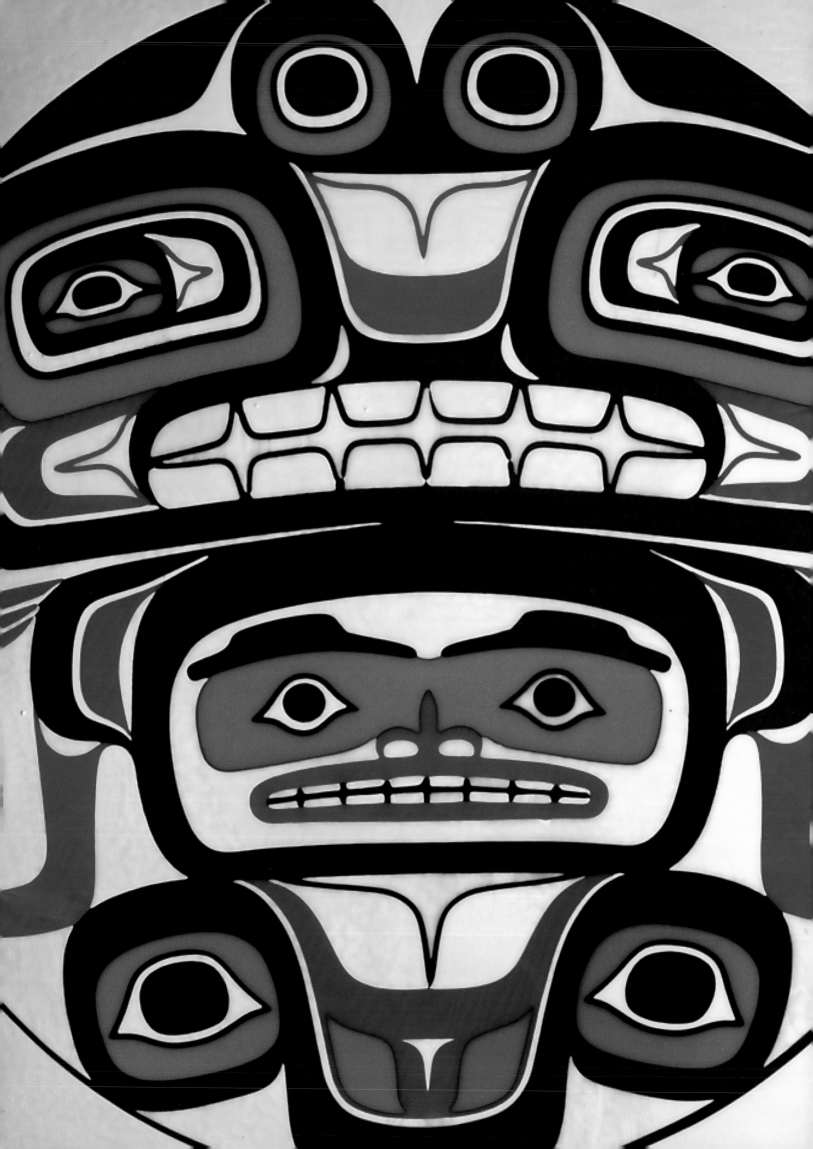

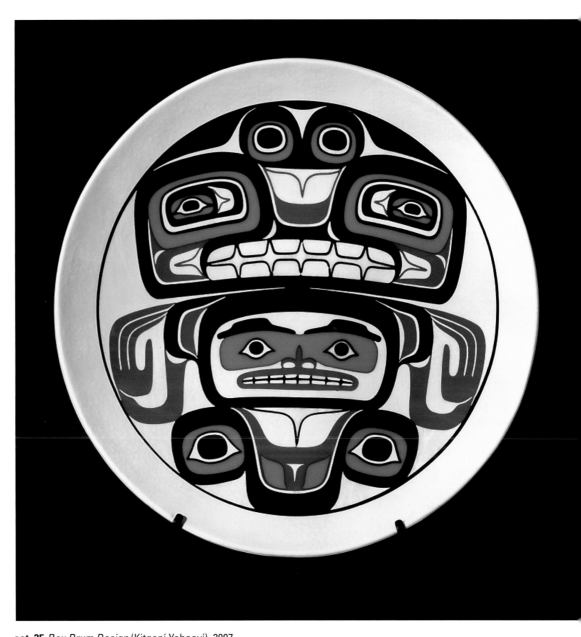

cat. 35 *Box Drum Design* (Kitganí Yahaayí), 2007

cat. 38 *Tlingit Crest Hat* (S'áaxw), 2007 (front and back)

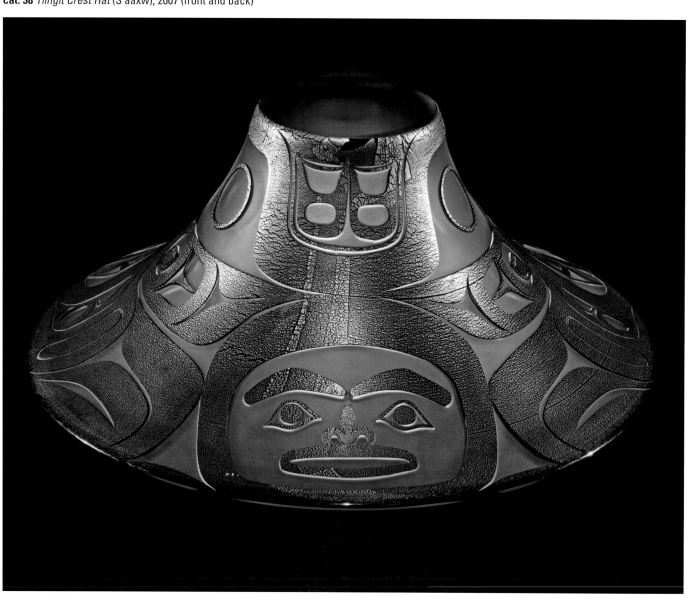

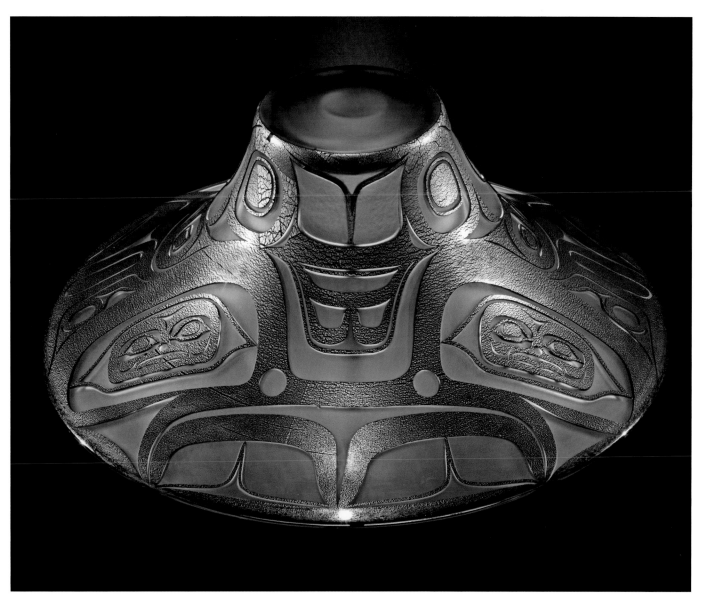

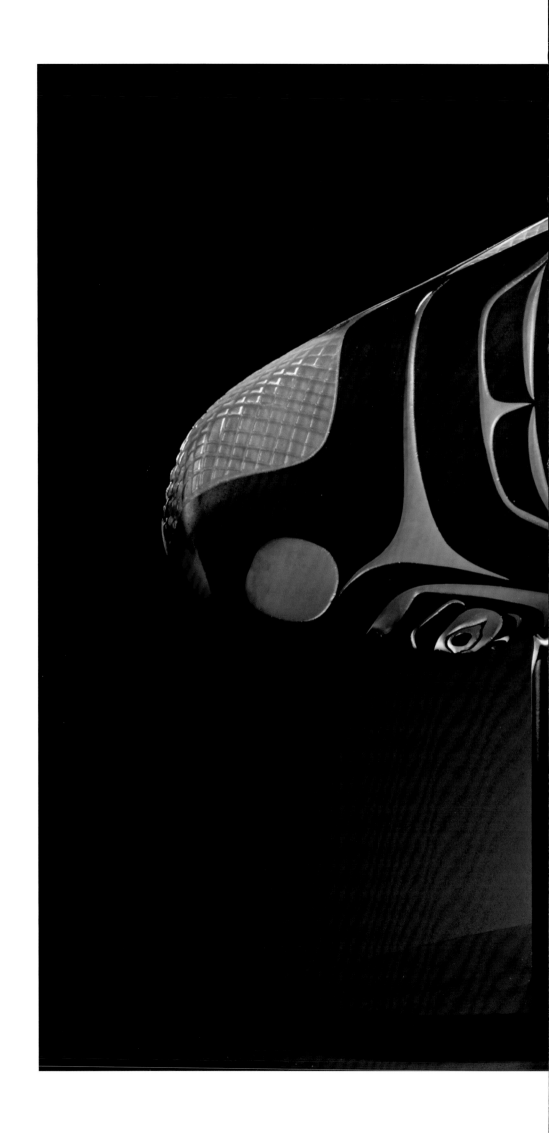

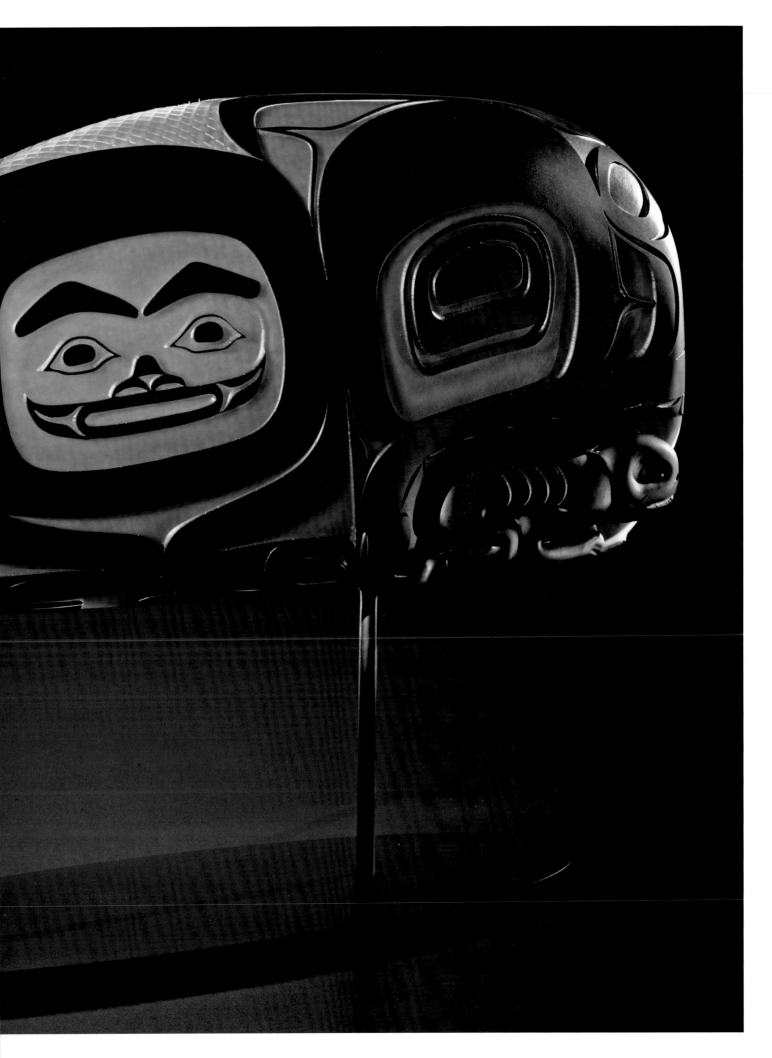

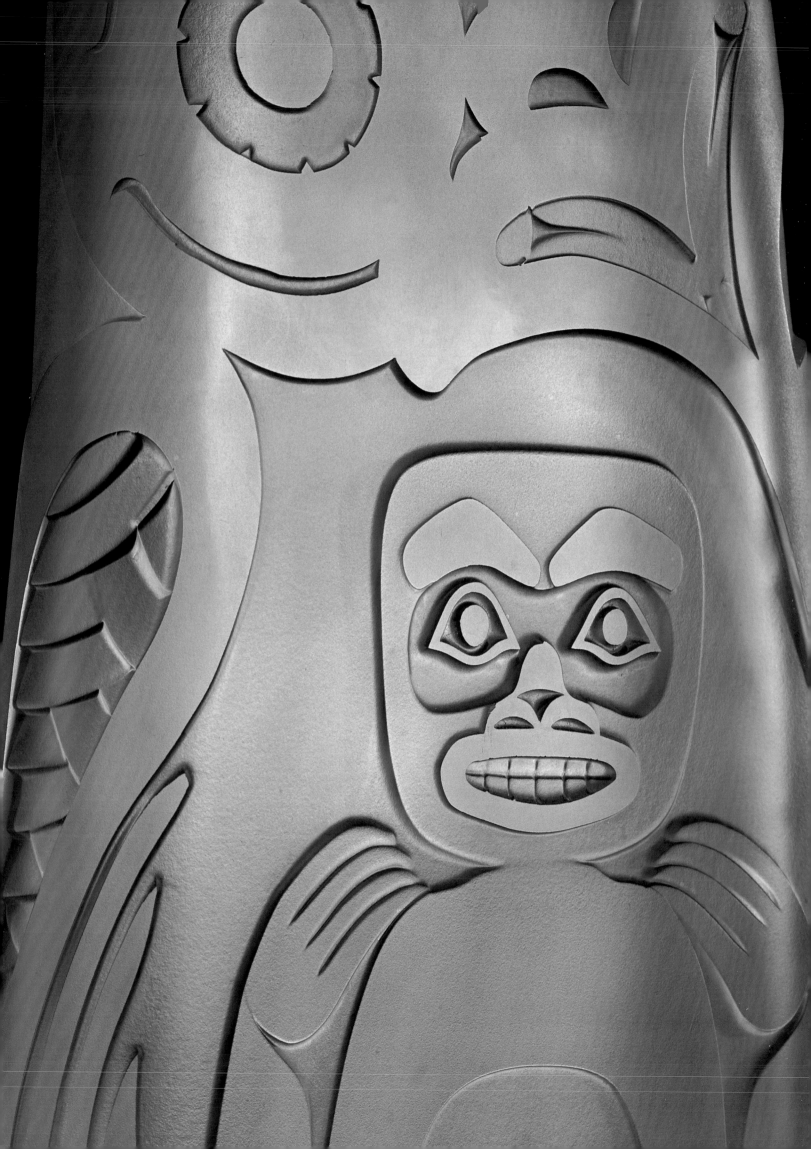

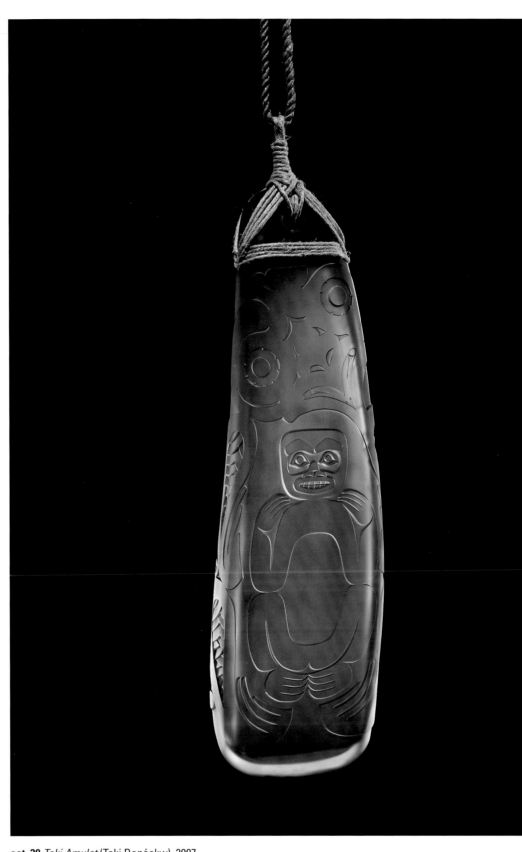

cat. 39 *Toki Amulet* (Toki Danáakw), 2007

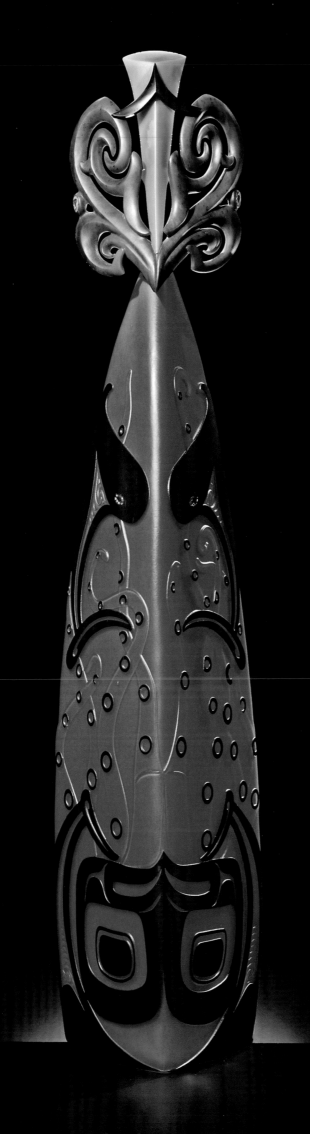

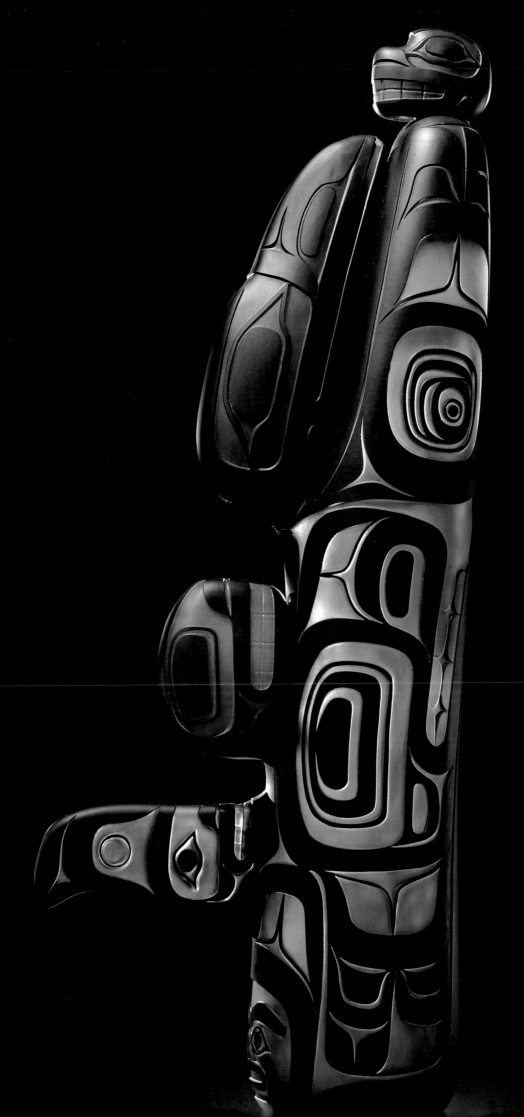

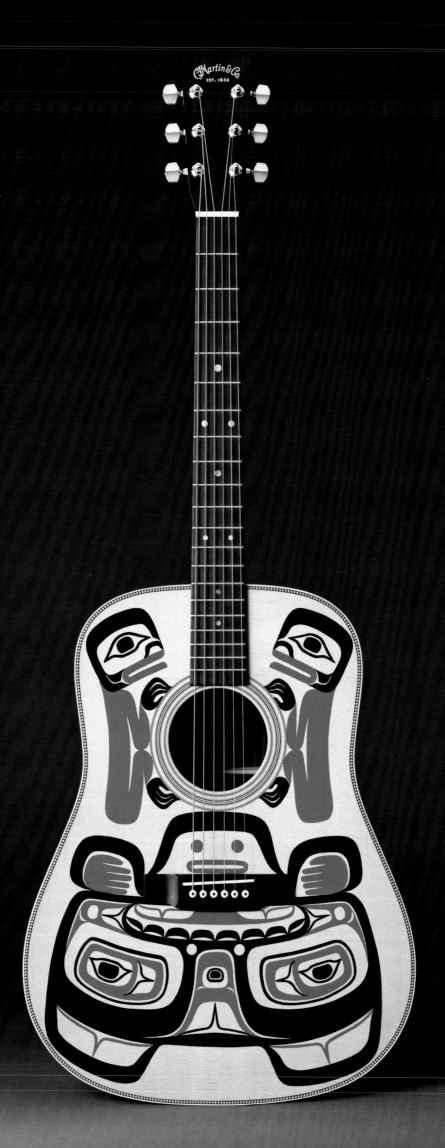

cat. 52 Martin Guitar design (Gil'jaa Kóo<u>k</u> Yahaayí), 2008

Opposite:
cat. 51 Customized Martin Guitar (Gil'jaa Kóo<u>k</u>), 2008

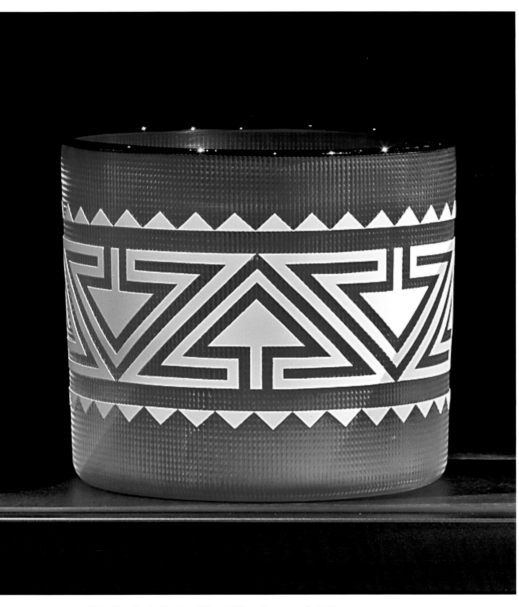

cat. 47 *Indian Curio Shelves* (Tlaagú Ḵágu Kayaashx'), 2008

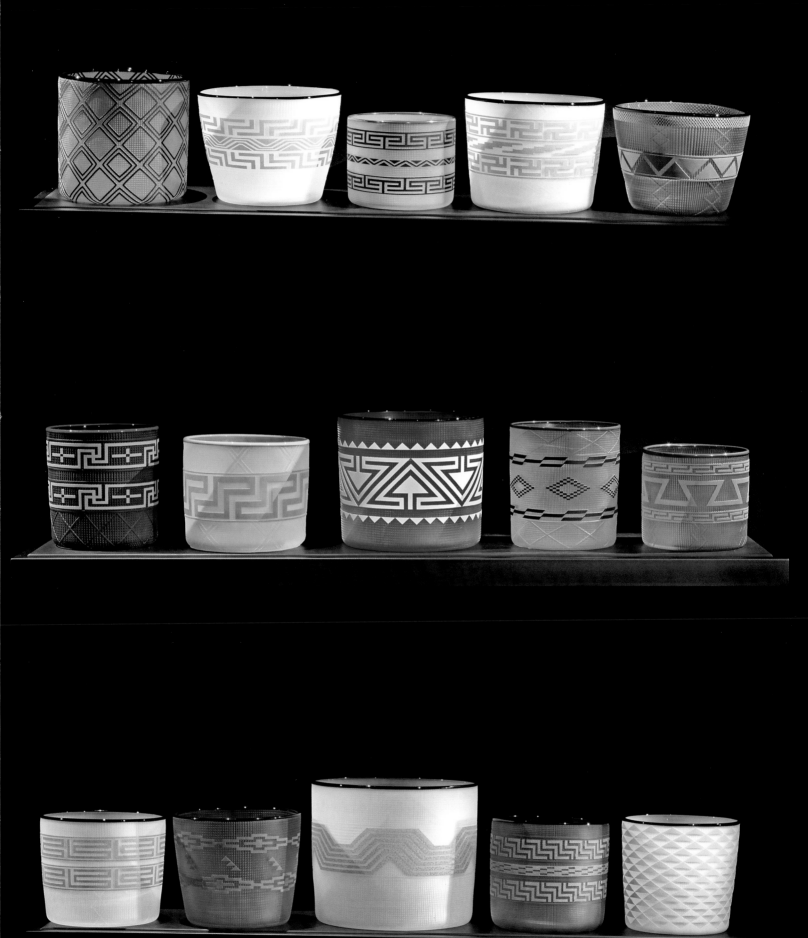

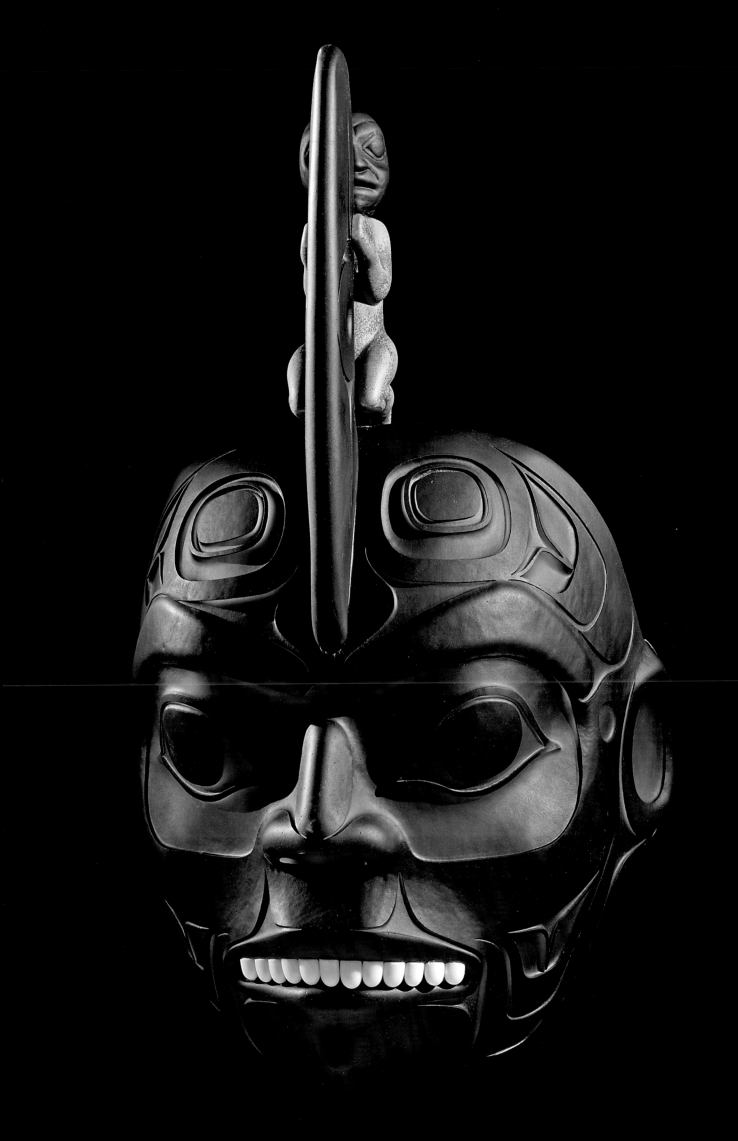

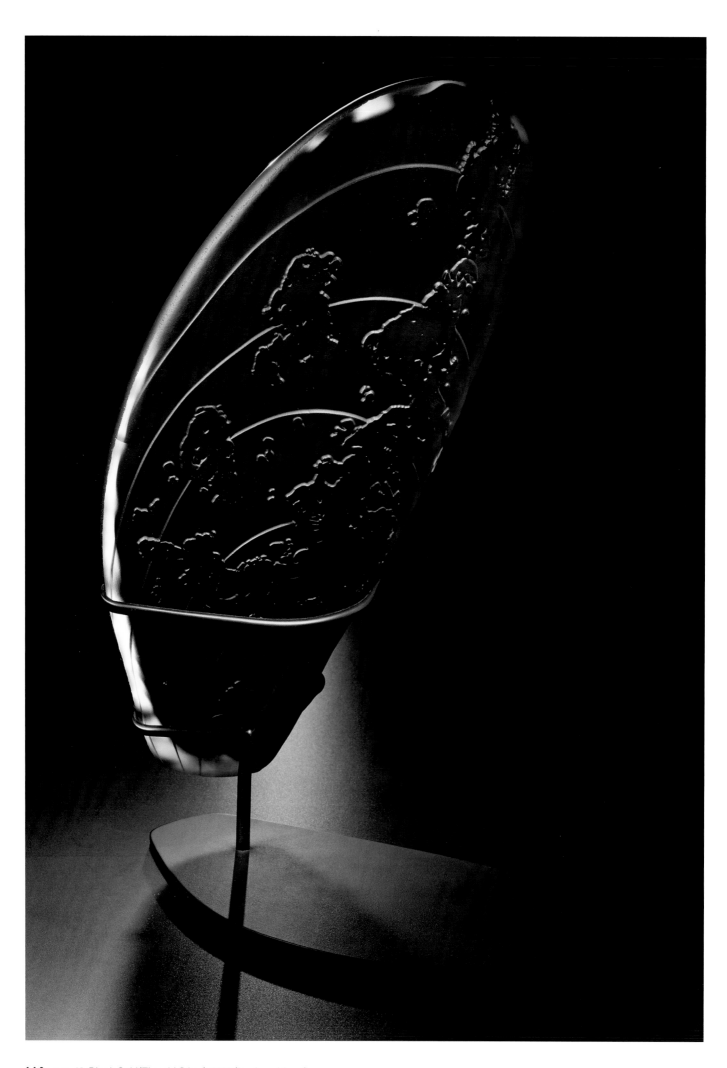

cat. 40 *Black Gold* (T'ooch' Góon), 2008 (back and front)

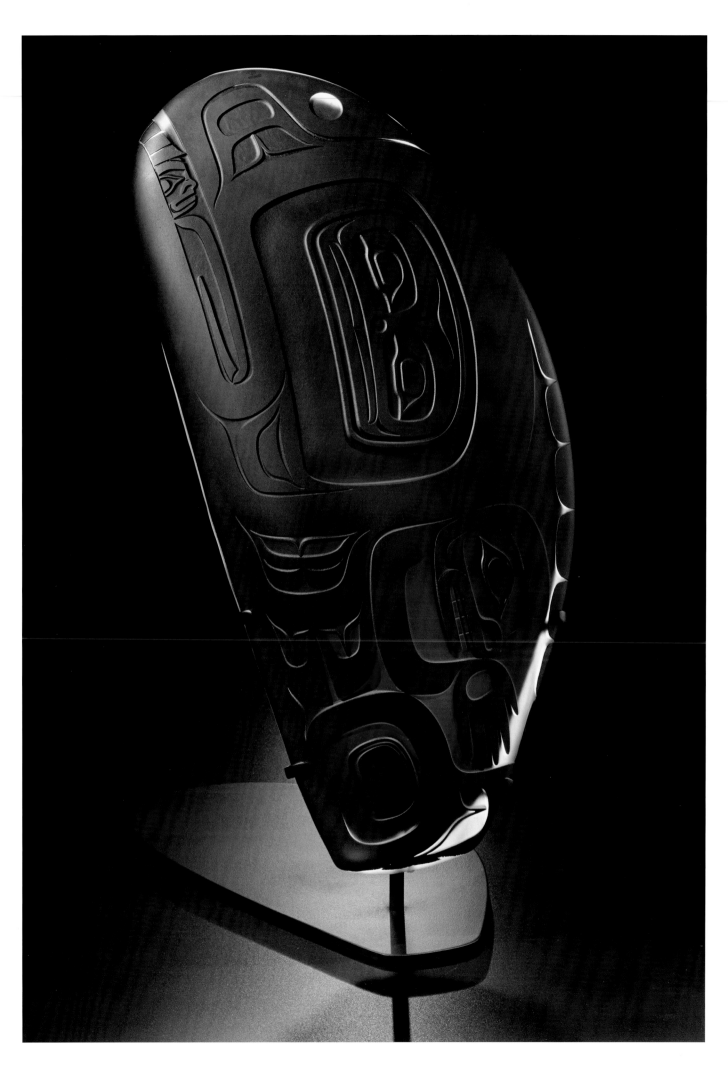

Next spread: **cat. 41** *Breaching Killer Whale* (Yaa Natán Kéet), 2008

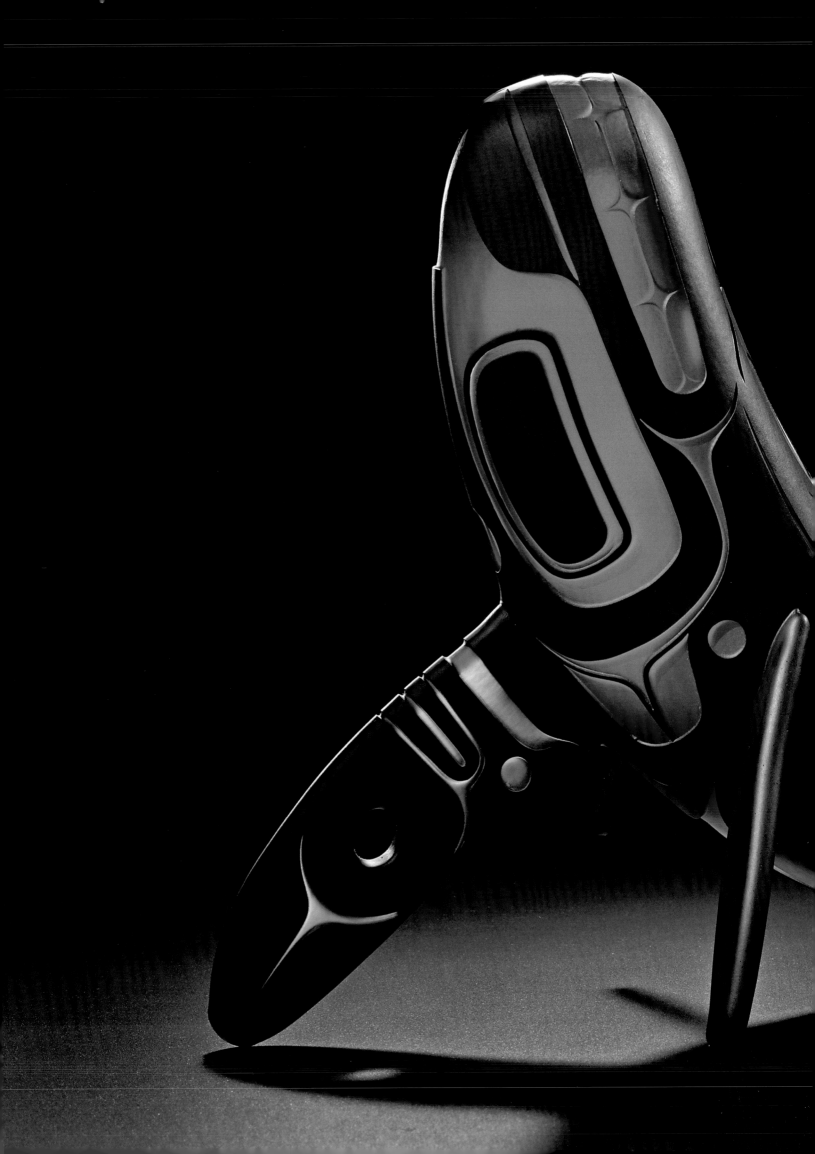

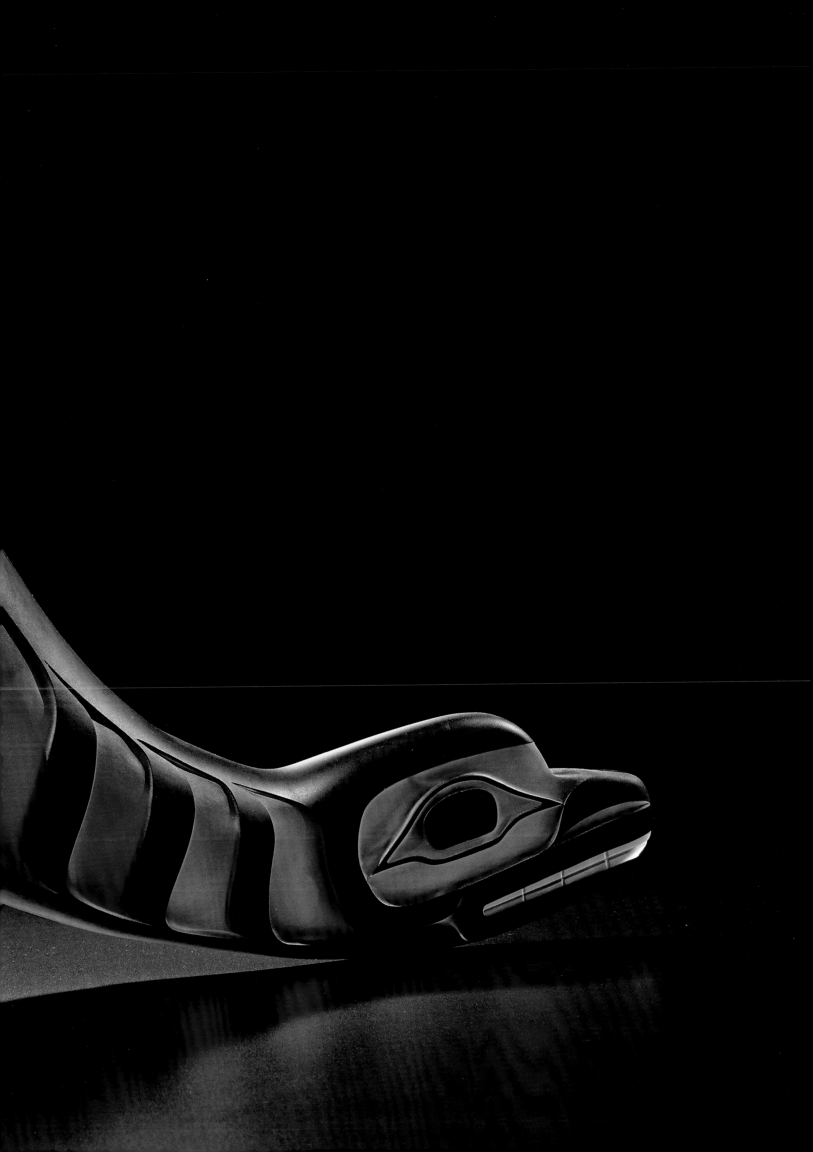

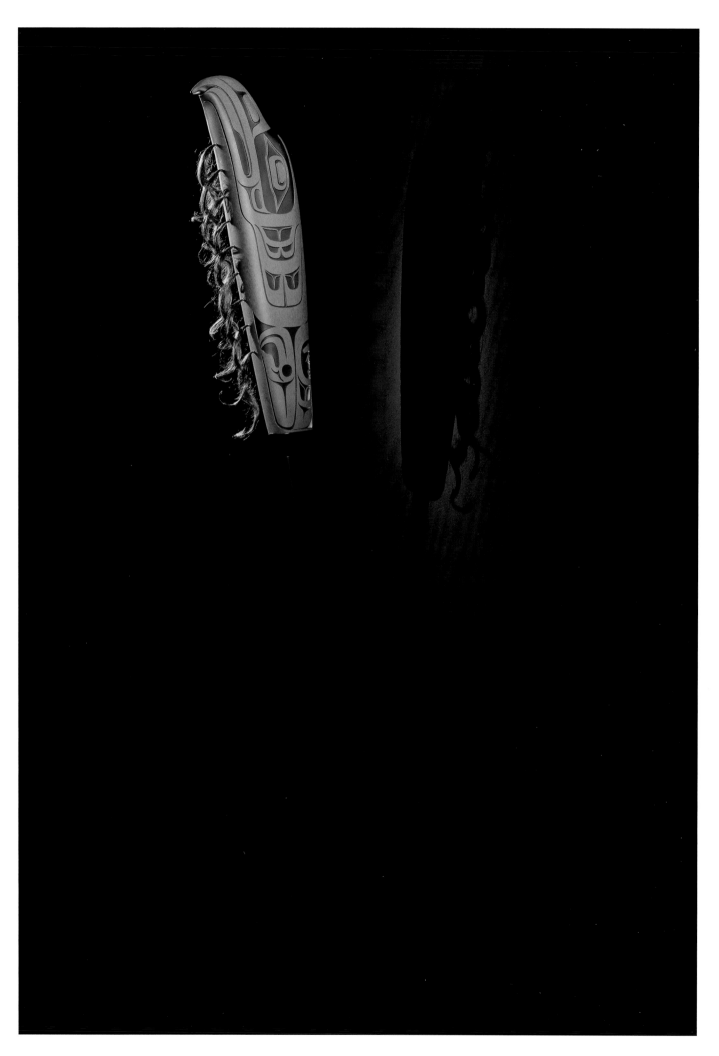

cat. 43 *Eagle Dance Staff* (Ch'áak Woos'aa G̲aa), 2008

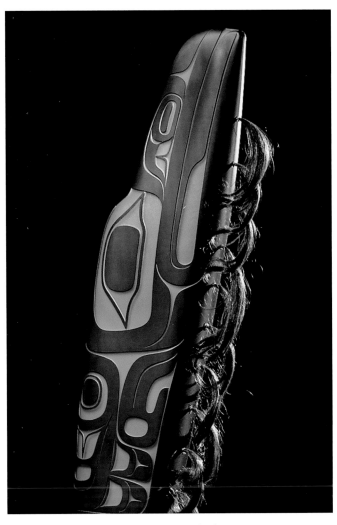

cat. 44 *Raven Dance Staff* (Yéil Woos'aa G̲aa), 2008

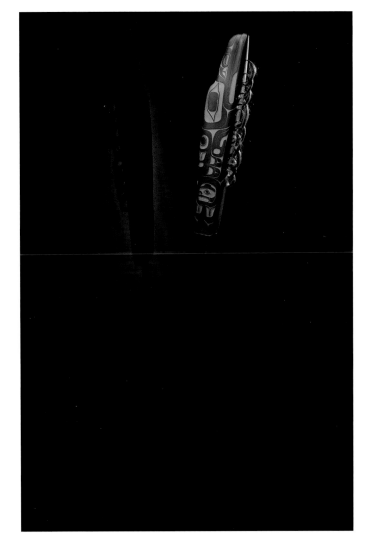

Opposite:
cat. 45 *Eagle/Raven* (Ch'áak'/Yéil), 2008

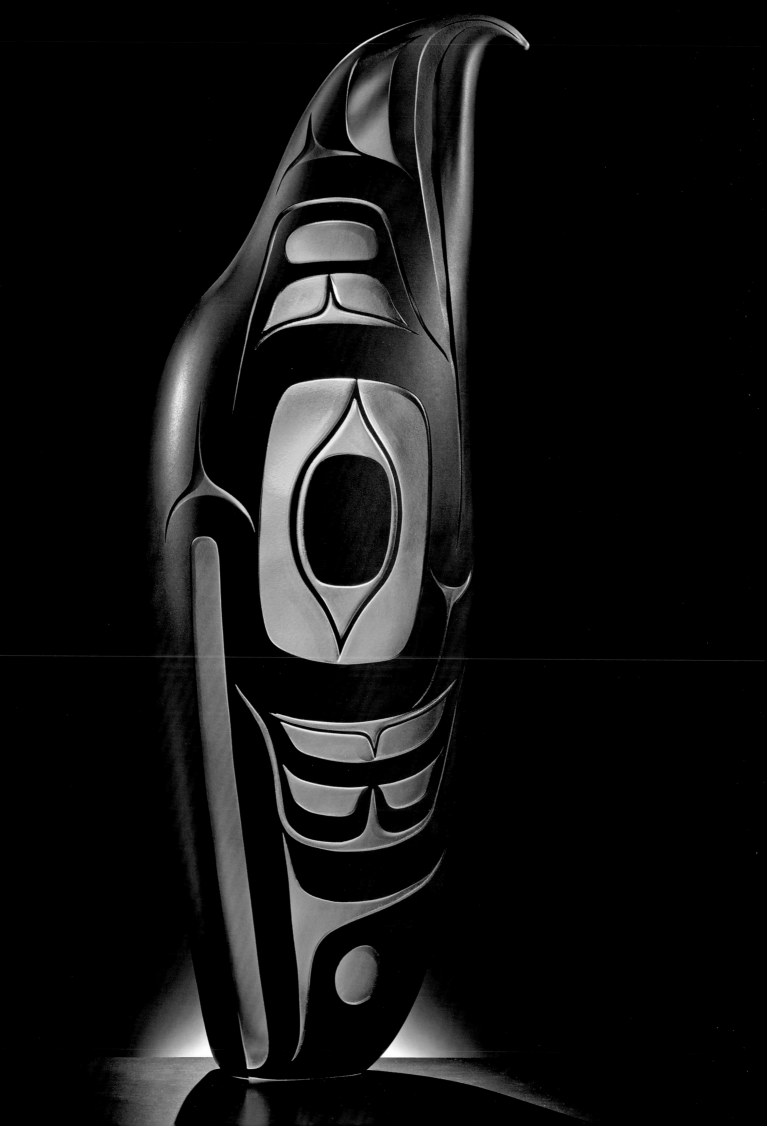

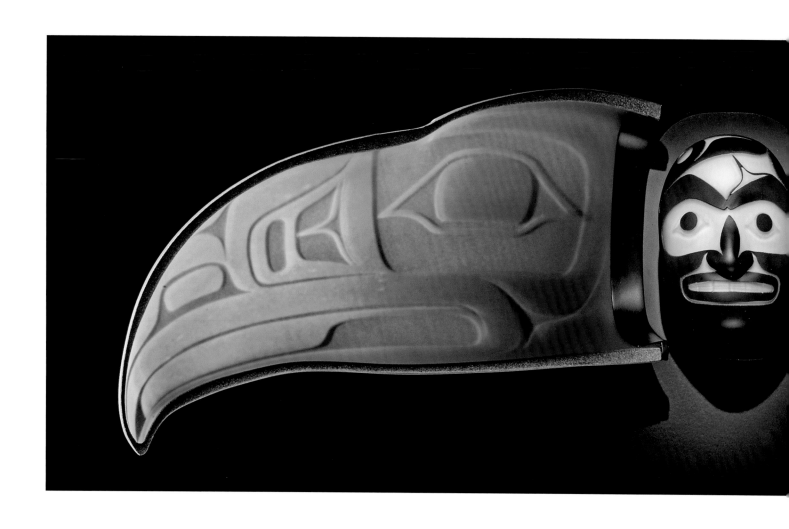

cat. 46 *Eagle Transformation Mask* (Ch'áak' La̱xkeit), 2008
(open and closed)

Next spread:
cat. 50 *Raven Steals the Sun* (G̱agaan Awutáawu Yéil), 2008

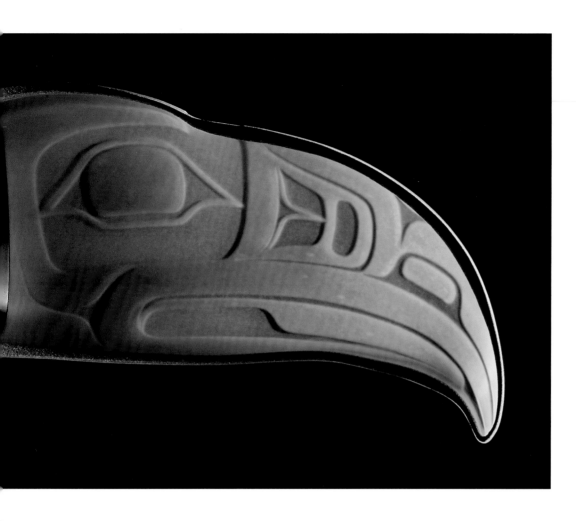

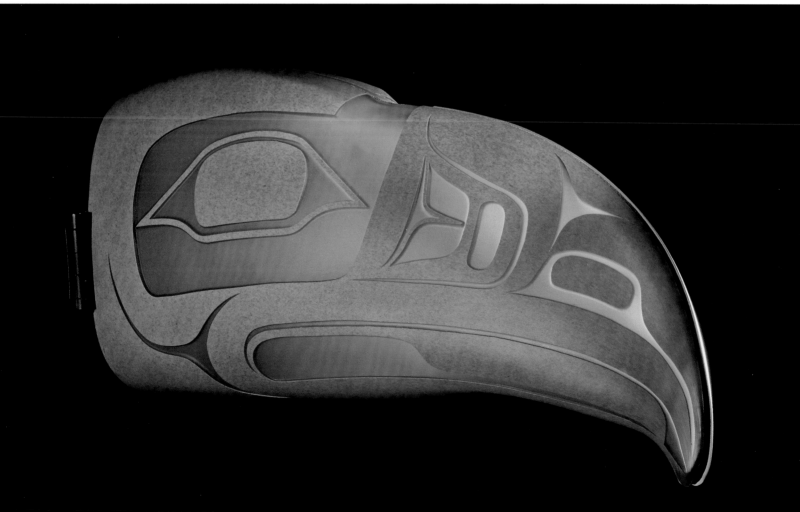

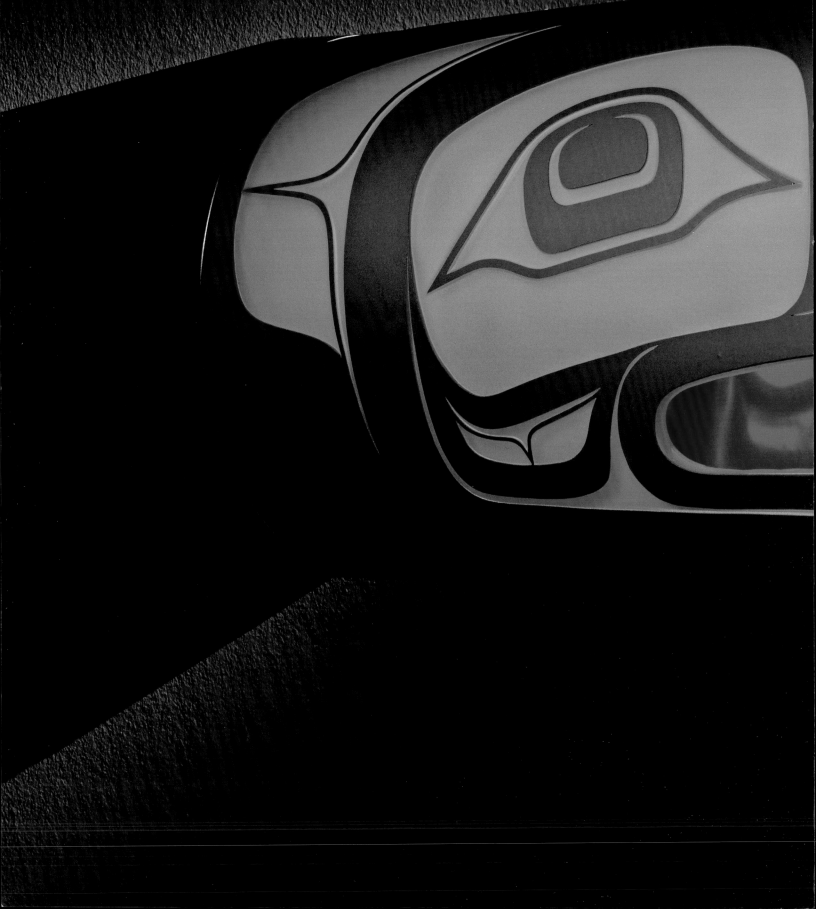

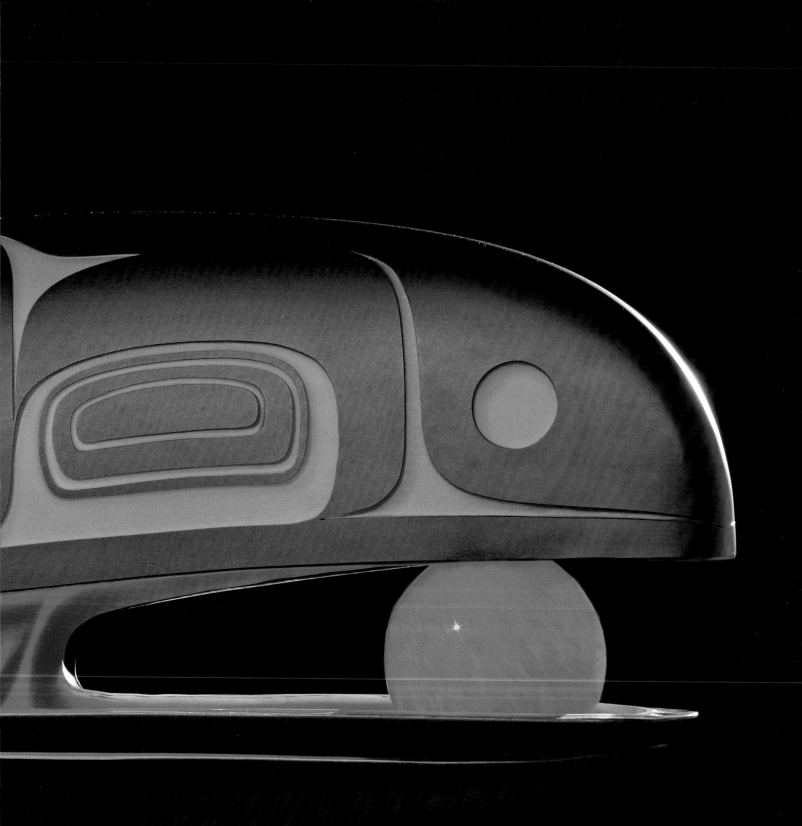

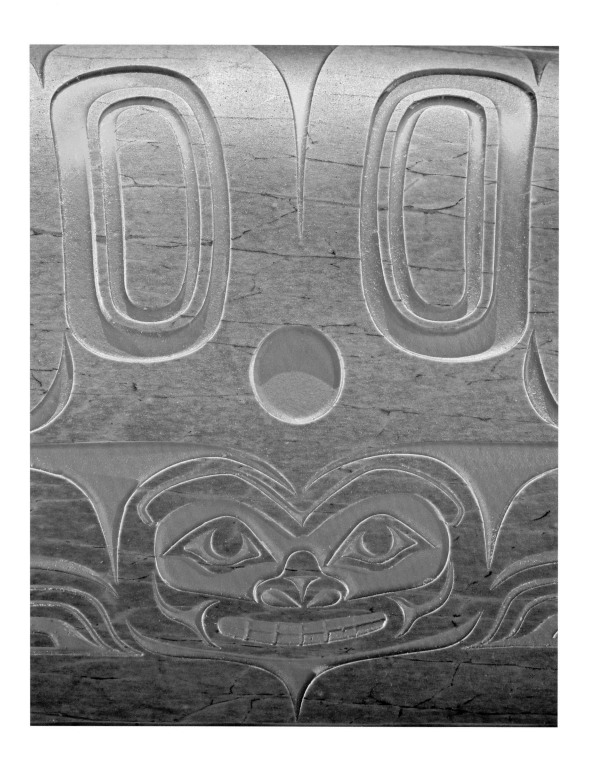

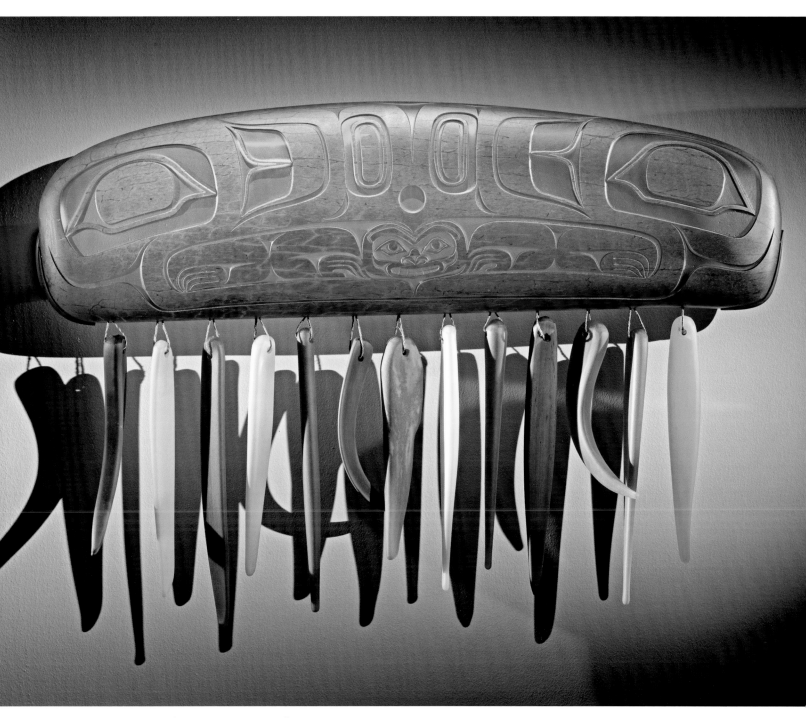

cat. 53 *Threshold Amulet* (X̠'awool Yéigi Danáakw), 2008

Opposite:
cat. 54 *Woodworm Amulet* (Aas Tutl'úk'x̱u Danáakw), 2008

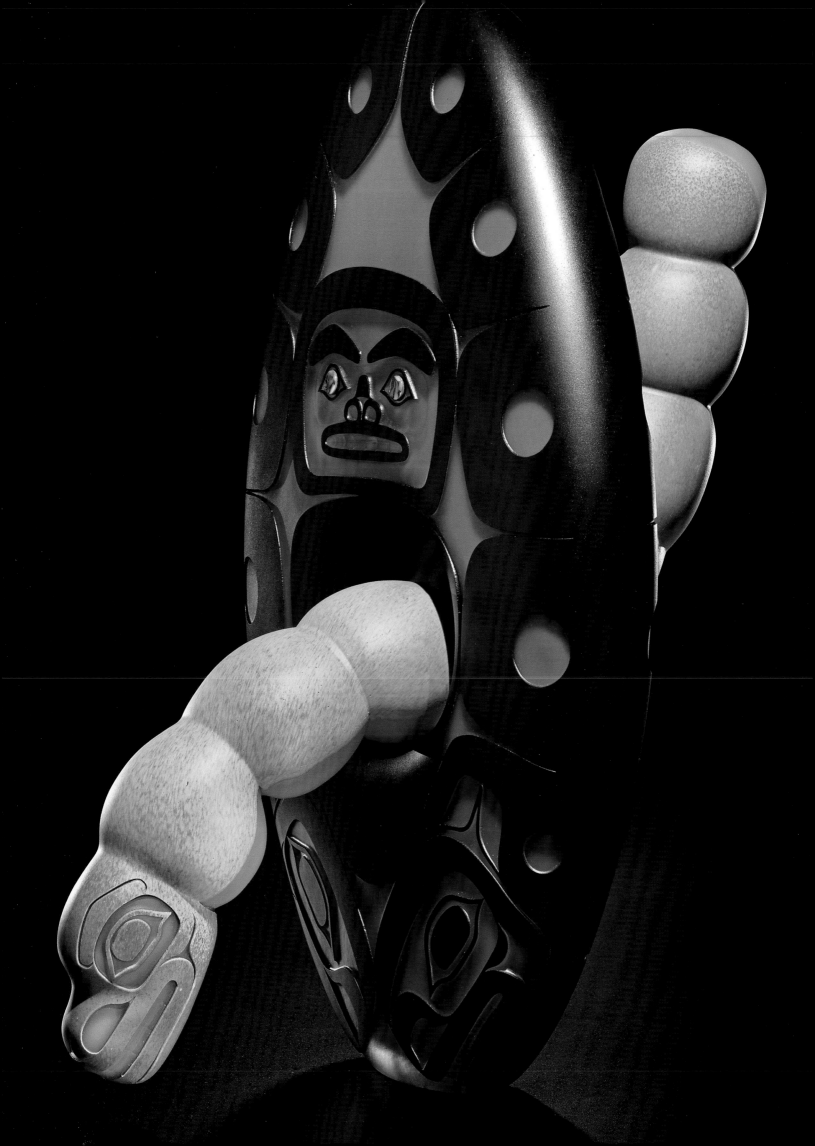

Drawings for *Clan House* (Naakahídi Yahaayí), 2008

Next six pages:
cat. 42 *Clan House* (Naakahídi), 2008

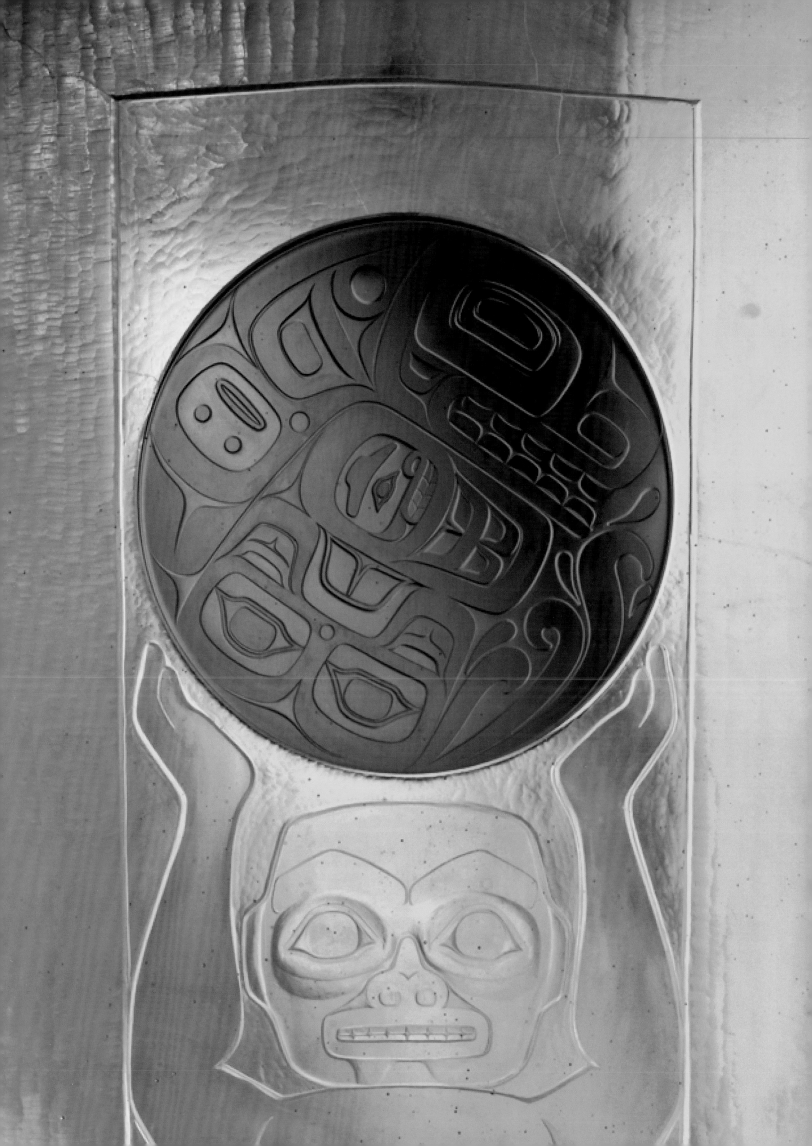

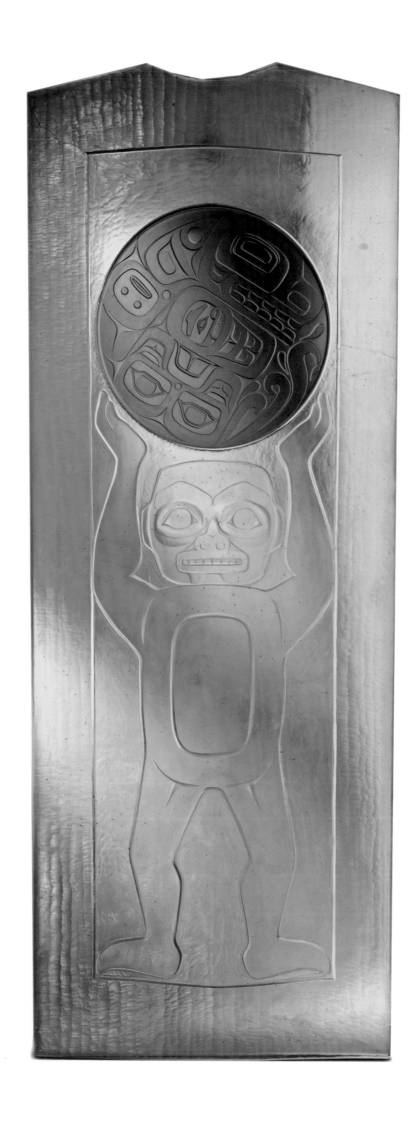

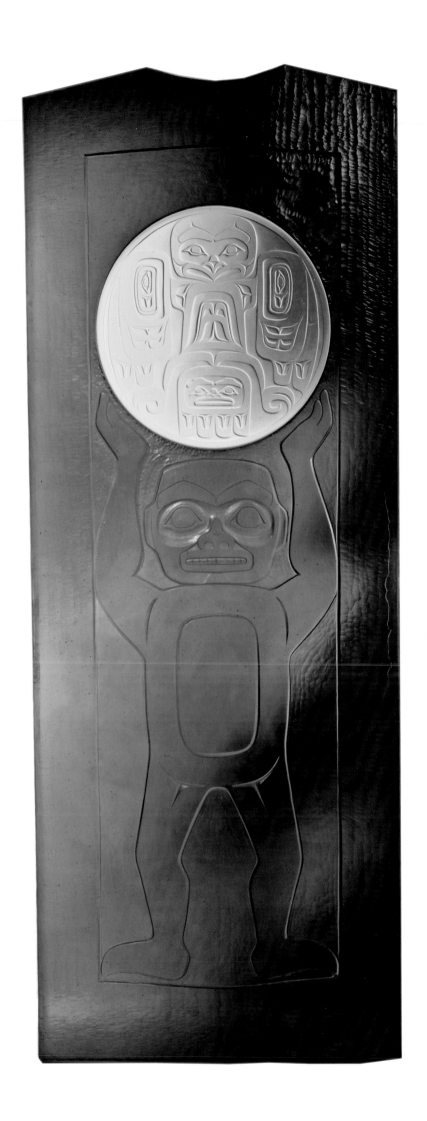

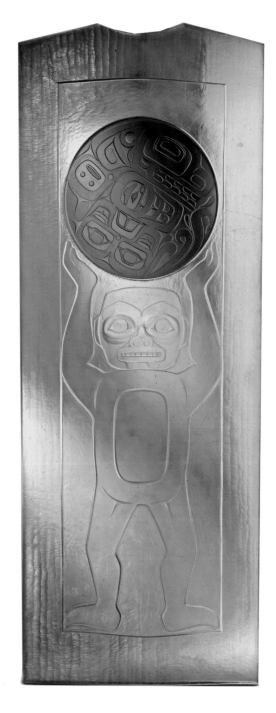

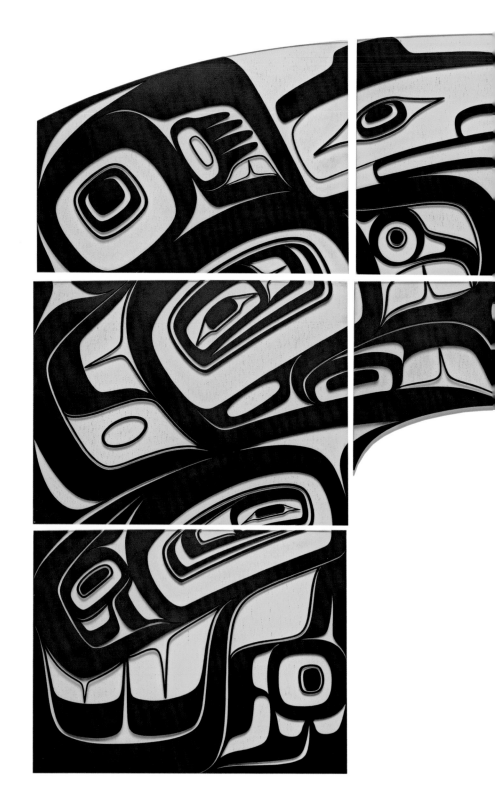

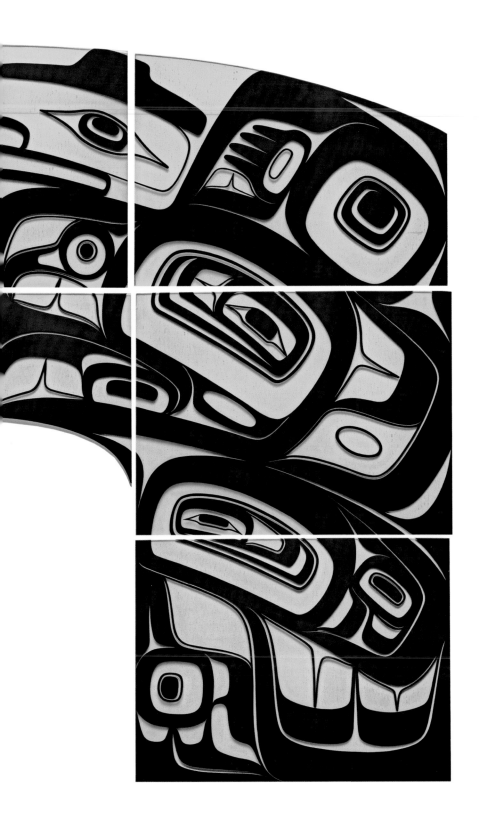

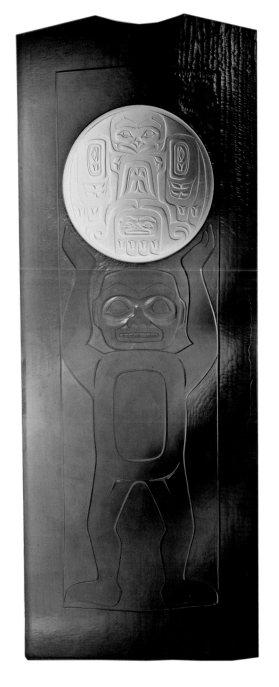

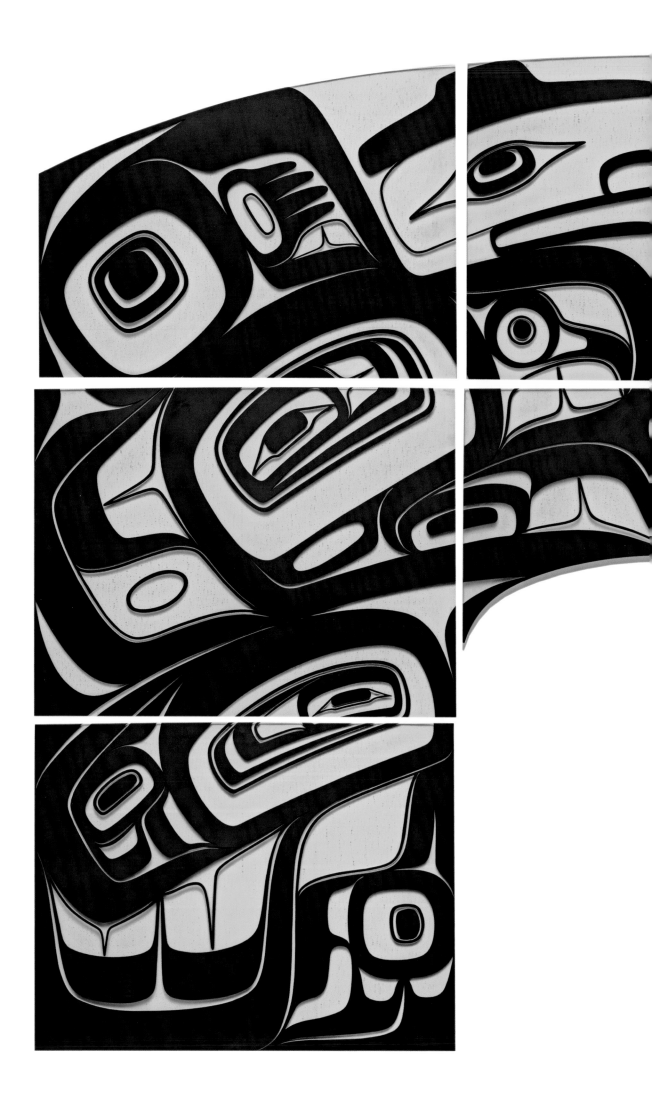

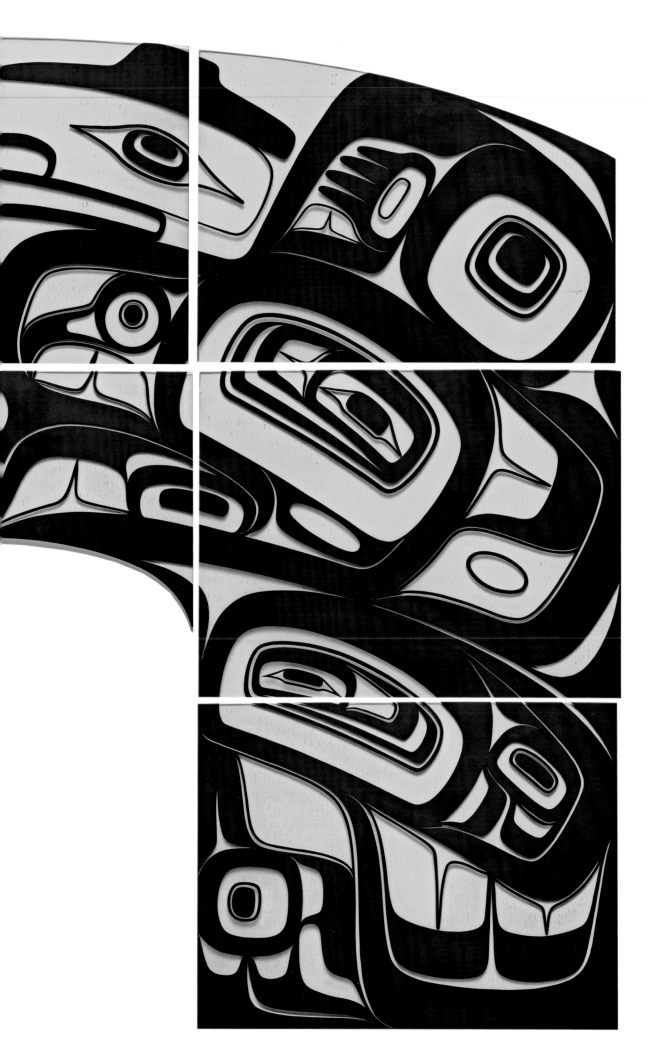

BIOGRAPHY

Born 1963, San Francisco, CA
Resides Seattle, WA

Education/Training

1984–99 Pilchuck Glass School, Stanwood, WA
Studied with Lino Tagliapietra, Checco Ongaro, Benjamin Moore, Dorit Brand, Judy Hill, Dan Dailey, and Pino Signoretto

Artist assistant to Benjamin Moore, Richard Royal, Dale Chihuly, Dan Dailey, Fritz Dreisbach, Dante Marioni, Lino Tagliapietra, Timo Sarpaneva, Stanislav Libenský, Sonja Blomdahl and Ann Wåhlstrom

1988–90 Gaffer, Pilchuck Glass School, Stanwood, WA
Glass Blower, Glass Eye Studio, Seattle, WA

Select Museum Exhibitions

2009 *Preston Singletary: Echoes, Fire, and Shadows.* A traveling exhibition through 2012 organized by the Museum of Glass, Tacoma, WA

2008 *Living Legacies: Homage to a Maestro*, Museum of Glass, Tacoma, WA

2004 *Our Universes,* National Museum of the American Indian, Washington, DC
Hybrid Harvest: Contemporary Native American Arts, Visual Arts Center, University of California, Fullerton, CA

2003 *Threshold*, solo exhibition, Seattle Art Museum, Seattle, WA

2002 *Changing Hands: Art without Reservation 2.* A traveling exhibition through 2008 organized by the Museum of Arts & Design, New York, NY

Fusing Traditions, Transformations in Glass by Native American Artists. A traveling exhibition through 2005 organized by the Museum of Craft and Folk Art, San Francisco, CA

Art & At.oow! Sealaska Juried Art Show, Alaska State Museum, Juneau, AK

2001 *Lino Tagliapietra e Amici*, Fuller Museum, Brockton, MA

2000 *Traditions in Glass*, Sheldon Museum, Haines, AK
Millennium Glass: An International Survey of Studio Glass, Kentucky Art and Craft Gallery, Louisville, KY

1998 *Head, Heart and Hands: Native American Craft Traditions in a Contemporary World.* A traveling exhibition organized by the Kentucky Art and Craft Gallery, Louisville, KY

Gallery Exhibitions

Solo Exhibitions, Traver Gallery

2008 *Ancients Emerged from the Fire*, Tacoma, WA
2007 *The Uncle Who Walked into the Forest*, Tacoma, WA
2005 *From the Fire Pit of the Canoe People*, Seattle, WA
2004 *Effigy*, Tacoma, WA
2002 *Vision Quest*, Seattle, WA

141 Preston Singletary, and his son, Orlo, 2004

Other Solo Exhibitions

2006 *Raven Steals the Light*, Heller Gallery, New York, NY
2001 *Glass Potlatch*, Chappell Gallery, New York, NY
1999 *Current Work*, Gallery San Nicolo, Venice, Italy
 One Man Show, Butters Gallery, Portland, OR
1997 *NW Coast Images in Glass*, Vetri International Glass, Seattle, WA
1991– The Glass Gallery, and West End Gallery, Bethesda, MD
1997

Group Exhibitions

2007 *Fire & Water*, Collaboration with Lewis Gardiner,
 Spirit Wrestler Gallery, Vancouver, BC
2006 *Manawa Pacific Heartbeat, a Celebrating of Contemporary Maori and
 Northwest Coast Art,* Spirit Wrestler Gallery, Vancouver, BC
 Visions in Glass, Blue Rain Gallery, Taos, NM
2005 *nDn Art*, Santa Fe Art Institute, Santa Fe, NM
2004 *Vetri: Nel Mondo, Oggi,* Istituto Veneto di Scienze Lettere ed Arti, Venice, Italy
 Cultural Edge: Contemporary Views of Native Artists,
 Lower Columbia College, Longview, WA
1998 *Premonitions*, Spirit Wrestler Gallery, Vancouver, BC
1997 *Four in Glass*, FOVA Gallery, Texas Tech, Lubbock, TX
1994 *Six Glass Artists*, Gallery Glass 1, Stockholm, Sweden
1992 *New Visions*, The Visual Arts Center of Alaska, Anchorage, AK
1989 International Glass Trade Show, Tokyo, Japan

Select Awards and Grants

2004 1st place, Contemporary Art, Sealaska Heritage Foundation, Celebration 2004,
 Juneau, AK
2003 18th Annual Rakow Commission, Corning Museum of Glass, Corning, NY
2002 Seattle Arts Commission, Purchase Award
2000 Mayor's Award, Indian Art Northwest, Portland, OR
1998 1st place, Diversified Arts, Best of Division, Indian Art Northwest, Portland, OR
1985 Work study grant, The Institute of Alaska Native Arts, Pilchuck Glass School

Select Collections

Alaska Museum of Natural History, Anchorage, AK
Brooklyn Museum, Brooklyn, NY
Corning Museum of Glass, Corning, NY
Etnografiska Museet, Stockholm, Sweden
Handelsbanken, Stockholm, Sweden
Heard Museum of Native Cultures and Art, Phoenix, AZ
Mint Museum of Craft + Design, Charlotte, NC
Museum of Arts & Design, New York, NY
Museum of Fine Arts, Boston, MA
National Museum of the American Indian, Smithsonian Institution, Washington, DC
Seattle Art Museum, Seattle, WA
St. Paul's Cathedral, Oklahoma City, OK
Washington State Arts Commission, Olympia, WA

SELECTED BIBLIOGRAPHY

Blue Rain Gallery. *Preston Singletary*. Taos, NM: Blue Rain Gallery, 2005.

———. *Tammy Garcia : Visions in Glass : A Collaboration with Preston Singletary*. Exhibition catalog. edited by Will Palmer. Santa Fe, NM: Blue Rain Gallery, 2005.

Brown, Glen. "Reviews: Four in Glass." *New Art Examiner*, March 1998, 62–63.

Brown, Steven C. *Native Visions: Evolution in Northwest Coast Art from the Eighteenth through the Twentieth Century*. Seattle: Seattle Art Museum, 1998.

———. *The Spirit Within: Northwest Coast Native Art from the John H. Hauberg Collection*. Seattle: Seattle Art Museum, 1995.

Chandonnet, Ann."Tradition and Experiment Fuse." *Anchorage Daily News*, June 13, 2002, D6.

Echoes, Fire, and Shadows. DVD. Directed by Todd Pottinger. Tacoma, WA: Museum of Glass, 2009.

Falk, Lars. "The Jet City." Gant Fall and Winter Catalogue, 2001.

Friederich, Steven. "SAM Merges Native Art from Past with Modern Styles." *The Daily of the University of Washington*, May 29, 2003, 7.

Fusing Traditions: Transformations in Glass by Native American Artists. edited by Carolyn Kastner. Exhibition catalog. San Francisco: Museum of Craft & Folk Art, 2002.

Ganglehoff, Bonnie. "Artist Profile." *Southwest Art*, August 1999.

Gault, Ramona. *Indian Artist Magazine*, Winter 1997.

Gurt, Carl Johan. "Preston Singletary, Tlingit." *Fjärde Världen*, January 2003, 5–11.

Hackett, Regina. "In the Galleries." *Seattle Post-Intelligencer*, March 7, 2002, D1.

Harjo, Susan Shown. "Native American Sculptor Heroes." *Sculpture Review*, Spring 2007, 22–25.

Herem, Barry. "A Seattle Collection." *Native Peoples*, July/August 2003, 64–66.

Hice, Michael. "Reviews: Tony Jojola, Preston Singletary and C. S. Tarpley." *Glass*, Summer 2000, 52.

Hinds, Geff. "Native and European Traditions Meet." *Native Peoples*, Spring 1999.

Holm, Bill. *Northwest Coast Indian Art: An Analysis of Form 1*. Thomas Burke Memorial Washington State Museum Monograph. Seattle: University of Washington Press, 1965.

Indyke, Dottie. "Preston Singletary." *Southwest Art Magazine,* 33, pt. 1 (June 2003): 32–34.

Jonaitus, Aldona. *Art of the Northwest Coast*. Seattle: University of Washington Press, 2006.

Kangas, Matthew. "Four in Glass: Carl Hasse, Masami Koda, Asa Sandlund, Preston Singletary." Lubbock, TX: FOVA Galleries, Texas-Tech University, 1997.

———. "Vision Quest." *Glass Magazine*, June 2004.

Kastner, Carolyn, and Rosalyn Tunis. "Fusing Traditions: Transformations in Glass by Native American Artists." *American Indian Art Magazine*, 28, no. 2, (Spring 2003): 56–63.

King, Gail. "Tackling Tradition with Style and Wit." *Wall Street Journal*, September 4, 1998.

LeDuff, Charlie. "Native Art You Won't See in the Casinos." *New York Times*, September 19, 1999.

Lerner, Jonathan. "City of Glass: There's Art as Well as Craft in Seattle," *Sky*, February 2005, 36–45.

Lynn, Martha Drexler. *Sculpture, Glass and American Museums*. Philadelphia: University of Pennsylvania Press, 2005.

Matuz, Roger, ed. *St. James Guide to Native North American Artists*. Detroit: St. James Press, 1998.

McFadden, David. *Changing Hands: Art without Reservation 2: Contemporary Native Art from the West, Northwest and Pacific*. Exhibition catalog. New York: Museum of Arts and Design, 2005.

"Metal Worker, Furniture Maker, Glass Artist." *Modern Masters*. Home & Garden Television, January 25, 2001.

Oldknow, Tina. "Preston Singletary Receives Rakow Commission." *Journal of Glass Studies*, 45 (2003): 194–96.

———. "Notes." *New Glass Review*, no. 25 (2004): 77–79.

Padernacht, Sandra. "Glass Act— Visions of the West." *Cowboys and Indians*, January 2007, 92–93.

"Portfolio." *Glasswork*, no. 7 (December 1990): 28–32.

"Preston Singletary Presents *Never Twice the Same (Tlingit Storage Box)*." *The Gather* (Corning Museum of Glass), Winter/Spring 2004, 4.

Reading, Nigel, and Gary Wyatt. *Manawa—Pacific Heartbeat: A Celebration of Contemporary Maori and Northwest Coast Art*. Seattle: University of Washington Press, 2006.

Ruhling, Nancy A. "Glass Acts." *Art & Antiques*, May 2004, 43–49.

Singletary, Preston. "Demonstrations: Glassblowing." *Glass Art Society Journal*, 1999, 95.

———. "Indian-uity: Glass Symbols of Cultural Knowledge." *The Glass Art Society Journal*, 2003, 40–43.

———. "From the Fire Pit of the Canoe People." *Fusing Traditions, Transformations in Glass by Native American Artists*, ed. Carolyn Kastner. Exhibition catalog. San Francisco: Museum of Craft and Folk Art, 2002.

Spirit Wrestler Gallery. *Fire & Water: Pacific Visions in Glass and Jade / Preston Singletary, Lewis Gardiner*. Exhibition catalog. Vancouver, BC: Spirit Wrestler Gallery, 2007.

Updike, Robin. "A Place to Reflect." *Seattle Times*, March 30, 1997.

Villani, John Carlos. "Breaking into Glass." *Arizona Republic*, May 11, 2003, E1.

Wagonfeld, Judy. "The Perfect Couple: Native American Artifacts and Glass Art." *Seattle Post-Intelligencer*, June 6, 2003, 18.

Weiss, Dick. "The Glassblowers of the Pacific Northwest." *Glasswork Magazine* [Japan], no. 11 (1990).

———. "Glassblowers of the Pacific Northwest." *Glasswork*, no. 11 (March 1992): 20–27.

Wichert, Geoffrey. "Haus eines Clan: Preston Singletary bei William Traver, Seattle/Clan House: Preston Singletary at William Traver in Seattle." *Glashaus/Glasshouse*, no. 4 (2001): 6–7.

———. "Reviews: A New Generation— Preston Singletary, Paul Cunningham, and Janusz Pozniak." *Glass*, no. 64 (Fall 1996): 53.

Winton, Ben. "Creating: Preston Singletary—Native and European Traditions Meet in Preston Singletary's Tlingit Glass Designs." *Native Peoples* 12, no. 3 (Spring 1999): 44–48.

Worssam, Nancy. "Crossing the Threshold." *Queen Anne Magnolia News*, June 11, 2003, 14.

Wyatt, Gary. "Collector's Corner: Contemporary Directions in Northwest Coast Art." *Native Peoples* 12, no. 3 (Spring 1999): 18.

———. "Cross Cultural Fusion." *Native Peoples Magazine*, November 2001.

———. *Mythic Beings: Spirit Art of the Northwest Coast*. Seattle: University of Washington Press, 1999.

Yelle, Richard Wilfred. *International Glass Art*. Atglen, PA: Schiffer Publishing, 2003.

CHECKLIST

July 11, 2009–September 19, 2010
Organized by the Museum of Glass
Viola A. Chihuly Gallery

All measurements are in inches; height precedes width precedes depth. When multiple dimensions appear, they are listed left to right as illustrated in this catalog.

All objects are by Preston Singletary (American, born 1963) unless otherwise indicated; all objects are courtesy of the artist unless otherwise indicated.

All objects made at the Museum of Glass, Tacoma, WA are identified with (*).

1
Scribble Vases, 1985
Blown glass and applied decoration
20 x 12 diam.; 21 x 15 diam.; 23 x 13 diam.

2
Wolf Hat
(G̲ooch S'aaxw), 1989
Blown and sandcarved glass
7 x 16 diam.
Collection of James Sherman

3
Eagle Plate
(Ch'áak' Kélaa), 1994
Blown and sandcarved glass
1 x 14 diam.
Collection of Theresa Sherman

4
Prestonuzzi Vases, 1995
Blown glass, applied lip wraps
and handles
7 x 9 ½ diam.; 19 x 8 diam.

5
Untitled, 1996
Blown glass, applied lip wraps
16 x 5 diam.; 15 x 5 diam.

6
The Genies, 1996
Blown *incalmo* glass
13 x 10 diam.; 17 x 7 diam.; 23 x 5 diam.

7
Sun Mask Vase
(G̲agaan Lax̱keit K̲'ateil), 1997–1998
Blown and sandcarved glass
14 x 14 x 5
Collection of Rachel Singletary Kopel

8
Alligator Goblet, about 1999
Blown and hot-sculpted glass
11 x 5 diam.
Collection of Dante and Alison Marioni

9
Ed Archie NoiseCat (Canadian, b. 1959)
and Preston Singletary
Designed and sandcarved by
NoiseCat; blown by Singletary
Frog Mask
(Xíxch Yéigi L'ax̱keit), 1999
Mold-blown and sandcarved glass
11½ x 11 x 7
Collection of Raven and Robert Fox

10
Wasco
(Jinook Kwáan—Chinook people), 1999
Blown and sandcarved glass
4 x 20 diam.
Collection of James Geier

11
Frog Woman Mask
(X'ichí Shaawát L'ax̱keidí), 2000
Mold-blown and sandcarved glass
11½ x 8 x 9½
Collection of Paul S. Fishman and family

12
Canoe Dishes
(Yáakw S'íx'x'), 2001
Kiln-formed and sandcarved glass
4¾ x 13 x 6½ (each)
Collection of Clarissa Hudson

13
Copper
(Tináa), 2001
Cast and sandcarved glass
16½ x 11 x 2
Collection of Lucy and Herb Pruzan

14
Fire Mask
(X̲'aan L'ax̱keit), 2001
Mold-blown glass; video projection
13 x 14 x 7

15
Spirit
(Yéik), 2001
Blown, hot-sculpted, and sandcarved
glass; iridized glass inlay
7 x 22 x 7
Collection of Tony Abeyta

16
Rain Mask
(Séew L'axkeit), 2001
Mold-blown glass; video projection
13 x 14 x 7

17
Raven Steals the Sun
(Gagaan Awutáawu Yéil), 2001
Blown, hot-sculpted, and
sandcarved glass
15 ¾ x 6 x 6
Collection of Michael and Cathy Casteel

18
Soul Catcher
(Káa Yahaayí Shatl'ékwx'u), 2001
Blown and sandcarved glass; iridized
black Bullseye glass inlay;
hand-woven cedar-bark rope
6 ¼ x 21 ¾ x 4 ½
Collection of Clay Johanson

19
Warrior Mask
(X'igaa Káa L'axkeit), 2001
Mold-blown and sandcarved glass;
horsehair
14 x 10 x 7
Collection of Larry Gabriel

20
Housefront Screen
(Hít Ya X'éeni), 2002
Kiln-cast, sandcarved, and enamel-
painted glass; steel frame
26 x 31¼ x 6
Collection of Ann M. Morrison and
Steve J. Pitchersky

21
Shadow Catcher
(At Yahaayí Shatl'ékwx'u), 2002
Blown and sandcarved glass
6½ x 17½ diam.
Collection of M.J. Murdock Charitable
Trust, Vancouver, Washington

22
Transference
(Tulatseen), 2002
Blown, hot-sculpted, and sandcarved
glass
10 x 25 x 8 ½
Collection of Luino and
Margaret Dell'Osso, Jr.

23
Never Twice the Same
(Tlingit Storage Box)
[Tleil Tlax Wooch Yáx Udatí (Lákt)], 2003
Cast glass, waterjet-cut, cut,
sandblasted, and assembled
18½ x 15½ x 15½
Collection of Corning Museum of Glass,
Corning, New York (2003.4.83) 18th
Rakow Commission

24
Whaler's Hat
(Yáay Kalaxachx'e S'aaxw), 2003
Blown, sandcarved, and
enamel-painted glass
13 x 12½ diam.

25
Frog Medicine Frontlet
(Xíxchi Naagú Kaktu.át), 2005
Blown and sandcarved glass; horsehair
and iridized black Bullseye glass
7½ x 12½ x 5
Collection of John and Beverly Young

26
Tammy Garcia (American, b. 1970)
and Preston Singletary
Designed by Garcia; blown and
sandcarved by Singletary
Parrot Seed Jar
(Yoo X'ayatáni Tsítsk'w At X'aakeidí
T'oochinéit), 2005
Blown and sandcarved glass
13 x 15 diam.

27
Transference
(Tulatseen), 2005
Blown, hot-sculpted, and
sandcarved glass
7½ x 21 x 7
Collection of Scott Karlin

28
Water's Edge
(Séew L'axkeit), 2005
Blown, hot-sculpted, and
sandcarved glass
5½ x 16¾ x 6
Collection of Luino and
Margaret Dell'Osso, Jr.

29
Bentwood Box
(Lákt), 2006
Cast and sandcarved glass
18¾ x 26 x 14½

30
Chieftain's Daughter
(Kéet Shagóon Sée), 2006
Blown, hot-sculpted, and sandcarved
glass; synthetic hair and abalone shell
13 x 8 x 5

31
Feast Bowl and Spoon
(Eix' S'íx'i ka Shál), 2006
Blown and sandcarved glass
15 x 9 x 9

32
Land Otter Man
(Kooshdaa Káa), 2006
Blown and sandcarved glass
19 x 10 x 5

33
Oystercatcher Rattle
(Lugán Sheishóox), 2006
Blown, hot-sculpted, and
sandcarved glass
24 x 17 x 6 ½
Collection of Alan and Lorraine Bressler

34
Raven Man
(Naas Shakée Yéil), 2006
Mold-blown and sandcarved glass;
copper leaf and synthetic hair
15 x 18 x 10

35
Box Drum Design
(Kitganí Yahaayí), 2007
Fused, slumped, and water-jet-cut glass
3 x 15 diam.

36
Lewis Tamihana Gardiner (Maori, b. 1972)
and Preston Singletary
Designed by Gardiner and Singletary;
jade carved by Gardiner; glass blown and
sandcarved by Singletary
Devilfish Prow
(Yáakw Shaká Náagu), 2007
Blown and sandcarved glass with
steel connections, *pounamu* (New
Zealand jade), Australian black jade,
Siberian jade, and *paua* (New Zealand
abalone) inlays
30¼ x 6 x 6½
Private collection

37
Shaman's Amulet
(Ḵaa Yakgwahéigoo Kei Ashatch Át), 2007
Blown, hot-sculpted, and
sandcarved glass
14 x 20¼ x 5½

38
Tlingit Crest Hat
(S'áaxw), 2007
Blown and sandcarved glass; gold foil
10 x 19½ diam.

39
Lewis Tamihana Gardiner (Maori, b. 1972)
and Preston Singletary
Designed by Gardiner and Singletary;
blown and sandcarved by Singletary
Toki Amulet
(Toki Danáakw), 2007
hemp binding
25½ x 7 x 3½
Collection of Kim and Tony Allard

40*
Black Gold
(T'ooch' Góon), 2008
Blown and sandcarved glass
24 x 10 x 5

41*
Breaching Killer Whale
(Yaa Natán Kéet), 2008
Blown, hot-sculpted, and
sandcarved glass
15 x 23½ x 12

42
Clan House
(Naakahídi), 2008
Kiln-cast and sandcarved glass; water-
jet-cut, inlaid, and laminated medallion
16 feet x 10 feet x 2½ inches
Collection of Museum of Glass,
Tacoma, WA with funds provided by
Leonard and Norma Klorfine Foundation

43
Eagle Dance Staff
(Ch'áak Woos'aa Ḡaa), 2008
Blown and sandcarved glass;
human hair, metal pole
67 x 2½ x 7

44
Raven Dance Staff
(Yéil Woos'aa Ḡaa), 2008
Blown and sandcarved glass;
human hair, metal pole
82¾ x 3 x 7

45
Eagle/Raven
(Ch'áak'/Yéil), 2008
Blown and sandcarved glass
22 x 7 x 5

46
Eagle Transformation Mask
(Ch'áak' Lax̱keit), 2008
Blown and sandcarved glass;
metal hinges
7 x 16 x 5½

47
Indian Curio Shelves
(Tlaagú Ḵágu Kayaashx'), 2008
Blown, overlay, and sandcarved glass
Overall: 10 x 52 x 14 (each shelf)

48*
Killer Whale Ancestor Mask
(Kéet Shagóon Lax̱keit), 2008
Mold-blown, hot-sculpted, and
sandcarved glass
18 x 10 x 7

49
Killer Whale Totem
(Kéet Kootéeyaa), 2008
Blown, hot-sculpted, and
sandcarved glass
30 x 12 x 6
Collection of Dr. Edward Zbella

50*
Raven Steals the Sun
(Ḡagaan Awutáawu Yéil), 2008
Blown, hot-sculpted, and
sandcarved glass
9½ x 26 x 9½

51
Hand-painted by Preston Singletary
Customized Martin Guitar
(Gil'jaa Kóoḵ), 2008
Hand-painted spruce soundboard
40 x 16 x 4¾
Courtesy of C. F. Martin & Co.
(The Martin Guitar Company)

52
Martin Guitar design
(Gil'jaa Kóoḵ Yahaayí), 2008
Pencil on vellum with paper
CAD template
39 x 27½

53
Threshold Amulet
(X̱'awool Yéigi Danáakw), 2008
Blown and sandcarved glass; hot-
sculpted glass bones, cedar-bark ties
16 x 23 x 2½

54*
Wood Worm Amulet
(Aas Tutl'úk'xu Danáakw), 2008
Blown, hot-sculpted, and
sandcarved glass
21½ x 13½ x 19

This publication is sponsored by

Leonard and Norma Klorfine Foundation

Windgate Charitable Foundation

JoAnn McGrath

The Seattle Times

City Arts Magazine and Encore Arts Programs

PHOTO CREDITS